NOTE ON THE PRESENT EDITION

John Sloan's teaching book Gist of Art has been out of print for many years. I am very pleased that Hayward Cirker has decided to bring it out in a new Dover edition. Apart from a few minor typographic corrections and bibliographic indications, the text is reproduced exactly as it appeared in the first edition published by the American Artists Group in 1939. The only new item in the second edition of 1944 (of course included here) was a diagram on page 67 which Sloan made as an improvement on the one I had drawn to explain isometric perspective. This 1977 edition will not include the two color plates in the chapter on painting because the explanation in the text is more satisfactory than those illustrations. One photographic portrait of Sloan has been dropped, but several more have been added.

When I showed Mr. Cirker a rough draft of the new Introduction and Chronology, he suggested that a completely new collection of illustrations should be added to give the contemporary reader a feeling of "the presence of the artist-teacher": photographs of Sloan that show him in Philadelphia and New York; drawings, prints and paintings that give a moving picture of the places he lived in and the changing styles of his own work. This illustrated Chronology provides a background that sets the stage for reading the book, or *listening* to Sloan as he encouraged students to do their own kind of work, and not to imitate the teacher's personal style.

In the original edition, a second section, "Forty Years of Painting," was added to the teaching text; this was really a separate book illustrating Sloan's lifework as an artist. Since 1939 there have been other more complete publications carrying the work up to 1951, the year of his death; most of these are listed in the Chronology. The old acknowledgments and Publisher's Note have also been omitted in the present edition, and the dedication has been changed. There is one inaccuracy in the text that might be mentioned: on page 3 Sloan said that he came to New York from Philadelphia in 1905. When I went through his papers after we were married in 1944, I found that he had moved in 1904. Moreover, a photograph of Sloan dated 1897 in earlier editions proved to be 1903, dated in his hand at the time. Sloan was a man who lived in the present.

H. F. S.

[v]

INTRODUCTION TO THE DOVER EDITION

The average lavperson who is interested in art, and even professional art students, are surprised to learn how many modern artists studied with John Sloan. He had no interest in promoting the imitation of his own work. When critics complained that he did not repeat subjects like The Wake of the Ferry or McSorley's Bar, Sloan said that he earned the time to do his own work by illustrating and teaching: "Why shouldn't I feel free to try out new subjects and new ways of expressing form and color? I suppose it would be more understandable if I imitated Picasso. When I saw his work in the Armory Show, along with that of Cézanne and the other great ultra-moderns, it opened my eyes to a fresh way of seeing the art of all time. I lost some of the 'blinders' of prejudice about subject matter which had made me pass by a lot of important things with conspicuous religious subject matter. Henri had stressed the painting of contemporary life, perhaps so much that some of us didn't realize how many Renaissance and Romanesque paintings or sculptures were really based on the contemporary scene of those times I learned from the Armory Show to have a more conscious interest in the problems of plastic realization, the concern with form that can be found everywhere in fine art from the time of the cavemen to this age of experimental transitions I have tried to assimilate ideas from study of the ultra-modern movement, while continuing to teach the importance of humanism."

When Sloan started to teach regularly at the Art Students League, in 1916, he was forty-five years old. His classes were crowded with students of all ages, many of whom worked at part-time jobs. Reginald Marsh and Peggy Bacon found Sloan's teaching a catalyst for their own kind of realism. Later on, Aaron Bohrod, Don Freeman and Eric Sloane also learned something about developing their individual talents. Otto Soglow, Chon Day, Carl Rose and Edmund Duffy turned to humorous illustration and political cartooning. Angna Enters came to Sloan's class to improve her commercial work, but was encouraged to work with form and motion. She became a distinguished dance-mime, making her own costumes and often composing music for her original episodes.

There were many students who went on as teachers: Kimon Nicolaides, who wrote The Natural Way to Draw; Richard Lahey, who

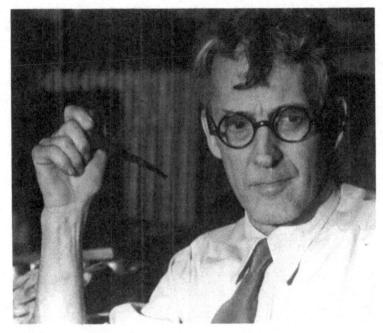

As Sloan looked in 1927, when the notes for Gist of Art were collected.

JOHN SLOAN on Drawing and Painting (Gist of Art)

John Sloan

Recorded with the assistance of Helen Farr Sloan

DOVER PUBLICATIONS, INC. Mineola, New York To the memory of JOHN SLOAN artist and teacher 1871–1951

Copyright

Copyright © 1944 by John Sloan All rights reserved.

Bibliographical Note

This Dover edition, first published in 1977 under the title Gist of Art: Principles and Practise in the Classroom and Studio and reissued in 2000 under the title John Sloan on Painting and Drawing: The Gist of Art, is a revised republication of the work originally published by American Artists Group, Inc., New York (first edition, 1939; second edition, 1944). The Note on the Present Edition, the Introduction to the Dover Edition, the Chronology, and the picture selection were new in the 1977 edition. For all other changes, see the Note on the Present Edition.

Library of Congress Cataloging-in-Publication Data

Sloan, John, 1871-1951.

[Gist of art]

John Sloan on drawing and painting : the gist of art / John Sloan. p. cm.

Previously published: Gist of art. 3d rev. ed. New York : Dover Publications, 1977.

ISBN-13: 978-0-486-40947-4 (pbk.)

ISBN-10: 0-486-40947-3 (pbk.)

1. Art-Study and teaching. 2. Art-Philosophy. I. Title.

N85 .S55 2000 760-dc21

99-054552

Manufactured in the United States by LSC Communications 40947308 2020 www.doverpublications.com was head of the Corcoran School of Art; and David Scott, who organized the Sloan centennial exhibition for the National Gallery, after being head of the National Collections of Fine Art.

Sloan's voluntary public service to many art organizations like the Society of Independent Artists provided him with a way of teaching ideas about "open door" and group exhibitions—which were carried on all around the country by students and friends who were trained by him. Holger Cahill and Fred Biesel, who were top administrators for the WPA art projects, learned much through association with Sloan while helping with exhibitions during the Twenties.

When I started to study with Sloan in 1927, his old pupil Alexander Calder used to drop into the classroom now and then. Ordinarily, Sloan did not like that kind of informality, but his face always lit up when he discovered Sandy behind a large board, drawing great free-line charcoal designs related to the new wire sculptures. David Smith was making magnificent humanistic drawings of the figure, listening to Sloan's talk about the importance of abstraction and geometry in design. (Smith later studied with Matulka, who gave him some special insights into abstract symbolism which were useful in focusing his talent.) In addition to these sculptors who made creative contributions in the modern idiom, there were Adolf Gottlieb, John Graham, G. L. K. Morris and Barnett Newman.

Because Sloan had spent so many years working in poster style for the Philadelphia newspapers, he had a very fine sense of abstract design which made him a thoughtful and constructive critic for students working in nonrepresentational style. He was very alert to unpleasant repetitions of rhythms that interfere with a fine sense of proportion. Criticisms about this kind of technical problem lose their meaning when set down in words without the presence of the work. When Sloan used to have open nights for criticism of work brought in by his students or anyone else who wanted to pay the fifty cents, everyone had the opportunity to learn from these practical comments. And no one could ever forget his contempt for the feeble symbolic image vignetted in space: "It looks like an oyster in full flight."

Gist of Art is composed of notes taken verbatim while Sloan was teaching in the classroom or lecturing to an audience of laypeople who had some serious interest in art. He was *speaking* to the producers and consumers of art. In selecting and arranging the material for publication it was necessary to consider what could stand alone

INTRODUCTION

in print without the presence of the speaker's voice and gestures. I wrote to a number of students to collect material in addition to the thousands of notes I had accumulated. Some of their notes paralleled those I had taken while Sloan gave painting demonstrations, some depended on the work being seen, and some anecdotes would fit better in another kind of book. After I had put the material together and rearranged it twice, Sloan read the final manuscript. He made a few deletions and added two footnotes. Then Sloan phoned me to say that he was pleased with the manuscript. "It sounds as though I am talking."

April 6, 1976

HELEN FARR SLOAN

CONTENTS

С	Chronology of John Sloan	XI
I	POINT OF VIEW ABOUT LIFE	1
п	POINT OF VIEW ABOUT TEACHING	6
ш	POINT OF VIEW ABOUT ART	18
IV	THINGS—THE MAINSPRING OF ART	43
v	DRAWING The attack; Line; Tone; Texture; Light and shade; Observations and reminders; Perspective; Optical illusions; Design; Space; Low relief; Composition; Crowds and places; Purpose; Criticism and taste; Study.	53
VI	FIGURE DRAWING	87
VII	PAINTING	109

[IX]

VIII	LANDSCAPE AND MURAL	•	•	•	•	•	•	•	146
IX	MEMORANDA	-	• sugg	, gesti	ons.	•	•	•	156
x	NOTES ON PAINTING TECHNIQUE Gesso Grounds; Tempera; Glazing.	•	•	•	•	•	•	•	166
XI	ETCHING, AND DIVERS MEDIUMS Aquatints; Lithography; Water color.	•	•	•	•	•	•	•	178
XII	THE GIST OF IT ALL	•	•	•	•	·	•	•	189
	Index	·	•	·	•	•	·	•	193

- 1871 Born August 2 in Lock Haven, Pa. (this small town on the West Branch of the Susquehanna River was a center for the lumber industry and later on became known for its paper mills). Named John French Sloan after his grandfather, who carried on the traditional family business of cabinetmaking which their ancestors had brought to America from Scotland early in the 18th century. (Handicraft industries were feeling competition from factory-made products, so Sloan's father, James Dixon Sloan, could not afford to go to college to get a scientific training for his talents as an inventor. Sloan's mother, Henrietta Ireland, was teaching in a girls' school in Lock Haven. Her Philadelphia family was in the "paper business," importing writing paper, greeting cards and books published by their relatives in England, one of whom, Marcus Ward, was "Illuminator to the Queen.")
- 1876 Traveled to Philadelphia with his father; fascinated by Machinery Hall at the Centennial Exhibition. The father, who was looking for work, finally took a job as traveling salesman for Marcus Ward Publications, of which his brother-in-law Alfred Ireland was American representative. The family moved to Philadelphia, finally settling in a small red-brick house on Camac Street. Sloan said that his father never earned more than \$25 a week. "We were poor but not underprivileged. . . . My two younger sisters and I always had all the books we wanted to read, and tools to make things with. Our parents were not demonstrative but they had confidence in us, encouraged us to do things on own own initiative."
- 1884 Entered Central High School, in the same class with William Glackens and Albert C. Barnes (who was to become famous for Argyrol and for his great art collection). After one semester, he was kept home to rest his eyes (Sloan was extremely nearsighted). "Of course I enjoyed the opportunity to spend more time at the library. I had read all of Dickens and Shakespeare before I was twelve. . . . My great-uncle Alexander Priestley had a wonderful library with folios of Hogarth and Cruikshank, etc. Another great-uncle, Rev. Horatio Hastings Weld, had been

editor of the Boston *Transcript* and was working for the Philadelphia *Ledger* when I was a child. Dr. Batterson, our minister, also had a fine library. He had designed his church in Romanesque style and imported fine statuary. I sang in the choir for many years."

1888 After failing as a traveling salesman and proprietor of a stationery store, Sloan's father finally had a melancholy breakdown. He lived for 30 more years, doing odd jobs and taking tender care of an invalid wife. The family decided that Sloan would have to leave school and help support his parents and his two young sisters. "I might have been a doctor, lawyer or preacher. . . . After working a few weeks for a lawyer, I got a job as assistant cashier in Porter and Coates's bookstore. They had a print department where I was allowed to study and make copies of Rembrandts, which I could sell for about five dollars. This helped with the take-home pay of six dollars a week. I also designed hand-colored greeting cards for 50 cents apiece. . . . So I drifted into art as a way of earning a living. Taught myself to etch from Hamerton's Etcher's Handbook. My first effort was a weakly bitten copy of a print by Turner."

1890 Using his father's paintbox (the elder Sloan was an amateur artist) and a piece of window shade for canvas, Sloan painted his first picture, a self-portrait now in the Delaware Art Museum, Wilmington. (He had taught himself to paint by studying A Manual of Painting by John Collier, London, 1886; on the flyleaf of his copy is written: "John F. Sloan-October 1889.")

Enrolled in a freehand drawing class at the night school of the Spring Garden Institute to get a little instruction in draftsmanship and imaginative composition. Meanwhile, worked full time as a designer for A. E. Newton's fancy-goods business. (Newton offered to send him abroad to study, but Sloan wanted to keep his independence, not relishing the idea of being indebted to anybody.)

1891 Tried to earn a living as a free-lance artist, doing streetcar ads for the Bradley Coal Co. in a poster style derived from the study of Walter Crane, Greek vase paintings and Japanese prints. Competition with salesmen from N. W. Ayer, one of the new advertising agencies, was too much for him. His English uncle William Ward sent him a letter of introduction to Mr. Beck,

manager of the Philadelphia Engraving Co.—"Saved, but not used. ... Looking back, I am amazed that I had the courage or audacity to refuse the opportunity to get regular employment. But I felt it would lead me away from doing my own work. ... It wasn't that I had ambition to be an artist, but a kind of negative decision—to protect some kind of talent."

1892 Offered a full-time job as illustrator by the art editor of the Philadelphia Inquirer, who liked the poster-style drawings in his portfolio. (Some of the old-time artists were still working on chalk plates, but Sloan drew in pen and ink for line-cut reproduction.) While he was also sent out to draw "current events" like the other artist-reporters (his Philadelphia friends William Glackens, Everett Shinn and George Luks), most of his work was done in the art department for the daily feature pages and Sunday supplement. "I had more time to work out abstract problems of design, line, arabesque. It was fortunate for me that the art editors liked my poster style and allowed me to work more slowly... I had less talent than the others in our crowd. Perhaps that is one reason I went further than they did—I had to work harder."

Started to go out on Sunday sketching trips with Glackens, doing watercolors. In the fall, entered the antique class at the Pennsylvania Academy of the Fine Arts; this was taught by Thomas Anshutz, who had been an associate of Thomas Eakins. Then Sloan met Robert Henri at a studio party given by the sculptor Charles Grafly. Their mutual interest in Walt Whitman was the beginning of a long friendship. Sloan always gave Henri credit for encouraging him to start painting pictures, and called him "the Abraham Lincoln of American art."

1893 Anshutz had taken leave of absence to study in Europe. Dissatisfied with the substitute teacher, annoyed by the academic process of drawing from the antique for long semesters before getting into the life class, and hoping to set up workshop classes with lower tuition, Sloan and some other students established the Charcoal Club. Henri gave criticisms in drawing and Sloan was asked to give them for composition. The fee was two dollars a month, but this was a depression year and the project was given up after a few months. Anshutz returned, Sloan rejoined the antique class, and was finally promoted to the life class. Just at the time this happened, Anshutz rebuked Sloan for drawing the

[XIII]

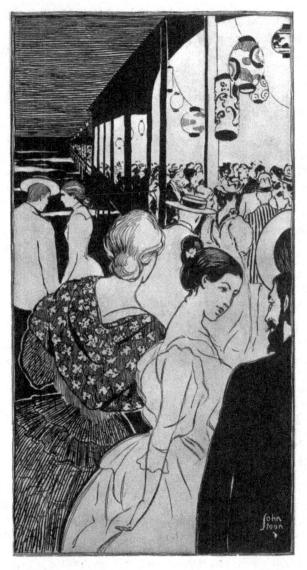

"Night on the Boardwalk," 1894.

Pen and ink for reproduction by linecut. Illustration for "Seaside Resorts" page of the Philadelphia Inquirer, July 8, 1894. Private collection.

"One of my early newspaper drawings made when I was interested in Japanese prints. I was given recognition as a member of the 'poster movement' before I had ever seen the work of Beardsley, Steinlen, Toulouse-Lautrec and the other European masters of that style. My first efforts as a painter were sketches made on Sunday excursions into the country. I painted for amusement with no idea of making art. Later Henri encouraged me to take up painting seriously." (Photo by Geoffrey Clements)

"Woman and Butterfly," 1895. Cover for second volume of *Moods*, A *Journal Intime*, one of the little avant-garde magazines published during the Poster Period. Sloan was art editor.

students working around the room into the background of some antique cast. "I was furious, and I left the class. In later years we became friends again, and after I started to teach regularly myself, I came to realize that he was right to scold me for going beyond the problem that was set up."

In the fall, Sloan and his friend Joe Laub took over Henri's studio at 806 Walnut Street. It became the social center for newspaper artists who came to hear Henri talk about art, and the place where their crowd spent a lot of time producing amateur theatricals.

- 1894 Received national recognition in the Inland Printer and Chicago Chapbook for his poster-style drawings in the Inquirer.
- 1895 Heyday of the Poster Movement. Sloan was art editor of the journal *Moods* and contributed to several other short-lived publications. The artist-reporters were being phased out of newspaper work as cameras became more convenient and halftones could be printed on high-speed presses. (Henri and Glackens left for Europe.) In December Sloan moved over to the Philadelphia *Press*, continuing to work in poster style most of the time.
- 1896 With mornings free, Sloan had some daylight hours for painting. He did portrait studies, and was invited to paint two murals, *Music* and *Opera*, for the Pennsylvania Academy, an honor with no honorarium.
- 1897 Henri returned from Paris, and used Sloan's studio for classes which gave Sloan the opportunity to observe and listen, though he never studied with Henri formally. Henri was full of enthusiasm for Manet and rapid execution. Sloan remembered being scolded for working too slowly and answering, "I work until I get solidity." It was one of the few times he had disagreed with his mentor's advice.
- 1898 Offered a job with the New York *Herald* at a better salary than he got on the *Press*, Sloan moved to New York for a couple of months, but the art editor did not appreciate his work and he returned to Philadelphia. He took back with him the idea for a series of full-page colored "puzzle drawings" to be executed with the benday process and to be printed on the new color presses

being installed at the *Press*. (Henri married and moved to Paris for two years; Glackens and Luks covered the Cuban campaign of the Spanish-American War.)

- 1899 June 18, started the series of some 80 colored puzzle drawings, working in the engraving department to etch the benday plates like aquatints. With more time to paint, did portraits and memory pictures of Philadelphia scenes, encouraged by letters from Henri.
- 1900 The paintings Independence Square, Philadelphia and Walnut Street Theatre accepted by juries of the Carnegie Institute and the Chicago Art Institute.
- 1901 Represented by three paintings in the Allan Gallery exhibition in New York City, organized by Henri, the first independent group show. August 5, married "Dolly" (Anna Maria) Wall. A tiny little Irishwoman, called by his friends "Sloan's outboard motor," her only faults were a tendency to melancholy moods and a weakness for alcohol. They took care of each other for 42 years.
- 1902 Recommended by Glackens as illustrator of the novels of Paul de Kock (the job included 54 drawings and 53 etchings), Sloan saturated himself in books on costume, maps, etc. "I could have found my way around Paris in the dark." But he had not gone abroad, even when Henri recommended it. "I was not interested in the Paris art students' life, and I did not want to lose my independence by accepting money from anyone to finance the trip. . . . I found the courage to stay in this country, to put down roots. . . . It was a time when many artists had become expatriates —imitating the Europeans and often tempted to paint sentimental or picturesque subjects."
- 1903 Now working only three days a week for the Philadelphia Press, Sloan had more time for book illustration and painting. Study of Rembrandt, Daumier and Leech strengthened the linework in the etchings made for the de Kock novels. The whole project of city life, even though in period costume, prepared him for his own original scenes of New York City. (Sloan never used models or photographs when composing illustrations. He studied

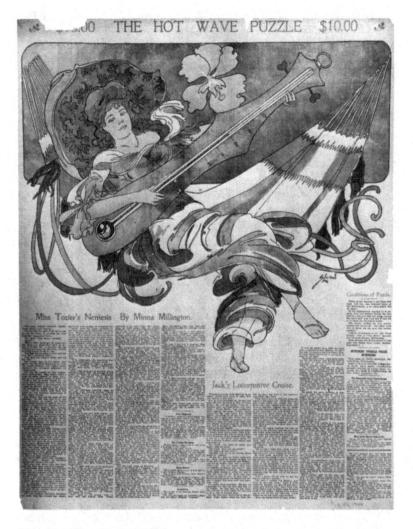

"The Hot Wave Puzzle," 1900.

Color page from the Sunday Supplement of the Philadelphia Press, Aug. 26, 1900.

While drawing these colorful Art Nouveau style "puzzles" for reproduction by benday process, Sloan was painting realistic memory-impressions of Philadelphia street scenes, using a low-keyed palette related to that of Manet. He was allowed to work in the engraving department to do some of the etching on the color plates, achieving results similar to aquatint. (Photo by Geoffrey Clements)

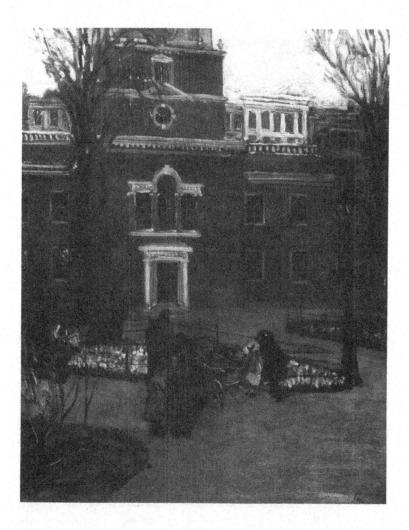

Independence Square, Philadelphia, 1900.

Oil on canvas. Kraushaar Galleries, New York.

"The first picture I ever sent out to an art jury." 'Accepted by the Carnegie Institute International, 1900. After Sloan moved to New York (in 1904) he noticed a similar city scene, writing in his diary on April 17, 1906: "Took a walk. Madison Square is thronged with Springtime—setting out pansies in large circular bed. The people stop and watch the flowers as they did in Philadelphia Independence Square when I painted my first exhibited picture, Independence Square." (Photo by Geoffrey Clements)

John Sloan, artist of the Philadelphia Press. Dated December 14, 1903.

Sloan's photograph, 1903, of the loft-studio at 806 Walnut Street, Philadelphia. Dolly Sloan is seen at the piano.

research materials for accuracy of background and costume, but worked entirely from imagination as though seeing real life in memory. Many contemporary illustrators posed models in front of the camera, and painted from the photographs.)

In December the *Press*, feeling the pressure of automation, subscribed to a syndicated Sunday supplement and Sloan was fired. But he continued to make "word-charade puzzles" for the paper through 1910. Each week he drew ten pictures in pen and ink, illustrating all kinds of things like dictionaries, dressmaking terms, etc. It paid the rent when he moved to New York.

- 1904 Moving to New York, Sloan took a top-floor apartment at 165 West 23rd Street in the Chelsea district. While walking the streets to visit the magazine offices, he had time to observe the life of the people and think about doing a series of etchings. He accepted a small loan from Henri so he could work without too much worry about getting commissions for illustrations. "But it always made me feel nervous to be in debt to anyone. I could not paint or etch unless I had the money in the bank for the next few months' rent and food. After I had a new commission in the house, then I could do my own work from ideas that had been stored up."
- 1905 Did "Turning Out the Light" and other New York City etchings. The painting *The Coffee Line* received honorable mention at the Carnegie Institute. Did illustrations for magazines in a realist style. "I got known for Irish humor subjects, so the editors said there was a limited demand for my work."
- 1906 Painted Dust Storm, Fifth Avenue (purchased by the Metropolitan Museum in 1921). On brief summer holidays in the country, began to paint small landscape sketches. Started the journal (through 1913) that was published by Harper & Row in 1965 as John Sloan's New York Scene. Substituted for Henri at the New York School of Art. During these years when Sloan took Henri's place, artists like Bellows and Hopper were in the class. The etching "Memory" dates from this year.
- 1907 Taught at the Pittsburgh Art Students League one day a week. Participated in the preparations for the show of "The Eight" to be held at the Macbeth Gallery in 1908, and in the protest

"Memory," 1906. Etching.

"A memorial plate made after Linda Henri died, an intimate print which has become one of the most popular of my etchings. . . . Henri was always amazed that I had remembered her gesture: her hand rolling her fingers as she read aloud. It was made purely from memory." Linda Henri (foreground) died in 1905; also shown are Henri, and Dolly and John Sloan.

The Wake of the Ferry (No. 2), 1907.

Oil on canvas. The Phillips Collection, Washington.

"This second painting of the theme differs from the first by being in a slightly less melancholy mood. It has been more frequently seen by the public for the reason that the slight repairs to No. 1 were not made for many years." The first painting of this subject is now in the Detroit Institute of Arts. Some 40 years after these pictures were painted, Sloan's old newspaper-artist friend Everett Shinn came to call on him at the Hotel Chelsea. The work of "The Eight" was then receiving some new notice from the art historians, critics and collectors. Shinn advised: "Sloan, why don't you make some more versions of your Wake of the Ferry? I can sell all the clowns I can paint." Sloan was saddened to hear that some commercial success was leading Shinn to make imitations of his early work.

against the National Academy jury which had rejected work by Luks and even Henri. This was a good year for painting: the two versions of *The Wake of the Ferry*, etc.

- 1908 Busy with the Macbeth show, handling the money and the catalogue, and taking photographs of the pictures. (Sloan was always good with figures, and was called upon to be treasurer of many voluntary artists' organizations.) The exhibition received a lot of newspaper attention, but Sloan and Glackens did not sell any pictures.
- 1909 John and Dolly met John Butler Yeats, father of the poet, who became a second father to them. (While trained as a lawyer, Yeats had studied art, and his appreciation and criticism were extremely valuable.) Henri and Sloan studied the Maratta color system, which afforded them a technical method for planning new color orchestrations and a way to control the palette when using a broader range of color. (They had been working with a limited palette based on earth colors, related to that used by Manet.)
- 1910 Spent a lot of time managing the Independent Artists Show, a precursor of the Armory Show. Joined the Socialist Party and was a candidate for the New York State Assembly. Painted Yeats at Petitpas'.
- 1911 Organized a group exhibition for the MacDowell Club, and contributed drawings to the New York *Call*. Recommended by Mrs. Jessica Finch (founder of the girls' school and college) to paint a portrait of Gottlieb Storz in Omaha, he grew so nervous about this commission that he came down with shingles.
- 1912 After several moves, found a loft-studio at 35 Sixth Avenue while he and Dolly lived on Perry Street, Fourth Street, etc. Invited to be a member of the Association of American Painters and Sculptors; this group organized the Armory Show of 1913, but Sloan was too busy to become one of the active organizers.

Began to have private pupils for drawing, painting and etching. Started to work from the nude for the first time since the few classes held by the Charcoal Club. His city scenes, which were becoming richer in color, included *McSorley's Bar* and *Sunday*.

[XXIV]

Yeats at Petitpas', 1910.

Oil on canvas. In the Collection of the Corcoran Gallery of Art, Washington.

"At the time the picture was painted the great human drawing card of Petitpas' was John Butler Yeats, the charming Irish conversationalist, artist and philosopher, father of W. B. Yeats, the Irish poet. Yeats's table drew young poets, painters, writers and actors who eagerly enjoyed his talk, which was always greatly entertaining. In the painting from left to right—Van Wyck Brooks, J. B. Yeats. Alan Seeger, who wrote *Rendezvous with Death*, Dolly Sloan, Ann Squire, John Sloan, Fred King. It is a satisfaction to have painted this record of Yeats, whose portraits in Dublin and England establish him, according to Robert Henri, as the best British portrait painter of the Victorian era. He died in New York at the age of eighty-four." (Photo by Peter A. Juley & Son)

WHAT NAMES FOR BOOKS OF REFERENCE ARE PICTURED HERE?

El Trep 1 Dusting (Dost Pring). 1 Couling ing (Bay Kong), 9 (round)

"Books of Reference," 1910.

Pen and ink. Published in the Philadelphia Press, November 13, 1910. From the time Sloan moved to New York in 1904, his only regular income came from the weekly "word-charade puzzles" he made for the newspaper. On December 9, 1910, he reported in his journal: "Today I mailed my last puzzle to the Phila. Press. . . . To think that my request for better engraving should have resulted in the ending of the whole matter and that the Press Sunday Jan. 1, 1911 will be about the first Sunday Press to be without a drawing of mine for sixteen years! This is probably slightly exaggerated but it comes near being true save for three months in 1898 when I was on N.Y. Herald." Henri and Sloan are depicted in the upper central panel.

"Anshutz on Anatomy," 1912. Etching.

"Tom Anshutz, our old teacher at the Pennsylvania Academy, gave anatomical demonstrations of great value to art students. . . . Those present in this etched record of a talk in Henri's New York class include: Robert and Linda Henri, George Bellows, Walter Pach, Rockwell Kent, John and Dolly Sloan." Sloan is in profile, upper right; Dolly, at center right; Linda Henri, at lower right. Henri is behind the lady wearing the fashionable hat.

Sunday Afternoon in Union Square, 1912.

Oil on canvas. Bowdoin College Museum of Art, Brunswick, Maine.

"Few paintings are very satisfactory to the artist at the time of making. How glad we are years after we tried our best—building better than we knew. Lavender light was in my mind." Sloan said that his motive in painting citylife subjects was to record "bits of joy in human life." Each picture is unique in composition and color orchestration. While working from memory, Sloan studied the places that were familiar, while choosing human incidents that gave him the inspiration for a pictorial concept. Sometimes he made a quick sketch with color notations.

Women Drying Their Hair, which were exhibited at the Armory Show the next year, as was the etching of Anshutz's anatomy demonstration.

Invited to be acting art editor of *The Masses* (without pay). (There was no response to his ad in the Rand School program offering "10 City etchings for \$25.00.")

1913 Served on the hanging committee for the Armory Show, but was very busy making drawings for *The Masses* and planning its layout. Max Eastman, the managing editor, later wrote that Sloan's policy of graphic design had affected magazines like *Harper's* and *The New Yorker*.

While he never imitated any of the modern artists seen in the Armory Show, Sloan said that he assimilated a great deal from studying the work of Cézanne, Renoir and Picasso. He also realized that the European artists had "the habit of working," no matter what the style or subject matter. "I had been dependent on waiting for the inspiration to paint a picture because I had so little leisure time to work for myself. So I decided to save up enough money to take off a few months, go to the country and work from nature, to get fresh ideas about plastic design and color rhythms." Made the first sale of a painting, to his old schoolmate Dr. Albert C. Barnes (Glackens was advising Barnes on his collection of modern art).

- 1914 First summer spent painting in Gloucester, Mass. Some years the cottage was shared with his friend Edward Davis and family. Sloan used to go out sketching with Stuart Davis, who was in a stage of transition toward modernism after having studied with Henri. With the outbreak of World War I, Sloan became disillusioned with the hope that Socialism would prevent international conflicts. He made no more political drawings for *The Masses* and withdrew from the Socialist Party.
- 1915 Moved to an apartment at 88 Washington Place in Greenwich Village. His studio was a made-over dining room with limited light.
- 1916 First one-man exhibitions at the Hudson Guild and Mrs. Harry Payne Whitney's Studio. Began his association with the Kraushaar Galleries. Resigned from *The Masses* when Stuart

THERE WAS A CUBIC MAN HOD HE WALKED A CUBIC ЯПО MILE HE FOUND A CUBIC SIXPENCE UPON A CUBIC STYLE HE HAD A CUBIC CAT WHICH CAUGHT A CUBIC MOUSE AND THEY ALL LIVED TOGETHER IN R LITTLE CUBIC HOUSE The Slad

"The Cubic Man." 1913.

Drawing, black chalk. Published in The Masses, April 1913.

Sloan was a member of the organization that put on the Armory Show and served on the hanging committee. He assimilated a great deal from that great exhibition of modern work by Cézanne, Picasso, and others. Marcel Duchamp's cubist abstraction of a woman walking downstairs was the most exciting feature of the show, the center of critical controversies. Sloan could not resist the opportunity to draw a parody to illustrate his humorous verse.

"At the Top of the Swing," 1913.

Drawing, black chalk with touches of black ink. Reproduced on the cover of The Masses, May 1913. Yale University, Art Galley, Gift of Dr. Charles E. Farr.

Sloan served as art editor of *The Masses* for several years, until the outbreak of World War I in 1914 influenced many contributors to vote for a persistent political slant in all the illustrations. Sloan felt that humanism was important. Teaching about cartooning and caricatures, he said that a negative "anti" point of view could not be the motive for real art. "I have always had enthusiastic interest in unspoiled girlhood, more in evidence in 1912 than now. Growth toward real womanhood is often checked at about this age." (Photo by Joseph Szaszfai)

Davis, Glenn Coleman and others asked him to support their protest against the literary editors, who were giving a political slant to drawings by changing the titles. Started to teach at the Art Students League, and gave summer classes in Gloucester.

- 1917 First one-man show at the Kraushaar Galleries. On the hanging committee for the first exhibition of the Society of Independent Artists (Glackens was president). Did the etching "Hell Hole."
- 1918 Elected president of the Society of Independent Artists, a position to which he was chosen annually until 1944, the last year a show was held. Last summer in Gloucester.
- 1919 First trip to Santa Fe; painted many landscapes and scenes of town life. Sloan said he liked the geometrical formations of the desert country. He became interested in the Pueblo Indians and joined with other artists to help protect their religious cultural traditions.
- 1920 Bought a house in Santa Fe. Every summer he helped with the Fiesta, designing floats, making costumes, etc.
- 1921 At the age of fifty, Sloan had sold only eight paintings. This year the Metropolitan Museum bought Dust Storm, Fifth Avenue, which had been painted in 1906. This was his first sale to a museum.
- 1922 Underwent surgery for hernia. Painted The City from Greenwich Village.
- 1923 Sold 20 paintings to George Otis Hamlin, of which 19, and a full set of etchings, were left to Bowdoin College (Brunswick, Me.) in 1961. The price of the sale was reported as \$20,000, but was really only \$5,000. Visiting critic at Maryland Institute, Baltimore.
- 1924 With a class of private pupils he made many figure drawings and portraits.
- 1925 Another operation for hernia. Publication of A. E. Gallatin's John Sloan (Dutton).

[XXXII]

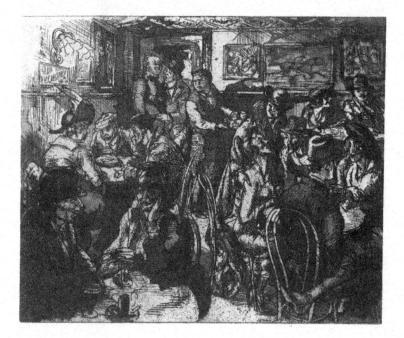

"Hell Hole," 1917. Etching and aquatint.

"The back room of Wallace's at Sixth Avenue and West Fourth Street was a gathering place for artists, writers and bohemians of Greenwich Village. The character in the upper right hand corner of the plate is Eugene O'Neill." At the Sesqui-Centennial International Exposition held in Philadelphia, 1926, this print was awarded a gold medal.

Street, Lilacs, Noon Sun, 1918. Oil on canvas. Kraushaar Galleries, New York.

While Sloan had done a few landscapes during his short summer holidays after he moved to New York, it was after seeing the Armory Show that he decided to save the money for a real painting vacation. From 1914 through 1918 he painted many landscapes, as well as genre scenes of town life and portraits, while summering in Gloucester, Massachusetts. "Gloucester afforded the first opportunity for continuous work in landscape, and I really made the most of it. Working from nature gives, I believe, the best means of advance in color and spontaneous design." (Photo by Geoffrey Clements)

Eagles of Tesuque, 1921. Oil on canvas. Colorado Springs Fine Arts Center: Mrs. A. E. Carlton Purchase Funds and Debutante Ball Purchase Funds.

"Within nine miles of a Europeanized city, for three hundred years the little Pueblo of Tesuque has made a noble fight against combined poverty and civilization. The population is small and on the day when we saw this cere-mony a mere handful appeared as spectators."

The City from Greenwich Village, 1922.

Oil on canvas. National Gallery of Art, Washington, Gift of Helen Farr Sloan. "Looking south over lower Sixth Avenue from the roof of my Washington Place studio, on a winter evening. The distant lights of the great office buildings downtown are seen in the gathering darkness. The triangular loft building on the right had contained my studio for three years before. Although painted from memory it seems thoroughly convincing in its handling of light and space. The spot on which the spectator stands is now an imaginary point since all the buildings as far as the turn of the elevated have been removed, and Sixth Avenue has been extended straight down to the businesss district. The picture makes a record of the beauty of the older city which is giving way to the chopped-out towers of the modern New York. Pencil sketch provided details." (Photo by Peter A. Juley & Son)

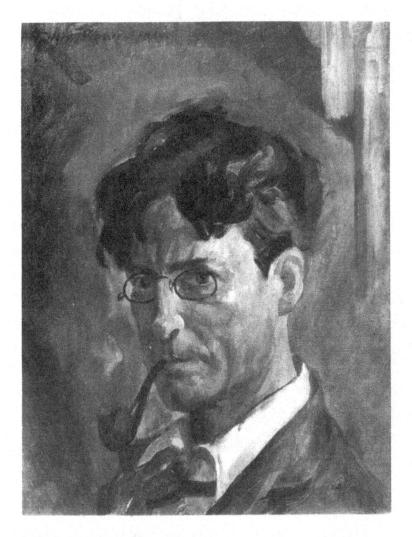

Self-Portrait with Pipe, 1924. Oil on canvas. Annie Halenbake Ross Library, Lock Haven, Pa. A former resident of Lock Haven, Harold M. Hecht, donated this portrait to the Ross Library in Sloan's birthplace. The Library has established a gallery where Sloan memorabilia are kept on exhibition. "John Sargent once defined a portrait as a picture made from a human head which had something wrong with the eyes or the nose or the mouth, and he surely spoke from experience. The advantage of self-portraiture lies in the fact that no heed need be paid to these defects." (Photo by Geoffrey Clements)

- 1926 "Hell Hole" won the gold medal for etching at the Philadelphia Sesqui-Centennial.
- 1927 Moved to 53 Washington Square, where he had a large, well-lit studio for the first time in New York.
- 1928 Publicity about the sale of 20 paintings to Carl Hamilton; the sale fell through when the stock market crashed in 1929. Began experiments with underpainting and glazing techniques.
- 1929 Elected to National Institute of Arts and Letters. Death of his old friend Robert Henri. (Sloan helped to organize the memorial exhibition held at the Metropolitan Museum in 1931.) Began to use linework in the color glazes, tempera for the underpainting.
- 1930 Painted Vagis, the Sculptor.
- 1931 After another operation, resigned from his teaching job at the Art Students League, and was elected President of the Board of Control of the League. Also served as president of the Exposition of Indian Tribal Arts, for which he and Oliver La Farge wrote the catalogue. Dolly Sloan helped support the home by working as manager for the Exposition, and in later years for the Gallery of American-Indian Art. Miss Amelia Elizabeth White and Mrs. Cyrus McCormick helped the Sloans through the depression years by buying a number of paintings.

Sloan started a series of etchings from the figure, drawn freehand on the wax ground without any preliminary tissue.

Publication by the Whitney Museum of American Art of Guy Pène duBois' monograph John Sloan.

Vagis, the Sculptor won the Carroll H. Beck gold medal for portraits.

- 1932 Resigned as president of the Art Students League in protest against the board's refusal to hire George Grosz. Taught briefly at Archipenko's Ecole d'Art. First Washington Square Outdoor Show, of which he was a founder.
- 1933 After the death of George Luks, Sloan was asked to take over that artist's school. Could not afford to make the trip to Santa Fe. Offered to sell paintings at half price in a letter sent

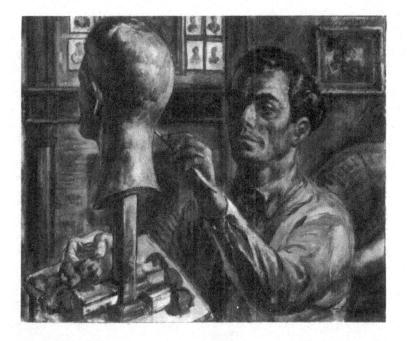

Vagis, the Sculptor, 1930.

Tempera underpainting with oil-varnish glazes, on panel. Kraushaar Galleries, New York.

"When a news agency asked for a photograph of this picture informing me that it had been awarded a portrait prize, I told them there must be some mistake, that I did not paint portraits. . . That it should be . . . condemned to a prize on those grounds was most surprising. Strong color-textural accompaniment to volume and graphic vitality." Sloan painted many portraits; nearly a quarter of his paintings were made from sitters, to please himself. Fewer than ten were commissions. (Photo by Peter A. Juley & Son)

to 60 museums. No reply that year, but the Boston Museum of Fine Arts acquired *Pigeons* (painted in 1910) when the letter was rediscovered in 1935.

1934 On the PWAP [Public Works of Art Project] for two months, painted *Tammany Hall* (now in the Metropolitan Museum) and *Fourteenth Street*, Snow (lost).

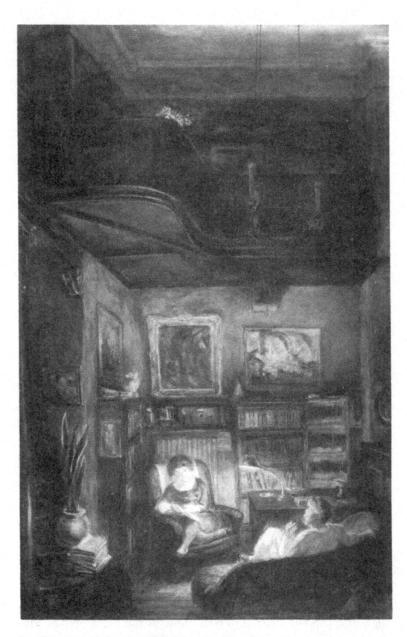

Our Corner of the Studio, 1935.

Tempera underpainting with oil-varnish glazes, on panel. John Sloan Trust.

"The writer and artist frankly admits a strong personal liking for this picture. It is a record of our home life in the studio. The cat on the balustrade is a figment of the imagination. The picture has power, and the problems of chiaroscuro are well met. Its departure from visual representation is much greater than is apparent. It was painted by daylight and from memory in the studio which was the setting." (Photo by Geoffrey Clements)

1935 After the Luks School petered out, Sloan returned to the Art Students League, where he taught until the spring of 1938. Moved to the Hotel Chelsea, 222 West 23rd Street, a block from his first New York apartment.

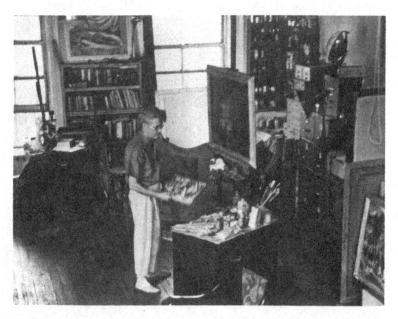

The studio in the apartment at the Hotel Chelsea about 1938, when Sloan stopped teaching at the Art Students League because of gall-bladder trouble. (Photo by Alfredo Valente)

- 1936 The Whitney Museum exhibited 100 of his etchings.
- 1937 Etching retrospective at the Kraushaar Galleries, which published a checklist. Made 16 prints to illustrate Maugham's Of Human Bondage for the Limited Editions Club.
- 1938 Wrote comments for the catalogue of his retrospective exhibition at the Addison Gallery of American Art. First operation for gall-bladder trouble.

- 1939 Publication of Gist of Art by the American Artists Group, the first in a series of books planned by Sam Golden documenting creative artists. Painted a mural for the Bronxville, N.Y., post office (Treasury Department commission).
- 1940 Designed a new house, "Sinagua," to be built of adobe bricks on a hill six miles out of Santa Fe. His friend Josef Bakos supervised construction.

"Sunbathers on the Roof," 1941. Etching.

"Twenty years during which my summers were spent in Santa Fe lessened my opportunities of studying New York life at its best in the summer. This etching, done many years after most of my New York plates, is, I think, of equal merit." . . . "In the spring as the rays grow warmer, the tenement roofs in New York begin to come to life. More washes are hung out—gay colored underthings flap in the breezes, and on Saturdays and Sundays girls and men in bathing togs stretch themselves on newspapers, blankets or sheets in the sun, turning over at intervals like hotcakes. I think that many of them are acquiring a coat of tan in preparation for coming trips to Coney Island. The roof life of the Metropolis is so interesting to me that I am almost reluctant to leave in June for my summer in Santa Fe."

- 1941 Second gall-bladder operation, complicated by double pneumonia. First summer at "Sinagua." One-man show at the Museum of New Mexico. Etching "Sunbathers on the Roof" commissioned by the American College Society of Print Collectors.
- 1942 Etching "Fifth Avenue, 1909" (done in 1941) received first prize in the exhibition Artists for Victory. Elected to the Academy of Arts and Letters.
- 1943 On May 4 in New York, Dolly Sloan died of a coronary while taking care of Sloan, who had had another gall-bladder attack. Sloan went to stay with Miss Amelia Elizabeth White in Santa Fe. Gall-bladder surgery finally successful. Exhibition of "The Eight" at the Brooklyn Museum.
- 1944 Elected president of Santa Fe Painters and Sculptors. Helen Farr took a leave of absence from schoolteaching for a trip to Santa Fe, to discuss a new edition of *Gist of Art*. She and Sloan were married on February 5 and returned to New York.
- 1945 Sloan and Shinn wrote catalogue notes for the Philadelphia Museum's exhibition of work by Artists of the Philadelphia "Press." Exhibition of etchings at the Renaissance Society Gallery of the University of Chicago; when Sloan gave the Moody Lecture at the university, he was introduced as the "Dean of American Artists." An operation to correct "double vision" was very successful. For more than 20 years Sloan had been handicapped by this trouble, wearing glasses with strong prisms to correct the muscular imbalance.
- 1946 75th Anniversary Exhibition at Dartmouth College, where his namesake cousin John Sloan Dickey was president. Exhibition of prints at Bucknell; while lecturing there, Sloan discussed the new phase of abstract expressionism and symbolism: "I am all for the study of cubism, graphic devices for representing what the mind knows about *things*. But the danger in too much abstract work today is that so much of it is *heartless*... It is going from the abstract, to the abstruse, to the absurd." He also predicted that the reaction against too much nonrepresentational work might be "a terrible kind of photographic realism."

[XLIII]

- 1948 Retrospective exhibition at the Kraushaar Galleries.
- 1949 Elected president of the New Mexico Alliance for the Arts. Donated 100 proofs of "The Wake on the Ferry" to the Art Students League.
- 1950 Awarded Gold Medal for Painting by the American Academy of Arts and Letters. Appeared on television in a docu-

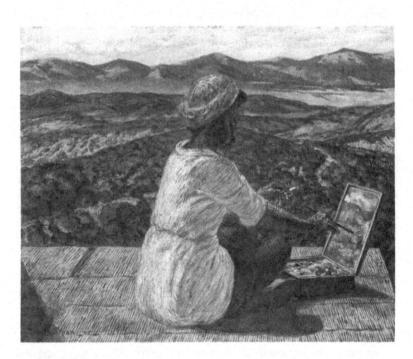

Girl's Eye View, 1945.

Tempera underpainting and oil-varnish glazes, on panel. John Sloan Trust. Helen seated on the roof of the garage at "Sinagua." In the background are the Jemez Mountains. On the flat mesa at the right could be seen cloud formations rising from the experiments being made at Los Alamos. "I like to paint the landscape in the Southwest because of the fine geometrical formations and the handsome color. Study of the desert forms, so severe and clear in that atmosphere, helped me to work out principles of plastic design, the low-relief concept." . . "One of the essences of beauty in graphic art is the significance of texture. . . Sign-made texture brings the form into sculptural existence, makes it 'realized.' By realization I do not mean realism. Realism is a kind of fact-painting. Realization is art existence. It comes when you make something more real to the mind than it is in nature." (Photo by Oliver Baker)

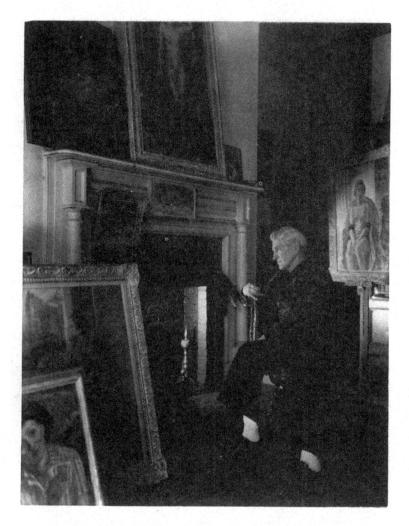

The Hotel Chelsea studio photographed about 1948 by Berenice Abbott.

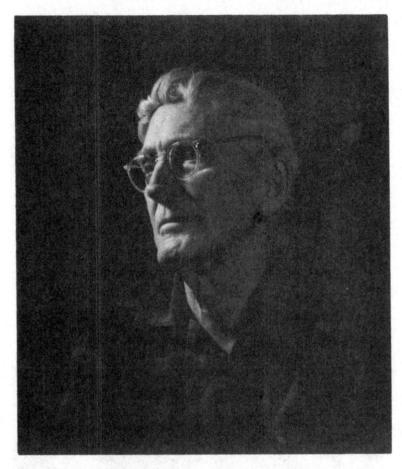

Berenice Abbott portrait of Sloan, about 1948.

mentary series that included Mrs. Roosevelt and Toscanini. Elected to the American Academy of Arts and Sciences.

Doctors recommended a change of scene for the next summer. Sloan had high blood pressure (largely brought on by the tension of painting a commissioned portrait), but he was also in need of new subject matter. "If we only had Central Park at the foot of our hill in Santa Fe. I wish I could spend the summers in New York to paint the wonderful city life, but the humid weather is hard on my health."

1951 At the invitation of President Dickey of Dartmouth, he sublet an apartment in Hanover, N.H., and started to design a new house to be built cantilevered over a gulch, saying that he could not afford to buy a piece of flat land and had always wanted to use an Archimedes pump to get water. He liked the small town and friendly people, and began to paint landscapes and think about pictures of mothers hanging out laundry and families picnicking near the golf course. A visit to his old illustrator friend Maxfield Parrish put him in a good mood for his 80th birthday. "When you reach our age," Parrish said, "you have to live each day as though you had thirty years ahead." So Sloan looked forward to a new chapter of work in that pleasant college town. When the doctors found that he must have surgery for a small intestinal cancer, Sloan faced that serious crisis straightforwardly. "I have had a lot of suffering in my life and I don't think I have ever complained. Illness has made interruptions in my work, but I would hate to fade out like an old light bulb." The operation was successful, but he died of medical complications ten days later, September 7.

Herbert West wrote of Sloan's "green old age" in John Sloan's Last Summer (Prairie Press, Iowa City, 1952).

- 1952 The retrospective exhibition at the Whitney Museum, which had been planned with Sloan's help in 1951, traveled to the Corcoran Gallery of Art and the Toledo Museum of Art. The catalogue by Lloyd Goodrich was published by Macmillan.
- 1955 Publication of the biography John Sloan: A Painter's Life (Dutton) by his old friend Van Wyck Brooks, who had been in the circle around John Butler Yeats in Sloan's painting of Petitpas'. The Philadelphia Museum purchased the "master set" of the prints (states, tissues, etc.).
- 1960 50th anniversary of the 1910 Independent Show organized by Bruce St. John, director of the Delaware Art Center (now Museum).
- 1961 Retrospective exhibition at the Delaware Art Center (catalogue: The Life and Times of John Sloan, by Bruce St. John), borrowed by the Pennsylvania Academy. Sloan's personal library given to the Delaware Art Center.

[XLVII]

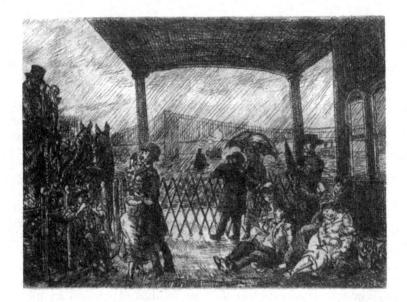

"The Wake on the Ferry," 1949. Etching.

"Letter from Cleveland in re my making an etching for their print club. Answering, they suggest that I make a lithograph of one of my old paintings, *The Wake of the Ferry*. I won't do it. But that gives me an idea for a humorous plate, The Wake on the Ferry." The Art Students League had asked Sloan to make an etching for sale to their members at \$5.00 each. He enjoyed making this picture of "merry-making mourners on the front of a ferry boat" for the amusement of collectors who could appreciate the contrast with the more romantic realism of his 1907 painting.

- 1962 Exhibition at the Walker Art Museum, Bowdoin College, featuring the Hamlin gift of paintings and prints; *The Art of John Sloan*, catalogue essay by Philip Beam.
- 1963 Traveling exhibition sponsored by the National Collection of Fine Art circulated for two years; catalogue: *John Sloan*, by Bruce St. John.
- 1965 Publication of John Sloan's New York Scene (Harper & Row).

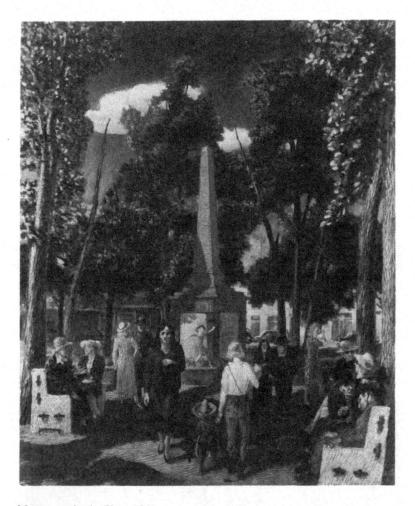

Monument in the Plaza, 1949.

Tempera underpainting and oil-varnish glazes, on panel. John Sloan Trust.

John and Helen are seated on the beach at the left. The plaza in Santa Fe is a place for observing the human family, taking pleasure in the park of a small town. "When I painted the pictures of New York city life, I saw the life of the poor and the middle-class people with an innocent artist-poet's eye. Historians have read a kind of social-consciousness into the work that has more to do with the social worker's point of view. . . . I earned the time to do my own work in etching and painting: it was my recreation, my avocation. In that sense I consider myself an amateur, just as Van Gogh was, who painted for himself with no thought of commercial success. . . . My generation of artists owe a great debt to Robert Henri, who taught us to do our own work without feeling bitter about the lack of contemporary appreciation."

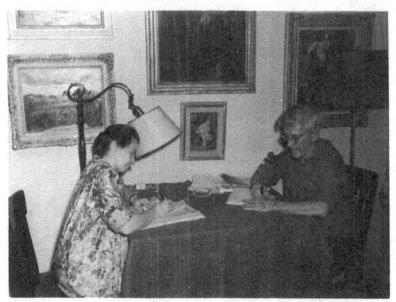

John and Helen Farr Sloan in the living room of the apartment at the Hotel Chelsea, 1950. The lampshade was painted by Sloan's sister Marianna.

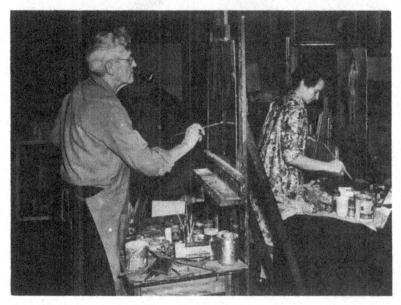

John and Helen painting in the studio, Hotel Chelsea, 1950.

- 1966 Exhibition, People and Places, at the Kraushaar Galleries, related to John Sloan's New York Scene.
- 1967 The Poster Period of John Sloan, with autobiographical notes edited by Helen Farr Sloan, published privately by the Hammermill Paper Company, which had taken over the paper mills in Lock Haven.
- 1968 John Sloan and the Philadelphia Realists as Illustrators, master's thesis by E. John Bullard (University of California, Los Angeles).
- 1969 John Sloan's Prints, a catalogue raisonné prepared by Peter Morse while working at the Smithsonian, published by Yale University Press.
- 1970 A Checklist for John Sloan's Paintings, prepared by Grant Holcomb, published by the Annie Halenbake Ross Library, Lock Haven. The John Sloan Exhibit, 1970–1971, to celebrate the double centennial of the artist and the founding of Lock Haven State College; catalogue essay by Helen Farr Sloan.
- 1971 John Sloan by Bruce St. John, published by Praeger. John Sloan by David W. Scott and E. John Bullard, published by the National Gallery of Art and Boston Book & Art; this major retrospective to celebrate Sloan's centennial traveled to the Georgia Museum of Art, Athens; the M. H. de Young Memorial Museum, San Francisco; the City Art Museum of St. Louis; and the Columbus Gallery of Fine Arts, and closed at the Pennsylvania Academy of the Fine Arts, his old alma mater. An eight-cent commemorative stamp was issued by the Post Office on his birthday, August 2, at Lock Haven.
- 1972 A Catalogue Raisonné of the Paintings of John Sloan, 1900-1913, University of Delaware Ph.D. thesis by Grant Holcomb; published by University Microfilm, 1973.
- 1976 John Sloan's American Scenes, exhibition at the Kraushaar Galleries. Dedication of the John Sloan Fine Arts Center at Lock Haven State College, April 25.

CHAPTER I

POINT OF VIEW ABOUT LIFE

FROM TIME TO TIME I have been asked for a biography, but there has been nothing eventful in my life. There have been ups and downs, but the main thing about it has been my work. What more do you want to know about an artist when you have his work? Even Giotto and Rembrandt were just simple men. There is very little known about Shakespeare. He was so simple they didn't notice him.

Here, therefore, is not a biography. It is merely a record of the thoughts and impulses that have been behind my work and teaching. It might be well, however, to start out with some of the beginnings of my rather tame career—the early influences.

My father was an artist, a skillful craftsman, painting in his spare time. A total wreck in business. My mother a humorful, gentle lady. My sisters and I all drew equally well.

Back in the Nineties, when I was working for the *Philadelphia* Inquirer, I met Beisen Kubota, Japanese Art Commissioner to the Chicago World's Fair, and I began drawing in a flat, sort of Japanese, black and white style. I was given recognition as one of the "poster movement." That was before I had ever seen the work of Beardsley, McCarter, Bradley, Steinlen, and Toulouse-Lautrec.

It was Robert Henri who brought me some Daumier lithographs and also a set of Goya's aquatints. Boardman Robinson's illustrations in the Sunday New York Morning Telegraph were a great inspiration. Steinlen in Le Rire was great in those days, so was Forain. Turner was another early influence.

[1]

At that time news illustrations were pen and ink drawings made from photographs or sketches made on the spot. The half-tone process had not yet been adapted to newspaper print. The staff artists were sent out to cover fires, parades, elections, and other happenings. Later, the staff photographer would bring in prints for us to work from. If the drawing had to be made in a hurry, the photograph would be cut up in sections and several artists would work on the drawings.

We studied the work of the English line draughtsmen: Leech, Keene, et al, men who worked for Punch and the newspapers. There was also Constantin Guys. These men usually made pencil or pen drawings directly on the block; or their drawings were photographed on the block. It was the engraver's job to cut the block.

About thirty years ago a critic called me "the American Hogarth." The idea stuck. You know how writers look up old articles when they are going to write something? I wish that remark were more true. I rate Hogarth as the greatest English artist who ever lived. He was certainly greater than Reynolds. And who else is there besides Constable? Of course, there is Blake, but one doesn't think of him as a painter.

Hogarth painted the life around him, with an illustrator's point of view, a very healthy thing for an artist. He was able to develop a sort of system in drawing and composition. He found a kind of beauty in life through his interest in real character. His engraved plates are powerful in plastic design and so full of humanity. The paintings made in the same vein are very great, but they say that when he tried to paint in the grand historical manner the work went up a tree. As for The Fish Girl so much admired by connoisseurs, I think he tossed that off to show that he knew how to make a flashy painting. His real things seem to be underpainted and glazed in the traditional formal technique.

One or two of the heads I painted in Philadelphia, back in those

POINT OF VIEW ABOUT LIFE

early days, look like the work of Frans Hals. I wonder if I would have come to a consciousness of the plastic concept by following in that direction? I came to it by working from memory and through the influence of the ultra-modern movement.

It was Robert Henri who set me to painting seriously; without his inspiring friendship and guidance I probably might never have thought of it at all. At that time I painted with a dark palette and denied the existence of blue effects, atmosphere, the whole theory of impressionism. My subjects were chosen with an illustrative point of view, literary, poetic motives. When an incident impressed me very much I wanted to make a painting of it. Today, any old subject will do. The model comes into the studio and takes a pose, and I start to paint. There are not so many finished pictures, now, but there is more study. Only now and then I start with pictorial intent.

When I came to New York in 1905 and was dependent on magazine and book illustrations for a living, I never could paint until I had an order for a job in my desk. Then I would paint day and night until the last moment and do the drawings just in time to make the dead-line. I have always been that way. I can't work when I am worried about the rent.

There is so much talk today about the American Scene. As though it had been discovered in the last decade! If anyone started this painting of the American scene it was our gang of newspaper men: Glackens, Luks, Shinn, and myself, back in the Nineties. But we didn't really start it. What about Homer, Eakins, and lesser men?

There is also much talk today about socially-conscious painting. My old work was unconsciously very much so, especially before I became a Socialist. After that I felt that such a thing should not be put into painting and I reserved it for my etching. They may say that I am now fiddling while Rome burns, but I question whether social propaganda is necessary to the life of a work of art. I don't see how a thoughtful artist under a Fascist or Communist government, where free expression is heresy, could help wanting to express his social feelings in his work. In this relatively democratic country today, I feel that, since we can talk about things freely, we can go on painting any kind of subject matter we like.

It is not necessary to paint the American flag to be an American painter. As though you didn't see the American scene whenever you open your eyes! I am not for the American scene, I am for mental realization. If you are American and work, your work will be American.

Patriotism, love of country, is very different from love for the government. I love the country in Pennsylvania, New England, and in the Southwest. I love the streets of New York. But I am suspicious of all government because government is violence. In the United States you must not speak for Communism. In Russia you cannot speak against it. Communism is government by the people, but the trouble is that so many people are the Fido type. In America the country is run by about a hundred bosses. In Russia and Germany there is one boss for every twenty men. There are more bosses but that is not freedom.

The governments are willing to turn their weapons, and tear bombs are the least of them, against the enemy or against their own people, their own citizens. Young people in their twenties are going to see things that I would like to live to see and yet it won't be pleasant. It will be terrible.

I don't like war. The economic interests get out their propaganda machines and persuade the people that democracy is at stake. And what do millions of innocent people go out and get killed and maimed for?—to protect the economic interests of the few.

Ever since the Great War broke out in 1914 this world has been a crazy place to live in. I hate war and I put that hatred into

POINT OF VIEW ABOUT LIFE

cartoons in the (old) Masses. But I didn't go sentimental and paint pictures of war. I went on painting and etching the things I saw around me in the city streets and on the roof tops.

War, blood, hate; poison gases; shell-shocked, mangled men; the competitive spirit—that is what is hateful about war. If we are to vote about getting into war, why don't they limit the voters to men between twenty-one and forty-five who have to fight.

Perhaps, mother-love is the biggest farce on earth. If it were real we wouldn't have any wars. If most of us took our religion sincerely, as a real thing, of course we would have no war. Now they tear up copies of All Quiet On The Western Front to throw down on Broadway in welcome to someone who invents a new machine of war.

God must be awfully far away or disinterested to let people go on living the way they do in dirt and in filthy holes contaminating one another, swarming out to kill when ordered.

They say that love makes the world go round. More likely, in our social set-up, it is the inferiority complex. It makes people want to get ahead, be important. The spirit of competition must be kept out of the artist's mind.

I have never been interested in painting or doing things that I know I can paint or do. I get an attack of enthusiasm once in a while that lasts me for several years. It is both good and bad for my work. When I have carried some pictures through to a fairly successful conclusion, I want to go on and paint something different. On the other hand, maybe I don't stick to one kind of thing long enough.

CHAPTER II

POINT OF VIEW ABOUT TEACHING

IF I AM USEFUL as a teacher it is because I have dug into my own work. Teaching lashes me into a state of consciousness; I find myself trying to prove in my work some of the things I dig out of my sub-conscious to pass on to others. Many an instructor passes on only what he learned as a student. But an artist today, if he has assimilated the meaning of the ultra-modern movement, may have advanced to a greater understanding of the meaning of art than he had thirty years ago. In the last hundred years art has been so diseased by the influence of the camera that any creative artist who is conscious of the technique of tradition should endeavor to pass on what he can about the language of art.

In my student days there was a great deal of emphasis on inspiration, self-expression, wit, and pictorial beauty. Robert Henri was the great teacher of this school. Because he was an American creative artist he was a preacher. He was also a great painter. He had the ability to arouse the creative spirit in almost anyone. When he took hold of an able and interested student he could bring out all the latent talent. It was through the weekly "open house" sessions in his studio that many who are now well-known were encouraged to become painters.

Henri gave much of his time to seeing students and writing letters to artists who sent him work from all parts of the country. His interest in art movements that have opened up opportunities for young artists, can never be adequately appreciated. His fight against the dominance of the National Academy, his fight for the

POINT OF VIEW ABOUT TEACHING

Independent Artists, and the MacDowell groups, his influence on the Art Students League to keep progressive teachers on the staff —all these and many other fights did a great deal for the healthy condition of American art today. I have tried to go on from the inspirational teaching of Henri to give my students more technical information about how to think and do.

Remarks To New Students

Again and again, I have said: I don't want to interfere with your way of seeing, if you are seeing Things. I have no tricks to teach you. I don't want to teach you any one way to draw. I don't want to teach you my opinions, but if you can get hold of my point of view I don't think it will hurt you. I am here to help you. I want to help you find a purpose, a reason for painting. I can tell you some things about the "how" to paint. Not any one "how". Then you must find your way through your own experience and hard work.

I can't teach you how to become commercial successes. I can't teach you to be illustrators, or how to make money doing advertising work. All the men who are getting there in advertising set out to be real artists.

People who take things too literally don't get much of anything from my teaching. By never saying anything I mean, I say a great deal. I never mean anything I say under oath. I never mean exactly what I say. Not even this. You have to read between the words.

Teaching has taken years of my life. But I feel that I must do it, that I must reach as many students as I can to arouse in them the creative spirit, and to teach them as best I can, some of the technique of the great tradition of art.

Bernard Shaw once said, "He who can, does. He who cannot, teaches." And some cannot teach. Now you may ask why am I here? Because I am a failure as a rent-payer, not as a painter.

I'm not just a nice old man coming to see you young folks twice a week. I'm not flirting, playing around. I'm serious about it. I am giving years of my life to do this. But we are here to play, to play because we are serious about it. Here we are, put on the most insignificant speck of dust in the universe, left for a while with a lot of other worms. If you don't want to be serious about playing, do something of no account. Go into banking. Buy collar buttons at five cents a dozen and sell them for five cents a piece.

This class is a laboratory where you can work out ideas and have me around to give you the benefit of my experience. If you can't stand a scolding that is given with the earnest desire of helping you, you don't belong here. Go into some class where you won't learn anything, where the instructor pats you on the back and quotes poetry.

We are all students and we always will be. Learn to yearn. Never spare yourself from hard work and the yearning to understand. Search into the meaning of things, the reality of life. We are just paving the way for some genius who will come along and consummate our efforts. Teaching makes me tired and often cross, but I am trying to pass on to you some of the things I have discovered. Fortunately, few are new.

It takes a great deal of strong personality to survive the art school training. Hard nuts that the art schools can't crack and devour get through and become artists.

No one living has the authority to say that the personal expression of any one of his contemporaries is absolutely bad.

Why is it that so many people who get old get dyspeptic or get wise? I am just on the verge, and will certainly get one or the other.

A negative, anti-thing can't be great. Anti-bad art, anti-liquor, for instance. I am anti-prohibition, but two negatives equal an affirmative. I am not anti-saloon. The kind of art made for any anti-reason, anti-war, anti-humanity, and so forth, can't be great

POINT OF VIEW ABOUT TEACHING

art. It can be important propaganda, satire, but not great art.

No great poet, no great artist ever allows facts to interfere with the truth. Facts are not necessarily truth. Poetry can convey the truth more than a statement of fact. The history of the Civil War has more meaning through the book, John Brown's Body, than it has through the facts of history.

Most plays are sums of facts. I rather think a play should be made up of untruths, to bring out some of the deep truth of life. Shakespeare did not hesitate to distort facts to expose truths about human nature. All of his work has a quality of punning, only he did it with ideas as well as word sounds.

Art comes from leisure and not from industry. I believe Plato said that.

Work for yourself first. You can paint best the things you like or the things you hate. You cannot paint well when indifferent. Express a mental opinion about something you are sensitive to in life around you. There is a profound difference between sentimentality and sensitivity. Artists are sensitive to life. If you start out with sentimentality where will you end?

Anyone who has something to say will find someone who is interested in his work. What difference does it make whether your work is appreciated or not? The work will still be yours. Anyway, most of us are only appreciated after we are dead.

Painting must have some stimulus. Keep the mainspring of life which gives you the creative urge. Keep your humanity.

When you have found something about people or nature that you want to talk about graphically, you will find a technical way to say those things. Find something that you care about saying, even if it has been said before.

The Teacher's Responsibility

Several years ago a New York newspaper designated me in a series of articles, "Town Types," as "one of the old familiar ones."

I was sub-titled, "an unbearded Tolstoi, a lot more sensible æsthetically." Maybe Douglas Gilbert was right about me. At any rate he wrote an amusing interview, and it is always a relief not to be too much mis-quoted, especially if one has definite ideas about art—anybody's art. I won't try to define it now; most students with whom I have come in contact and who are doing interesting work do not go in for specific definitions of anything. They are always looking, but never entirely satisfied.

That is the reason that helping students of art has always interested me, and the reason that my efforts as a teacher at the Art Students League for the last twenty-four years,—although having certain drawbacks as far as the time element and its effect on my own work are concerned,—have nevertheless maintained an attraction for me. Teaching has been, in spite of the extra exertion, a valuable stimulant to my own work.

It is for these reasons that I believe that a message I wrote to the Art Students League on assuming the Presidency of the Board of Control may have some permanent interest.

"Although for sixteen years I had been an instructor at the Art Students League and as such familiar with the scope of its functions and its daily routine, upon my election as President of the League I became impressed with the importance of my position.

I believe the League to be the largest and most successful cooperative art institution in this country. Without endowment, purely under the administration of its own artists and students, it is financially sound, and a demonstration of the fact that the artist is not, as so often rated, an inferior business man.

Maybe it is because I am new on the job, or maybe it is because I was put under a \$50,000 bond which the League Constitution requires of the head of the Board of Control, I repeat, I am impressed, and I feel a great sense of responsibility. I thought I had taught long enough to have a pretty good idea of what it was all about. Now I think it might be a good idea to have some of

POINT OF VIEW ABOUT TEACHING

the teachers bonded too. Not because of any financial irresponsibility—oh, no! But maybe just to make them feel their responsibility in teaching art. I confess I had much less consciousness of responsibility as a teacher than I have as President.

One reason why the League is first among the art schools of this country is the fact that it furnishes such a varied menu of nourishment for a hungry art student, ranging from the conservative to the most ultra-modern. A student at the League can choose his art studies much as he can choose food at an automat. He may shop around and even provide himself with materials for indigestion. But it is this very feature that is one of the most important in his progress, providing he keeps his mind open. Too many students at the League have settled down to be fighting advocates of some particular one or the other of the delicacies to be found in the League's bill of fare. So, we have people frothing at the mouth and fighting for the preëminence of pie, while others are devoted to the interests of soup. Some are, figuratively speaking, rabid vegetarians and still others stick to a strict meat diet.

Of course, this is a little like a political speech from a perambulator, but it does reflect life and it is probably invaluable in a school which provides so much opportunity for so many varying points of view.

A student at the League should therefore cultivate an attitude toward his studies which is both flexible and critical. It should be flexible enough so that he can change his mind as often as need be; and it should be critical in that he need not take either the professed 'modern' or the professed 'conservative' at their own evaluation.

Good modern artists are the conservative artists who follow the fine old tradition of setting down a concept in painting. They jump over the period of the past seventy-five years of degeneration due perhaps to the influence of the camera which gives a reflected visual image. This visual painting is still being done today by the so-called 'conservative' academicians who have no tradition behind them other than the camera.

Many intelligent people have accepted the false idea that accuracy in representing visual facts is a sign of progress in art. Such imitation of superficial effects has nothing to do with art, which is and always has been the making of mental concepts. Even the scientist is interested in effects only as phenomena from which to deduce order in life.

The good ultra-modern artist as a teacher puts his students through a thorough, hard, and rigorous training apart from the visual aspect of things, teaching them to put their mental processes into their painting. That is why work away from the model is often better than with the model before one. In the presence of the model, the student is tempted to look and reproduce something that 'looks like' the model, while it would be better for him to put down his mental image of the model from memory. I might add, incidentally, and as a 'terrible example', that all of my early paintings, including my old city street life paintings, were done from memory.

'Looks like' is not the test of a good painting. It indicates merely visual similarity and shows that the artist has not put his brain to work. If, before transmitting to canvas what the eye casually beholds, the artist will spend some time in the study of his subject matter, the result rendered will more likely be a solid concept and not a mere general aspect.

Every art student should paint the simple solids: that is, spheres, cubes, cylinders, pyramids, and cones. Everyone knows these forms mentally. Therein lies their importance. Still lifes as set up in most art classes are too complicated. The eye of the student is diverted from the simple basic forms which they actually conceal, and he tries to get his painting to 'look like the things look', thereby falling into the error of the casual aspect.

In an article in the March, 1931 number of The Arts, we are

POINT OF VIEW ABOUT TEACHING

told that Thomas Eakins always insisted on his students painting simple studies of such things as an egg, a lump of sugar, or a piece of chalk to try to get the texture. Texture is one of the great pitfalls. Many artists have had reputations built up on their so-called mastery of texture, notably Sargent. But Sargent did not know how to paint texture. Yes, he could paint satin, but then everything he painted he made satin. The texture of realization is what counts, not realism.

A still life which I would set up would consist of a white tablecloth, an egg, and an ordinary yellow earthenware plate.

If I had my way, I would equip an art school with hundreds, no, thousands, of the simple solids, in different sizes, covered with all sorts of materials including cloths of all textures and surfaces, metals of all hues, woods of all kinds, rough, smooth, polished. And the student would draw and paint these for a couple of years with figure drawing on the side for dessert.

Even with his dessert, however, the artist should learn to find these basic forms. Cézanne said that the five simple solids are all there is to nature. It is the ability to feel this when painting a human face, for instance, that makes for artistic understanding. To bring this about, the student should learn to imagine a cylinder which has a hemispherical top for the head; put a half cone before it for a nose, then take two reversed hollow spheres for the eyes with solid spheres set in them for eyeballs. The mouth is a truncated cone which does not begin directly underneath the nose but extends all the way back to the ears following the line of the jaws. In this way he will learn constantly to analyze apparently complicated structures into the simple basic forms. How clearly some modernist experiments have shown this!

There, you see I slip back into teaching at the slightest chance -which proves that I'm not yet really inured to the office of the President of the Board of Control."

When a person reaches my age (three-score and some) if he

is an artist he is aware of life. He has learned to keep in touch with his generation, and every generation is *The* generation to an artist. But none of us lives in an unchanging world. We have to meet the world we are in as it comes along. Many people think of an artist as a recluse. I think that an artist is a spectator who not only sees, but interprets. He has to be alone to interpret but he has to be abroad to see.

To be a spectator one does not need to have experiences. The artist does not need to touch the thing he is working from. His imagination and understanding are based upon his ability to project himself into the outside world. He possesses ideas, images, in his mind. Maybe the mountains and deserts are a part of him. I have enjoyed them, painted them. In that sense they belong to me. Likewise, the person who owns a picture is not its consumer unless he appreciates it.

Perhaps it is the evidence of seeing and remembering that has interested me so much in the work of the unrecognized American Indian artists.

The work of students of art makes me feel like giving them from my store of life and art. When I think they see and remember and that some may be able to interpret in color, design, plaster, or what they please, I feel a definite interest in how they do it. If the Society of Independent Artists, for instance, only introduced to the small, appreciative audience of art lovers, one artist of significance a year, I would think that show worth while. That it has produced more is gratifying. And I, for one, can never be disinterested in the person who attempts to use the language of the brush, the chisel, the etching needle, or the crayon.

I am not advising anyone, old or young, to become an artist, but I will say that it is a highly satisfying life. That fact you, yourself, must know, just as you know that it seems completely discouraging at times.

How far a person can go with his art depends on what is within

POINT OF VIEW ABOUT TEACHING

himself to go on. This qualification is not inherited, for it means about one hundred per cent hard work plus an interest in what is going on around you and a conception of your own which comes, not from copying, but from producing or creating.

Artists are not bound by positive limitation. They see. They know what to eliminate as well as what to include. They know (and knowledge does not come from a limited experience) just how to interpret their outlook on life.

I have never been outside the United States, but while this fact means that I have seen few of the masterpieces of the past, it may mean that I have got my own share here and now. Perhaps I agree with the Chinese philosopher who said that if you stayed in one spot, all the world would come to you.

My Contribution

Back in the Nineties our gods were Whistler, Velasquez, and Frans Hals. We were too much concerned with getting the impression of the moment, the beauty of easy brushwork, the surfaces of things. But because I made my living as an illustrator, my drawings were all done from memory and so were most of my early paintings. No one can remember the visual appearance of a thing, but memory can recall the Thing itself. For this reason my early work is not without artistic merit. All fine art is the result of the artist coming to grips with the reality of things. Also because I was a draughtsman using the pen and etching needle, I was using these tools to make things with signs. Every line is a sign unless used to imitate appearances.

When the work of the ultra-modern artists was brought to this country by Alfred Stieglitz and the Armory Show, I consciously began to be aware of the technique of art: the use of graphic devices to represent plastic forms. While I have made no abstract pictures, I have absorbed a great deal from the work of the ultramoderns. Through a study of the moderns and the working out of

GIST OF ART

plastic problems in my own painting, I have arrived at a greater valuation of the old masters than I had thirty years ago. I wish I had known then what I know now and had thirty years more to live.

My greatest interest is in the European tradition of three-dimensional painting, particularly the painting of life around me. While my work is sufficient evidence that the city streets and landscape have afforded me a rich subject matter, there is now a prevailing idea that I am no longer painting "Sloans" because I am also doing figures and portraits. These subjects are just as much part of my life experience as the teeming streets of New York. To have the subject in front of you while you work, makes the artistic problem much greater. For to paint from what is in front of you as though you were painting from memory, using the model as an inspiration for an exciting plastic design, requires more mental technique than to paint from memory alone.

No apology need be made for what is commonly misnamed an "easel painter." The small picture which is painted for the artist himself has a special integrity of expression and fire of its own which a mural that is made for the public consumption cannot have. A mural is like a speech or epic, but there is also room for the lyric poem or essay. The small picture in the hands of a master like Rembrandt, is one of the highest forms of human expression. It is a precious thing like a gem, in which the artist can concentrate the full powers of his ability and understanding.

I have only a few things to say to the student, but it is necessary to say them over in many ways to make the points clear. They are mostly technical: The importance of the mental technique of seeing things; an emphasis on plastic consciousness; the fact that all things in nature are composed of variations of the five simple solids: cube, cone, sphere, cylinder, and pyramid; the significance of devices in drawing, by which we represent three-dimensional forms on a two-dimensional surface; the low relief concept of

POINT OF VIEW ABOUT TEACHING

composition; the importance of foreshortening rather than visual perspective in signifying spacial projection and recession; the use of color as a graphic tool; emphasis on realization rather than realism as the essential character of reality in art.

I think my own real contribution is the analysis of the separation of form and color as an aesthetic quality. The separation of form and color through the technical process of underpainting and glazing gives realization that cannot be achieved in direct painting; although direct painting may bring splendid results with the principle in mind: witness Van Gogh. Whenever Van Gogh drew a line on top of the color surface he was separating form and color. I believe the artist should be conscious of the separation while drawing: think of the form first, and then the color texture.

CHAPTER III

POINT OF VIEW ABOUT ART

ART SPRINGS FROM AN INTEREST IN LIFE but it isn't art if it ends there. The art life of a thing created by man comes through the use of symbols combined to make images of ideas. These images, when projected in form understandable to the senses of other human beings, are works of art, artifices. The prehistoric man drawing with a blunt tool on the wall of a cave made an image of an animal —he made art. Every word is an image, a symbol. The writer automatically uses symbols. The word animal does not look like the thing but is a symbol for the communication of the idea.

Drawing is one of the three means of communication between spirits, like speech and music. You wouldn't say nowadays, with pride, "I can't understand a book. I never learned how to read." Everybody should be able to draw a little the way we write a little or whistle. One reason for the existence of art students and artists is the desire to acquire an additional means of self-expression. In school we may learn our craft but we learn to become artists by making contacts with the world. There must be a desire to express the inner life we have felt and lived.

Art is an ideograph. So long as you are not making ideas you are not making art. The artist forms concepts of what he has observed in nature. He crystallizes the prose of nature into poetic images. Art is the result of the creative urge of life consciousness. It is the graphics of ideas.

The artist has an ability to see nature and form his own concept. Beyond that he must have some creative imagination, that faculty

POINT OF VIEW ABOUT ART

for materializing his vision of nature in the medium he has chosen.

There is such a thing as looking at nature too calmly, without any excitement. The artist must get a kick out of something in nature before he can create. If you only get a kick out of other works of art you should not be an artist. You should be a connoisseur, or a buyer or a consumer of art.

A critic once asked Degas, "What is this thing, art? What is it all about?" And Degas said, "Well, I have spent my life trying to find out and if I had found out I would have done something about it long ago." He did not specify what. But he could not have done more than he did do in painting his pictures.

You may define art, but you cannot define good art. Art is not like grammar; there is no good grammar and bad grammar. There is good and bad art.

Good art cannot be defined because such a definition would have to include the word beauty. People have written volumes to define the word beauty, and I can't believe that the books would have been so long if they had found the definition. My own definition of art does not specify good art: Art is the result of a creative impulse derived out of a consciousness of life.

If the work looks as though the artist made it to look like something else that sold for a thousand dollars, if that was the motive behind the work, it is not art because it didn't come from life consciousness and a creative impulse.

An imitative impulse is to repeat something, while a creative impulse is to make something with mental control brought to bear on the material which the eye brings to the mind. The mind adds its consciousness of, and experience with reality to anything that is seen by the eye. The reason an engineer knows the tracks ahead of him are the same distance apart is because they seem to be coming together. His mental experience with this visual phenomenon tells him the tracks are parallel.

The artist has this consciousness of reality in life around him,

GIST OF ART

and also in the life within him which is just as real. Possibly it is more real than the life around him because it is the life within him applied to the life without, which really gives him his creative consciousness. Many people either never have it or else it is atrophied.

An artist gets in contact with real things. He establishes contact in a way others do not. He is in contact with animate and inanimate nature. He sees the desert and feels the great creative spirit of natural forces. He can project himself into nature about him. He can look at a cat on the back fence and feel as that cat feels and, in a sense, know what that cat thinks. The artist does not need to experience to understand. While he is the custodian of life consciousness, nevertheless, he remains a spectator. He maintains a spectator's attitude toward life.

He seeks to find order in life, and to invent ways to put that sense of order in his work as a document of his understanding. Even a half-way good picture has had more of this establishment of order in the making of it than the layman is ever conscious of. The artist's business is the placing of things in order; his mind takes creative impulses from life and places them on canvas, arranges them in the words of poetry or the notes of music, so others can follow and find what he sought for them.

A work of art, a creative impulse, does not have to spring from liking, from love, from an admiration of the subject. In fact one quality of "would-be" art is that it does spring too much from a cheap kind of liking. Art generally comes from liking things but it can also be the child of hate or dislike. Hogarth's work is a good example of that. Many of his pictures were a sort of tirade, diatribe on the manners and ways he disliked. And yet, if you like the kind of life he is portraying in his sermon pictures, you will find that he hasn't spoiled it for you. Take that series of the Rake's Progress. He takes you behind the scenes with players in their dressing rooms, smelly dirty places, but such jolly places to be—he gets

that over in spite of the fact that it was hatred of that sort of life which led him to draw it.

The artist has to find something in or about life which interests him. He has to pause and select the elements that will put his idea across. It doesn't have to be some great tragic event; just a couple of plums on a plate, seen with the mind, will suffice for subject matter. A man like Renoir puts three plums on a plate and turns the surface of an eight by twelve inch canvas into a result that is as æsthetically vivid as a piece of carved relief.

The real tools of the artist are graphic signs made of line, tone, and color, combined to make images of things. A child's drawing of a hand made of a square with four lines sticking out for fingers and another for a thumb, is a sign or image for a hand. Every word is an image-symbol. The real vitality in a work of art comes through the use of sign inventions, devices to convey plastic ideas.

One of my ideas about technique is that I regard the mind itself as a tool. Most artists paint as though they had no minds. Their paintings look as though they were made from eye to hand with no intervention by the brain. That isn't art. Art is the response of the living to life. It is therefore the record left behind by civilization.

I believe that my definition of art includes the art craftsman, the true artisan—the man who feels the need to express some creative appreciation for life even when making a chair or weaving a rug. The craftsmen are being squeezed out of existence by machines. A man who shoves a bolt into a passing car and then shoves a bolt into another passing car, and so on, can't be expected to have much pride when he sees a Ford roll by. He can't have the pride that an artist workman has who has made something himself.

The work of the American Indians is a perfect demonstration that things not generally regarded as works of graphic or plastic art, are indeed the works of artists. Their pots, blankets, paintings are so evidently inspired by a consciousness of life, plus a thing we have not got—a great tradition.

It might be said that there is no real traditional art in the world today except in the work of the Indians. None of the great nations are really following traditions in the sense that the Gothic period had tradition. The Indians have a great traditional base. They work together with the same feeling of being a part of the community that inspired the unknown artists of the great Gothic period. Certain conditions in the social relations of men must change before we will have any return of that kind of united spirit, which, running through the artists, will make them work together.

We have only a carry-over of the European tradition as it has been maintained by the French. The French school is the only one that has survived in a healthy way during the past two hundred years. With regard to the other schools we are always speaking of the art of the past. Is there any Dutch art, English art, German art, Spanish art or even Japanese art today? Certainly there is no Italian art today, but there is the great Italian cultural heritage from past centuries. Art has stopped, if not died, in most of the countries where it flourished of old.

The tradition we have inherited from France is one of individualism. I think art would be greater if we could lose some of that intense individualism. When it is less evident, the most impressive work is made, gigantic efforts of the human mind and handtruly social documents, with no name to be found on them anywhere. Today we paint a picture and cannot wait to put our little name in the corner. That is all right, but it might be better if the work were anonymous.

I believe there is no progress in art. While we may derive our impulses from different subject matter than the artist of four hundred years ago, the underlying purpose is just the same. The man who scratched his concepts of animals on the roof of a cave

[22]

in Spain thousands of years ago, just had a space to work on and something to work with and he put down his ideas. That is what the artist does today. I never could agree with the ultra-modern artists who wanted to burn the paintings in the museums, implying that what they were doing was progress. There isn't any advance. Some art is greater than other art, but there is no change in the inherent character of art. The mental technique today is the same as it was fifty thousand years ago.

One phase that was mistaken for progress in art was the clever eyesight painting that came in with the influence of the camera. Maybe the degeneration of art started with the discovery of scientific perspective. Any standard of art based on visual verisimilitude has nothing to do with the root principle of art. Art springs from an interest in reality, the concept of the thing itself.

Aesthetic Consumers

The artist paints first of all for himself, but the very next person he paints for is the æsthetic consumer, the person who is equipped to enjoy and appreciate. His point of view very often is broader than the creative artist's. He may have a taste for a number of kinds of art. There are some artists who are too much appreciators and enjoyers of the finished product of others to be able to create themselves. It brings about a kind of inferiority complex that prevents the creative spirit from functioning. Suppose I knew all the art in the world, I would think, what is the use of my painting. I might have an idea, a concept that wanted to come out, but with all this consciousness of and admiration for the glorious things that the creative minds of the world had already produced, what would be the use of my trying to do anything. I'll stack saucers in the nearest cafe. That attitude has stopped many a sensitive artist at the beginning of his career.

The æsthetic consumer is a person who gives some time to pictures, studies them, gets acquainted with them. Pictures are like people, you get to know them through long acquaintance. The consumer is glad to meet new pictures; he likes and dislikes according to his own judgment.

You don't have to understand pictures. I really feel that an artist can make a good one without understanding it. Most people think that they understand a picture when they have recognized the subject. That isn't understanding. I like the slang expression "to get" the picture. You can say that about any kind of work, representational or abstract, if you pay enough attention to it. You can't expect to know a picture at a casual glance. It may be that when you really know them, you will learn to like the ones you disliked at first.

A man who owns a work of art is not necessarily an æsthetic consumer. A consumer may be an owner but a consumer is not necessarily an owner. The owner has no right to destroy a work of art; he can consume it by appreciation but in no other way. A consumer of art is different from a consumer of a boiled egg: one can consume a work of art and still have it.

The buying of art comes from so tremendously different motives. Few buyers buy because they like the work themselves. First of all, the buying of well known pictures at high prices has been very logically proved to be one of the conspicuous wastes. The buying of any picture is a waste of money from the American point of view, and the buying of a very high priced picture is a conspicuous waste that will be heralded in the newspapers. People buy pictures to prove that they have money. The gods of the business man are money and power. Money brings no power except over cowards. There is only one kind of power worth having and that is power over one's self. Many people think that will power is something worth while. John Butler Yeats, painter, father of the Irish poet, said, "Will power is the poorest equipment that an artist can have. No artist could have it and be a really effective artist. If Shakespeare had had will power he could never have written his plays."

Another usual reason for buying pictures is that it leads to a kind of social success. There is no quicker way to find your name in the papers regularly than by starting a collection of pictures. Another thing, if you buy several pictures, you can write books on art. It makes you feel that you are an authority, have culture.

Some people buy art as an investment. The man who owns an undisputed Rembrandt has something with more value than any other thing in his possession. Of this world's holdings, a vital work of art is an investment more secure than anything else, save perhaps gold bullion.

The real collector of art buys what he likes, lives with the pictures, discards some, and buys again. The price of a picture is no indication of its worth. Good pictures, good contemporary pictures don't cost much. The best artists who are painting for themselves don't expect to make a living at painting, and price their work within the reach of the average person. You can buy a topnotch painting for the price of a cheap second-hand car, or a fine print for the price of a couple of theatre tickets.

Take the case of Albert C. Barnes, the most important modern collector in America. When he started he had the ordinary rich man's collection and had spent many thousands of dollars. He told Glackens that he had acquired paintings from the best dealers in New York and Philadelphia. Glackens said, "I know what you have. A couple of Millets, red heads by Henner, a Diaz, and fuzzy Corots. They are just stinging you as they do everybody who has money to spend." Barnes was a practical man and didn't like that idea. But Glackens told him to put those things in his attic and it was arranged that Glackens should take a letter of credit and go to Paris. There he bought the nucleus of the A. C. Barnes collection of modern pictures: Renoirs, Cézannes, Matisses, and many others but particularly he laid stress on the Renoirs. That started Barnes on the right track. He began to live with those pictures, studied them, and bought more of them. He weeded out

[25]

the old ones and sold off those he no longer cared for. Today he knows more about Art than any artist needs to know.

Like, buy, learn better, sell, and buy again. Just buy what you like. Most people are afraid to do that because somebody will come along who they think knows more about art than they do. Among the pictures you dislike today are the ones you will like later, if your taste improves. This is true of Dr. Bode, Thomas Craven, or anyone. If you have any other point of view there is too much conceit in your personal opinion.

They say that art is a luxury because of the depression. But I really believe that this is the time when people should turn to the artists. Not the artists whose work is selling for thousands, but the interesting work of men who sell their things at reasonable figures. I believe the work of artists, poets, musicians, is a kind of food for starving souls, as necessary as food for the body. Why should we worry about feeding bodies if they have starving souls? Unless it is a case of fuel and oil to keep a dumb machine working that can work only so many hours without them. Wherever there is intelligence and the soul is starving, there is no use worrying whether the body starves or not. That may sound churchy but I don't mean it so. Select your own soul-food in the way of art. If indigestion sets in you need a change, and you can find a food that digests better.

You Can't Make a Living at Art

The idea of taking up art as a calling, a trade, a profession, is a mirage. Art enriches life. It makes life worth living. But to make a living at it—that idea is incompatible with making art.

This idea of making a living at art first occurs to parents. The plain fact is that it can't be done. As a matter of fact you can't "on your own" make a living at plumbing or any other kind of honest labor. You can't make a living at anything without doing your share to make a thousand times better living for someone else.

The phrase "making a living" implies only existence, anyhow.

Then there is this idea that the world owes you a living. Here is a little thought about that. It isn't particularly logical but it makes my point. You were paid when you were born, with the privilege of living. Death is all that is coming to you. Life came to you when you were born.

Shun this idea of going into art with success as an aim, wealth as an aim, for the purpose of getting on in the world, getting the good things in life. Success has apparently become much more the art student's aim than it was in my time. It spells disaster. No one who sets out for success gets the real thing. All you can get is a little sauce poured over you while you are alive. You may achieve a car, a good car to bump into other cars less good or better.

Success, what do we mean by it? Sargent was supposed to be a success. He painted his picture, an expensive conglomeration of oil paint marks imitating the light and shadow shapes on faces, furniture, and satin dresses—he painted that picture over and over again. He was decorated and lionized, made a lot of money. And what is his status today? How long did that kind of success last? There is only one thing to do about success—shun it. The only kind of success to desire is success with yourself. To make steps, progress, with yourself.

Today the artist is constantly questioning himself, "What am I doing, is it art?" That is a very irrelevant question. The real creative artist doesn't care whether his work is art or not. He has his work to do, is driven by a creative fire. He can't concern himself with whether what he is doing is art.

Who is to answer the question, what is art? Today there are lots of opportunities for the young artist who is beginning to produce, lots of sources from which to find out what is art. There is the government. You can get assistance from the government in deciding. For ten years I advocated off and on, mostly off, that the government take an interest in art. Many people are now asking the government to do so, people who opposed me years ago when I was urging governmental interest in art.

I want a Department of Art in the government because I think it would dignify the profession. The government spends money on utilities, why should it not spend money on the spiritual utilities, the things which are the really civilizing instruments of humanity. France has had a department of art for over a hundred years, and France is the most art conscious country in the world. The art selected by the government isn't always the best. But the fact that the government takes an interest and supports art financially, raises the level of the profession, increases public interest.

Of course, alas, as the government takes up art, it will gradually establish standards, standards of mediocrity, because any matter of taste which is decided by vote is bound to be influenced by the bad taste of the majority. But I want to see these standards set up by an organization that is really national, not one like the National Academy which is a private institution and no more a National agency than the National Biscuit Company.

When these governmental agencies, commissions, get to work deciding about art they remind me of a cattle ranch. Did you ever see a round up and branding? Well, these government authorities on art are the punchers, the cattle branders. I suppose we can all hope that if our work is found good by the government, we will feel the brand on our left hip.

I have other reasons sincere enough, for wanting to see the government in art. I am Irish, and so I am naturally "agin the government." In government can lurk the foes of all that is best in human life. I want to be able to differ with the government all along the line. I hate nearly everything else it does, its support of privilege, the wars it gets us into. Why shouldn't I hate it in my own line, my own calling. Having the government the advocate of the mediocre in art, the employer of art, would be a good thing.

[28]

We would know where to locate the enemy. Until we have a Department of Art I shall have to vent my scorn on the National Academy. I have been flattering them thus for twenty-five years. I want to have something higher up, more worthwhile, to vilify.

Don't think I am not in favor of having the government support the arts. The art projects set up during the depression have done more to stimulate art in America than any other movement in the past three hundred years. But in the light of history you can be sure that any organization set up to promote culture will become an institution and carry on only second-rate ideas. The stronger the institution the less chance there is of its retaining vigor through changes within itself. A few people get hold of the paying jobs and they rule the roost. Wherever you have economics mixed up with art, there you have politics.

When you get to the point where you begin to step into organizations and put letters after your name, you begin to look down on others from the gutter. And I wonder how you can look down from the gutter! One can imagine a bum lying in the gutter, with a mirror in his hand. He lays his mirror in the mud, looks into it, and says, "Thank God, there is somebody below me!"

Our conservative academies don't carry on the tradition of painting Things. They have degenerated into superficial training of the eye and hand for eyesight painting that has nothing to do with art. They give prizes for the best of these facile or clumsy imitations of the appearance of nature. The better the imitation the larger the award. They implant the virus of competition.

When you enter one of these institutions you get a musty whiff, that old cathedral smell. Here are the habitual art students, wishfully yearning to draw, and being praised twice a week. They make tedious charcoal drawings. A charcoal paper with a bromidic smudge on it results from a week's work with stump and chamois. The people who made those drawings were once innocent human beings, people with a desire to be artists. Now they are like the

[29]

blind led by the blind. This sort of teaching is a septic influence. Walter Pach's Ananias: or The False Artist did a great deal to expose the institutions and artists who betray their noble calling. Since we have to speak well of the dead let us knock them while they are still alive.

The jury system is a cherisher of the commonplace. The only kind of jury that is of any use gives proportional representation to each brand of art represented by a member of the committee. If there is one progressive member to three conservative members he should have a right to select one-fourth of the pictures in the exhibition. Otherwise, the other three votes control the entire selection of pictures. It is just a joke when they put a progressive name or two on most juries.

Voting in matters of taste can never result in the selection of the best work. All the greatest artists were not recognized by the majority of their contemporaries, either artists or critics.

The juries and exhibitions today are going in for stylized work, the American Scene. Good pictures which are concerned with less static, spectacular realism, do not pass the juries because their style is not in fashion today. Juries and museums recognize what is in fashion; they are fashion experts. The mode today is a kind of sentimental realism, related to the Rogers groups of the last century.

There is another place to turn to when you want to find out if your art is good. The critics. They are paid for telling artists whether their art is good or not. They can extol; they can condemn. There are two places of honor, the extolled and the condemned: You will think success is knocking at the door. And they can ignore. That is the worst they can do to you. (But you can get into the paper some other way—a little racketeering or second-story work.) I suppose I should know. I have even been accused of being a publicity hound. I think it is because I have a quick and bitter tongue. When a reporter calls me up to get some ideas

[30]

about what has happened I often have some sourish things to say. There are other reasons. Anyone who has been in the newspaper business as long as I, may get special attention in the press. Certainly no one can accuse me of selling my work through publicity. I have had lots of it and never sold a painting until I was fortynine years old, and not very many since. No, I have some ability to get art matters into the news through my sharp but honest tongue, and I have used that to further the cause of many art movements from the Society of Independent Artists to the work of the American Indian.

The dealers, too, will tell you if your work is worthwhile, if they look at your work at all. They have a pretty well fortified position. The artist's relation with the dealer might be explained thus: You make confectionery, say chewing gum, and the dealer proposes that, if your gum is a new and little known brand he might take it on a sixty-forty basis. You get forty percent and the dealer gets sixty percent. But if it is an old, more-used gum, he would take forty and you sixty. He says, "I'll take your gum and I'll provide the show case. If any is sold I'll give you part of the money. If it becomes popular I may increase your share." So that is another place to find out.

There is one other place to find out if what you are doing is art—within your own honest judgment. Art is something which has been created in response to an urge that came through contact with life. The critics, the dealers, the government—are trying to define good art. There never will be any standard of art. What a terrible thing it would be if everyone knew and agreed upon what was good. A definition defines, puts up markers, says that something can be analyzed into black and white. Anything is art that originated as a response to life. That is a pretty broad category, but it gives you a yardstick that rules out a lot of things.

I am making no plea for conservative art. There are other things that are nothing but technical drill which, because of their relationship to art that is made in response to life, must be included as worthwhile. I am keenly alive to the importance of ultra-modern art, which is valuable in the study of technique. I believe in five or even ten years of enthusiastic technical study. Study of the old masters through Picasso and Braque, Cézanne and Renoir. I regard all but a handful of the moderns as disseminators of technique. Young people are always throwing themselves into one camp or another, conservative or progressive. I regard the conservative camp of today, the academic work made today as a visual imitative effort that has nothing at all to do with art.

That I am alive, it hurts me to confess, does not prove that one can make a living at art. The fact that men decorated with parts of the word Ananias make a living selling canvas with oil paint on it doesn't prove that you can make a living at art. That which you make for yourself, that you make for nobody else—you won't make a living from that. I have made a living. I have been able to scratch enough together to pay the rent from the time when it was twelve dollars a month including gas, to a time, not so far away, when it was two hundred and fifty a month. I didn't make a living from the pictures I made for myself, but by illustrating and teaching.

If making pictures that somebody buys makes the art commercial,—Picasso is a commercial artist. So was Van Gogh, but not while he was alive. Why does Van Gogh get on the front page of the paper? Because he is a great artist? No. It is the sob story about his life that gets him on the first page. Now the critics recognize him, are proud of it. Do our critics think they are superior to the French critics of the 1870's who condemned Van Gogh? Art criticism in this country is in its infancy. France has had it for three hundred years. I am no good at dates—I may have understated it by a thousand years. You can be quite sure that any art critic we have today is missing the Van Gogh of today, just as the French critics did in the Nineteenth Century. Van

[32]

Gogh received a hundred and nine dollars for his work while he was alive and now some of his pictures sell for fifty thousand dollars. Was Van Gogh a success? From the commonplace point of view he was not. But I think he was a success. Reading through his letters, you will find that he felt he was a success with himself. But not with the academy, the juries, the dealers. His art was the product of his inner self in response to the life around him.

If you are a success in your lifetime you are almost sure to be forgotten afterwards, almost without exception. One such was Rubens; he was a success. But he did something most artists don't like to do. He learned his trade and practised it like a bricklayer. He was practically the same artist when he was twenty-five as when he died. He wrote those pictures like a man writing visiting cards at a county fair. The technique of Rubens was a mighty technique, something that seems to have left us in the last hundred years. He was a great artist, great in his own lifetime. There may be other examples of the exception to the rule.

I have tried to function as an artist, doing the things I wanted to do; sometimes because somebody wanted me to do something else. An artist can be independent as an artist. He can't be independent as a human individual. Times were better for the artist when, to make a living, you could get a job washing dishes at night. This kind of artists' jobs is gone. There are five hundred people waiting for one job now.

We artists who paint for ourselves are not in the same boat with carpenters and bricklayers who rightly demand work. We can't point back to the time when we made a living at art. I am all for the working people organizing to protect themselves. For many years I was an active Socialist and even ran for office! But I draw a distinction between an artist and a working-man, a craftsman. The artist, the real artist, must work for himself. Artists who classify themselves as tradesmen have given up their birthright to independent thought. There is only one creative action in the world

[33]

GIST OF ART

today that has any right to be done independently, and that is art, the Arts.

A shoemaker or a carpenter or a manufacturer who is independent is a traitor to his group. Art is the one place where individualism hurts no one. The part of the artist that is a human being is inter-dependent. I am not so foolish as to expect the artist to make an impossible division of himself. But I don't think art is a practical means to a living. To make a living you have to make something that someone else wants. The working-man works for somebody else. He may sell his work to capital or to the government. But in a better world than ours no one will have to sell works of art for a living.

If an artist makes his living as a craftsman, doing commercial work, he must belong to a labor organization that will protect his living. The work he does for himself, his painting, cannot come under the standards of commercial competition.

I question whether you can really be an artist when you have given up your independence. What I am really saying is that the artist who paints for himself is an amateur. In that sense I am proud to be an amateur. So was Rembrandt and so, too, Van Gogh.

I cannot say too strongly how absurd it is to judge whether an artist is good or not by how much his work sells. Selling is a rare consequence of making what happens to be in style largely through the influence of publicity. Pictures that sell may be the work of an artist or just products of some snappy technique. The work of great artists and little artists may sell, you can't tell which way the fashion will turn. The artists who are great today may be of little importance tomorrow. The one who wasn't even called a little artist may eventually be called the great artist.

The dealers, with few exceptions, make a living selling French pictures in the back room. They may show American art in the front room, but they always have a few choice pieces to show their

clients, precious things just over from Paris, some rare Cézanne that was discovered in a rubbish heap. Cézanne knew some of them weren't so good and he threw them there. Europe sells us a few things with a tear in her eye and says, behind her hand, "Good riddance for good money!"

There is a museum out in Kansas City. In the will of its patron is a stipulation that no American artist's work can be bought until thirty years after his death. Some of them who die early may get in sooner than those of us who were born before they were. No doubt there are plotters, dealers, preparing to have some pictures ripe when the thirty years are up—or even meditating murder.

Though a living cannot be made at art, art makes living worthwhile. It makes living, living. It makes starving, living. It makes worry, it makes trouble, it makes a life that would be barren of everything-living. It brings life to life.

In a better world everyone will be an artist. Art products will be "swapped." Maybe pictures will be exchanged for somebody's hand-made table or woven textiles or fine pottery. An interest in art will take the place of superiority in wealth. Men will take pride in having hand-made things at a time when the machine supplies all the necessities. Art may come to be the great desideratum in a machine world that has abolished hunger and poverty as the result of three hours machine tending per man per day.

Originality and Imitation

Students worry too much about originality. The emphasis on original, individual work in the past years has done a great deal to produce a crop of eccentric fakes and has carried art away from the stream of tradition. Tradition is our heritage of knowledge and experience. We can't get along without it. If we tried to live alone in the woods we would have to start civilization all over again. Humanity would get nowhere without imitations. We would not know how to eat, speak, live without learning by imitation.

[35]

Of what use would language be without imitators? You can create your own vocabulary of word sounds but nobody will understand you. One James Joyce is a miracle but a nation of Joyces would make life impossible.

Art is so much a matter of signs. All phases of creative and plastic art contain these signs. At some time or other these signs were invented or created. If they had been found only in the work of their creator they would probably never have been accepted. It is through the imitator that the significance of signs in the arts is spread to a wider and wider field until many of them are exploited by all ages and all peoples.

An artist who, in years of work, has accomplished only imitations has no need to feel himself a failure. He is, perhaps, working more for the general good in the way of spreading art appreciation than the selfish creative genius. It might not be too much to say that the creative master is a failure until the imitators have found him.

The human ear is a perfect example of what I think about originality. All ears may look alike and yet no two in the world are identical. The convolutions are there in all ears but they are subtly different in each individual.

You can do all the imitating you want, you can respond to anything you choose in life, and in doing that you will simply be doing what the greatest originators among humans have done. Originality cannot be sought after. It will come out when you express your convictions. Never be afraid of losing your individuality. If you have something personal to say you will not be able to hide it.

Originality is a quality that cannot be imitated. The technique of the language, on the other hand, is something that belongs to all who can understand it. Rubens' technique has been in the world so long that it belongs to everybody who can understand and use it.

Sometimes it is best to say something new with an old tech-

nique, because ninety-nine people out of a hundred see only the technique. Glackens had the courage to use Renoir's version of the Rubens-Titian technique and he found something new to say with it.

Cézanne may have tried to paint like El Greco, but he couldn't help making Cézannes. He never had to worry about whether he was being original.

Don't be afraid to borrow. The great men, the most original, borrowed from everybody. Witness Shakespeare and Rembrandt. They borrowed from the technique of tradition and created new images by the power of their imagination and human understanding. Little men just borrow from one person. Assimilate all you can from tradition and then say things in your own way.

There are as many ways of drawing as there are ways of thinking and thoughts to think.

Little people with precious techniques, secrets, mysterious recipes for making art, are always chary of sharing their information, because that is all they have. That is not the attitude of a real creative artist. You never hear that one scientist is worrying about another scientist using what he has found out. And yet I had a letter not long ago from a student in Pennsylvania, in which he told me that he had discovered a wonderful method of painting, absolutely new—and he was afraid it would be stolen from him before he could perfect and patent it. What was he to do? I thought of writing him on a postcard, saying, "My dear Sir: I am printing this because I have discovered a new and wonderful way of writing and I am afraid of having it stolen by the postmaster who looks at your mail."

Too little knowledge of technique is a handicap as it holds back what we want to express. The trained hand can control and facilitate the unconscious impulses of the mind.

I can't tell you how to do it. It isn't a secret or I could tell you what it is. The people who make art don't know how they do it.

They don't do it uniformly well. When you "know how to paint" you can be a professional portrait painter than which nothing is more tedious.

Look at the elusiveness and keenness of an artist like El Greco. You may think for a moment that you know how he did it. It isn't as simple as all that. There is a formula that we can see, and then there is something else, some spirit, vision, understanding.

The academicians are the men with little recipes. They learned how to make one picture and they spend their little lives making that same picture over and over again. The masters did have a certain kind of formula, a sort of system in seeing, a method in constructing pictures. That is how we recognize their work. We know a Rembrandt when we see it because we recognize the formula he used, his way of thinking about things.

Know What You Want To Do

You can be a giant among artists without ever attaining any great skill. Facility is a dangerous thing. When there is too much technical ease the brain stops criticizing. Don't let the hand fall into a smart way of putting the mind to sleep. If you were so clever that you could paint a perfect eye, I would know that you would always be too clever. Some things are too well done and not done well enough.

The danger of learning too soon just how you want to paint often results in mass production.

On the other hand, don't be fooled into thinking your work is better than it is because the technique is fumbling.

Be master of your own ability. Work with some confidence in yourself. Work that shows a lack of decision about how the thing is to be seen and executed in the medium betrays a vacillating mind. When you pick up a pencil you are an authority unto yourself. Don't let technique get the best of you. Master it so you can work with more spontaneity and less labor. Skill in expressing what is

[38]

on your mind is necessary but it takes more than that to make art.

When the work steps forward it is through the use of an ability that isn't always at your command. Keep striving and searching for greater realization. Through that yearning the problems of execution will be solved.

Be sensitive to the qualities inherent in the medium. Paint honestly and avoid tricks.

For a while people thought that putting the paint on roughly was art. Now we know that an artist is a craftsman. It lets in a lot of manicurists.

If there is desire, humanness, and sincerity, even with a fumbling technique a result may be arrived at.

See things your own way. Find out how you, yourself, see things. Do not deceive yourself by following some popular style. If the trend is towards murals do not hesitate to paint easel pictures or miniatures if your concept of things lies in those forms. It is part of mastery to know one's form, one's limitations. Rembrandt did not try to paint frescoes in the grand manner.

If you are most interested in design, perhaps you should not be painting pictures. Rather be a great artist in making pottery or furniture than an unhappy artist painting pictures that do not express your true vision.

Years ago Angna Enters, the great dance mime, came into my night class to finish her equipment for commercial art. I said some things to her that made her think—perhaps something about a feeling that I got from her work that she wanted to express herself in motion as well as line and color. She told me years later that I drove her out of art! With her great human understanding and artistic ability she has created a pantomime theatre that is unsurpassed today. She designs and makes her own costumes, even to dyeing the leather for shoes. She is a great professional artist in the theatre who now paints on the side.

If you are most interested in vivid imagery, it may be that you

GIST OF ART

should be a poet. If you have an intense feeling for rhythm, perhaps you should be a musician.

But if you love to draw, draw. Let it be a means of spiritual communication between you and your fellow beings.

Art and Nature

Nature is what you see plus what you think about it. Artists change our thoughts about nature and so, in a sense, change nature. A masterpiece does not look like nature, because it is a work of art. The language you want to speak is art, so study art from the masters. Nature is made up of things, facts, phenomena. You have to select what you want to make art. It is the job of the artist to correct what he sees by what he knows. Anything you know helps the mind to dominate the eye in seeing. The artist's mental image of the thing seen in nature, expressed in graphic terms, is what gives creative vitality to the work.

Nature: atoms, plants, animals, humans, inorganic things—the whole universe; life around us: cities and mountains, plains and rivers; clouds and sky; the oceans; fire and sunlight; the table and dishes we eat from every day—all is nature: the artist's subject matter. There is no image that was not derived from a memory of something seen. Rembrandt was a great inventor but he has never been accused of inventing or changing nature.

Get your impulse for making a picture from some incident in nature. It may be something about an elbow at a window that tells you all about the room inside.

Every individual has a life of his own and his own concept of beauty. If he responds to those things in life that he has selected as material for creative expression, his work may reach as high a plane as any that has been produced.

The artist should have a point of view, the spectator's attitude about his subject. But he does not need to paint the age in which he lives. They say we should paint the Machine Age, paint speed

and change. That is all right if you are interested, but it is not necessary to respond to dynamos and microphones. We have not yet learned to use labor-saving machines to save anything but wages —how then can we paint them with understanding?

The artist seeks to record his awareness of order in life. One may find it in landscapes and another in social themes. The subject may be of first importance to the artist when he starts a picture, but it should be of least importance in the finished product. The subject is of no æsthetic significance.

The average person is satisfied that he understands a picture as soon as he has recognized the subject. If it is a fat,old woman bathing herself, he passes on because he doesn't like her.

The real artist finds beauty in common things. When what you see in nature is obviously beautiful, a picture postcard sunset—then is the time not to paint. Avoid sloppy sentimentality over the obviously spectacular and picturesque. These depend on the color and excitement of the moment. A record of emotions isn't art in any medium, even music. Emotions of a graphic-plastic nature are another thing entirely. The best creative inspiration and stimulation you can get is the tempting impossibility of expressing by signs the third-dimensional realization of Things.

Paint what you know and what you think. Keep your mind on such homely things, such deep-seated truths of reality, that there is no room for the superficial. Put over the selected viewpoint of the mind about the subject. Don't be afraid to be human. Draw with human kindness, with appreciation for the marvel of existence. Humanism can be applied to drawing chairs and cobblestones. Look at the work of Daumier.

There are no superiors among masters, but we may distinguish between the work of Michelangelo and Rembrandt by saying that the latter was more human.

A concern with the abstract beauty of forms, the objective quality of lines, planes, and colors, is not sufficient to create art. The

GIST OF ART

artist must have an interest in life, curiosity and penetrating inquiry into the livingness of things. I don't believe in art for art's sake. I think that very often a literary motive may inspire the finest art, in fact almost always. But the literary title might better be destroyed or kept for the artist's autobiography. If paintings were designed as Opus 1, 2, 3, etc., they might receive more attention from the public.

I sometimes wonder what is to supplant religion in stirring up works of art. Look at those Russian icons! But I don't know why it might not be possible to get that same sort of thing in a painting of bits of human joy in life. I know of a little picture by Philip Evergood, card players on a hand car, that looks like a religious painting.

The purpose of subject matter is to veil technique. The great artist uses the cloak of resemblance to hide the means.

If you want to make great art paint a common thing. The difference between a head drawn by a naïve artist like Rousseau and one drawn by Rembrandt is that Rembrandt drew with greater significance (the use of signs) and understanding.

Draw the things that interest you, that you like or dislike. Many great works of art were motivated by the artist's hatred of the thing drawn. Goya's War Series is an example. But in the finished work you do not feel that he hated life and human nature. Work which only conveys the emotion of dislike remains caricature or propaganda.

CHAPTER IV

THINGS-THE MAINSPRING OF ART

AN INTEREST IN THINGS is and always was at the root of art. Giotto painted things. He didn't draw them the way Michelangelo did but they were both after things, the essence of solid forms.

Through the influence of the camera, few artists today know the difference between the aspect and the concept of a thing. It requires mental technique for a student or artist to look at nature and see things. A camera can't see a Thing. It is mentally blind. The camera can't see form. If you see form in a photograph, your mind put it there. We don't even learn form through the eyes. We learn it from the sense of touch. The first two years of a child's life are spent in coördinating the sense of touch with the visual impressions of things seen by the eye. We recognize the shapes of objects by experience, knowing that certain combinations of tones, light and shade effects, indicate shapes of which we have a tactile knowledge.

The eye is only a lens. Triangulation, looking with two eyes, gives a greater sense of the third dimension than can be seen with one eye. If you look around a room with one eye shut you lose your sense of space. You will see just flat color facts. But if you look at a good picture with one eye it has just as much form as can be seen with two eyes because the form is signified, made by signs.

The art schools of the last hundred years have taught students to imitate the visual impression of the light and shade shapes seen by the eye, with no concern for the subjective, real shape of things. People who have a clean innocence about life and the things they see can't understand the average art student's drawing. A child can't. A few years ago an Indian shown a photograph could not tell top from bottom.

The ultra-modern movement is a medicine for the disease of imitating appearances. It is a return to the root principle of art: that art is the result of an interest in Things, not effects. They would have laughed at me if I had talked about drawing Things three hundred years ago for they saw only things, not appearances. Ultra-modern art is simply a return to the technique of art, the use of symbols, graphic devices for things. There is essentially nothing being done by it that cannot be found in an El Greco.

Most of the ultra-modern artists are practising, exposing the grammar, the tools of expression. The imitators are very useful because they spread the technique. The only value of the Surrealists' work is in its moderate concern with realization, the kind of art existence you find on a much higher plane in Dürer or Mantegna. The literary associations in their work are of no importance to anyone but the artists themselves. Or are they? Sad if true.

The stumbling block in modern art is that the artist becomes more interested in craftsmanship than anything else. Cubism is not art in itself. It is the grammar and composition of art. The ultramodern movement has made us conscious of the skeleton of tradition.

Not that significant technique is the only important element in art. The old masters' work has the same technique which has been discovered by the modernists, but the masters cloaked it in readily recognizable subject-matter or story telling. There never has been a time when it was not good form to speak well of Giotto, Rubens, and Titian, but we have not been conscious of why they were good. It used to be quite possible to look at their work and see only the subject and design,—what might be called the beauty of the work, or its emotional content,—and not be at all conscious

[44]

THINGS-THE MAINSPRING OF ART

of the technique. In fact, it is one of their achievements. In the light of modern investigation, however, such absence of understanding is no longer possible.

Avoid imitative painting, the copying of light shapes and shadow shapes. But this does not mean being alienated too far from representation. Work which is purely non-representational loses some of the texture of life. Students cannot have too much training in cubism but there has to be an interest in life before the work takes on a healthy creative vigor.

The Separation of Form and Color

At the root of all the plastic arts is the consciousness of forms made of combinations and modifications of the universally understood simple solids: the cube, cone, cylinder, pyramid, and sphere. The graphic artist projects his concepts of these forms on a twodimensional surface by the use of line, tone, and color devices.

Signified third-dimensional projection is one of the æsthetic elements of a work of art. The attempt to imitate sculpture, modelling as seen in nature, by the use of light and shade planes is of no significance.

Realization, the tactile existence of the form, is another basic æsthetic quality. The definition of the form in its entirety, the character of the material represented, not imitated, gives life to the art form created. Realization comes through a feeling of the bulk and weight of the thing, the bruises you would get if you stumbled over it in the dark. Texture clinches the form, brings it into tangibility.

Another point that lends realization to the work of art is the artist's consciousness that form and color are two separate things. The mind cannot sense form and color at the same time. They do not actually happen in anybody's mind at the same time there are two efforts. The mind registers back and forth very rapidly from form to color. It may make the change a hundred times a minute. Only the mind sees form. If form exists at all it is only in the mind and as the result of experience gained through touch. Color is a surface texture on the thing. We do not understand form through color but through the indications of lights and shadows. If we saw form through color we might mistake a persimmon for a tomato.

The great black and white draughtsman, the sculptor, and the blind man know that form and color are separate. The form itself is what the blind man knows about the thing. Color is a surface skin that fits over the form. Many great works of art have only form, the sculpture of the thing. Color as used to signify realization by men like Titian and Rembrandt, gives greater life and tactile existence to the work.

Realization is the keynote of the Renaissance. Rubens was a master of form and color. He had a formula for making realization, which belongs to any artist who can understand it. Rubens' technique belongs to everybody. It is Rembrandt's and Renoir's. People criticized Glackens for using Renoir's technique. Why not use a traditional technique if you have something of your own to say? Renoir's technique is the technique of tradition, of the separation of form and color.

Because Glackens is a contemporary whose work has been neglected by most critics on account of a surface resemblance to Renoir's, I want to make a special point of the real technical relationship between Glackens and Renoir. Both men worked on the principle of the separation of form and color, which is the technique of tradition. If Glackens is like Renoir, Glackens is like Rubens, Rembrandt, Titian. The same technical principle of plastic realization is in the work of all those men. Of course you won't mistake a Renoir for a Rembrandt. But if you don't recognize the resemblance you don't recognize the principle. People, critics with the "art student" mind, recognizing the superficial technique of Renoir, see only that and pass on.

THINGS-THE MAINSPRING OF ART

If what you mean by technique is only a superficial thing, how the paint is put on canvas, that is nothing. If Glackens' work had not been identified with that of Renoir, if he had imitated the prevalent Munich technique of the 1890's, Duveneck for instance, no one would ever have called him an imitator. Glackens learned something from Renoir about how to think in paint, but anything he painted was his own. We all need direction to find our way to some relationship with the stream of art. Some imitation is absolutely essential. We catch up with the conduct of today by imitation.

There is no use in trying to be strictly original. All you need to be is honest, and you will gradually reach the conclusion that the world around you isn't real enough to be worthwhile. You soon find that what you see is not real enough to put down. Glackens, like Renoir, worked from a mental concept of the thing itself.

Glackens was a great colorist because he used color as a plastic force. In his work you can see the neutral colors weaving together to build the form, and then the positive colors put on as separate statements to give the form color-texture. The technical process resolves itself into a separation of the color-plastic constituent, from the form. The energizing color-plastic surface is there in his work as in a Renoir, Rembrandt, or El Greco. I, myself, believe that there must be some of this quality that comes from the separation of form and color in any worthwhile work of art. There must be some of it, no matter how simply it is used. If there are only a few lines on a piece of paper there is separation of the form and the color as an enhancing surface texture.

The technique of the old masters was based on that process. They made the form first with light and shade and then the color was fitted over it, and so there is no joining. In the academic work of the last hundred and fifty years there has been no separation of form and color. In a real work of art the form lies under the color, is climaxed by color textures. Put your hand against a Rembrandt of the finest period, when the paint was put on in grooves and scrapes and chunks. Compare the realization in his painting to the flat color of your hand. If you want to make a real test, look at both with one eye. The painting is more real than the hand because the form is realized by Rembrandt's devices, form clinched by color. Perhaps the separation of form and color is more readily recognized in a Rembrandt than in a Renoir. But the principle is there in Renoir and in Glackens.

This related technique which you will find in the work of Titian, in Rembrandt, in Rubens, in Renoir, and in Glackens, is a means to super-realization.

Cézanne was related to this group, although his method was more geometric. Analysis and dissection of the traditional technique is the sub-conscious motive of the whole ultra-modern movement. It is a struggle toward the human, plastic, structural concept of reality which existed in the world to about the time when the camera was invented. The ultra-modern movement is important because it brings us back to a consciousness of the analysis, of the anatomy of things. It brings us back to the artist's concern with the noumenon, the thing itself, rather than the phenomenon.

Things Have Bulk-Art Has Form

The thing itself has bulk and modelling. Art has form. If you merely copy the modelling it won't have sculptural impulse. Thickness through doesn't make form. The simple design that is painted around a fine Indian bowl has form. A Chinese painting has no modelling, but form signified, represented by graphic devices.

Form is a kind of slang word these days. Many people think that bulbosity and form are the same thing. There are some who think a form is classical because it is cylindrical.

Of course it is impossible to define good form. The drawing of flat planes, rounded planes, bumps and holes—is only modelling. There must be a sense of organized geometrical shapes, some plan

THINGS-THE MAINSPRING OF ART

of beauty in the selection, definition and combination of the forms.

One factor that contributes to the fineness of a painting is the limitation of the sculptural quality to low relief. I don't believe there is more than two feet of real depth of space in any great painting. The sense of space is represented by devices. The harmony of sculptured planes is one of the beauties of bas-relief sculpture.

Poetry, music, painting, have form. By form in this sense, I mean the way the artist wraps the thing up and delivers it to the public. It has something to do with manner, style. Imitators may get the form, in this sense, but not the content. They get the stylization but not the true style which is created by the idea. Stylization is just a superficial exaggeration of shapes, a punctuation of decorative qualities.

Style is such a subtle thing that we scarcely see it in the great masterpieces. Style is the finish with which the artist cloaks his thoughts. It is the outside edge of the inner content, the tangible surface of the form. Style is the result of a harmony of concept, a selective force that is the artist's guiding spirit.

The Archetype

The artist has a mental concept of things in nature; he knows their normal structure and proportions. To this he adds his personal point of view, his selection of shapes and proportions and qualities that interest him as being fundamental and beautiful. This mental formula for a thing is called the *archetype*, and it is the basis for comparison to which the artist refers when observing a particular thing in nature.

The artist formulates his idea of the average structure of human beings, trees, mountains, horses, dogs, and so forth. He develops a system of thinking about the general construction of things which makes it possible for him to observe the particular, record it if it interests him, but always as a variation of the norm type.

GIST OF ART

Archetype thinking may be observed in the work of all the masters. It contributes to the monumental, permanent character of their work. It has a lot to do with the unity and integrity of their concepts. It keeps what we used to call "character" out of great work.

The people in a Daumier or Breughel all look as though they belonged to one family. It is this formula by which we know that a picture is the work of a certain artist or school.

Just as the artist develops some structural system in seeing forms, he works out formulas for expressing them. He uses formulas and systems of drawing and design to express his feeling for order. Discipline of thought and technique are essential in creative work. "The artist must have a heart of fire and a mind of ice."

The Approach

There is no one way of drawing that is right. Nor is it good to be dependent on any one way of doing things. The greatest masters were always searching and groping toward more powerful, significant form, forcing the technique to suit their desires. Delacroix's Notebooks are full of observations about the problem of finding a better way to say what he was after.

Go to the masters to learn how to draw and paint. Study them, particularly the work you don't like. That is the road to advancement, that is the way to learn. But get your impulse to work from life. You may copy Cézanne or El Greco, but whatever you make will be your own. Whatever I make is a Sloan, no matter whose technique I may borrow.

Study and work and paint pictures. You cannot paint pictures by merely wanting to paint them. All the inspired work of the masters is backed up by a lifetime of hard study. Find your own way of working. You may work three hours a day, or fifteen. You may work steadily or only when you feel like it, but it is best to get in the habit of working regularly.

[50]

THINGS-THE MAINSPRING OF ART

It is good consciously to study the devices of drawing, to practise methods of painting. This knowledge must become part of your subconscious equipment or it will bother you when you are trying to create. Make laborious studies to find out how things are made in nature and to increase your technical ability. But do not be afraid to loosen up and have a good time making a picture. When you make a drawing for fun it is apt to be good because you are not hampered by the idea of making Art. In a good drawing you make use of all the information and ability you have been storing up while studying.

An artist who just wishes to paint with nothing in him to paint from, remains an art student all his life. He depends on schools and teachers, and learns methods and manners. The real artist needs no teacher. He will find a way to draw or paint if he has the urge.

Have the courage to make mistakes. Believe in yourself. Learn to be your own teacher and critic. Go to the masters to learn how to do the things that trouble you.

There is a healthy condition in the art student when he starts to create pictures and still goes on studying and assimilating. The important thing is to get the creative urge stirred up, to find out what you want to say about life. When you have that purpose you can go on studying for life.

Almost anything you study may be useful to you as an artist: music, geometry, bricklaying, anatomy, botany. But don't get side-tracked into too much scientific research.

Great art lies somewhere between naïve and intellectual art. Art is not the result of pure reason. There must be some feeling, emotion, excitement about life. Pure abstraction isn't art, it escapes from life. The trouble with Egyptian art is that it is too abstract, too much an art of mathematics, death. The human mind cannot grasp an idea unless it has texture, the texture of living existence.

[51]

Setting out to do what ultimately cannot be perfected is what makes art. The effort to do the impossible leads to creative work. It is impossible to paint every leaf on a tree. Trying earnestly to do so results in a creative symbol, as in Rousseau.

Some of the greatest artists' work is full of faults. Those faults have something to do with their greatness.

If you go out for beauty, what will you get-something sweet and innocuous. I strongly suspect that if you go out for realization you may get beauty. Not always, but I think that is the right approach.

There is work which annoys nobody at all, and there are people who pass through life without ever irritating anybody. The kind of work they do is practically faultless to everyone, and consequently enormously stupid. It has that certain degree of slimy innocuousness which is necessary in work that has to pass the opinion of fifteen or twenty voters.

Those paintings are just oil painted documents in handsome gold frames. They win prizes. But what does such a picture have to say. It seems to say, "Aint nature lovely?" But all it really says is that J. Stuntjoy Smythe was in Montauk Point in June; and nature was pretty; the sun threw purple shadows north-northeast. That kind of picture is eating space wherever it is, even in the cellar.

The academic art class takes students and teaches them how to make bad drawings. After they can make perfectly bad drawings, (it takes quite a while to learn how to make very bad ones), they are graduated. They get studios and make bad paintings. The more they paint, the worse they get. If you ask one of those men where their drawings are they will tell you that they are "out of drawings." No one ever heard of a great artist who was out of drawings. Rembrandt was drawing twenty days before he died, so he could paint better.

CHAPTER V

DRAWING

DRAWING IS THE CORNERSTONE of the graphic, plastic arts. Drawing is the coördination of line, tone, and color symbols into formations that express the artist's thought. Drawing and composition are the same thing. They can't exist separately. The artist sees order in life, that is one of the important things he has to say about it. To formulate his visual images he must have order in his thinking and order in his expression. A sense of the structure of things, of their geometrical composition, the ability to see order in nature and then the technical ability to compose these plastic ideas, is essential to the artist. But if you go out and see nature through a formula of composition you won't go very far.

By the graphic means of line, tone, and texture are made symbols for third-dimensional activity; for form and space, and light and shade.

The line drawing of a cube is a racially accepted symbol for spacial activity. Because it is a sign it is more vital than the reality. A squashed circle is a symbol for the top of a cylinder seen in perspective. It explains the objective character of the form better than an ellipse, which is only the visual appearance of the thing. A set of radiating lines drawn around an object say "light" more powerfully than anything else because it is a sign-convention.

Graphic symbols, devices, are the tools of the artist just as word symbols are the tools of the writer. Study them while you are young, digest them. Men like Picasso and Braque are working for you and me, exposing the technique.

[53]

GIST OF ART

Drawing has a permanent advantage over all the other methods employed by the artist. When you take a black pencil or crayon and make marks on the white surface of a sheet of paper in order to express something you have in mind, you are using an instrument which confines you strictly to the making of symbols.

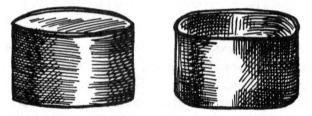

Cylinder Drawn with Visual and Isometric Perspective

If I am a student in a life class and there is a beautiful, fleshcolored model on the stand, and I draw that flesh-colored model with charcoal that is black on paper that is white, I am doing something that has significance entirely as sign-making. Black marks on white paper can never look like that model and therefore, a drawing can never be as bad as an imitative colored painting. The fact that the graphic artist has a means which precludes imitation puts up a barrier between him and a certain kind of worthlessness that can result through stupid imitation of visual sensation without any mental consideration or creative expression getting into the work.

A good drawing has nothing of imitation about it. It gets its value from the quality of invention that the artist has to put into the medium of charcoal or pencil to express what a colorful, living figure suggests to him. We all have graphic courage. When you stop to think that we will put black charcoal marks on white paper to represent a pink figure you will realize that you have lost the fear of dissimilarity. That is one reason why there seems to be a power in reserve in monochromatic work. Students in the average art academy are encouraged to copy the outlines they see on a model: the high-lights, half-lights, threequarter-lights, half-shadows, three-quarter-shadows, full-shadows, and the reflected lights,—all in the places where they are seen on the model. That is just as near to black and white photography as they are able to get. It is as far away from art as anything which uses black and white symbols for colored things can go. This putting together of light and shadow shapes has nothing to do with significant drawing.

The instruments of drawing are the pencil, crayon, and pen. Charcoal is a splendid medium because it enables you to achieve so many of the qualities that exist in paint. If there is use for the floating cloud, the blending quality, it is there in charcoal. If there is use for a strong linear signal, it is there. If there is use for the granular textural dryness, as contrasted with the flow of the blended tone, it is there.

The pen is also a wonderful means of intellectual expression in the hands of the graphic artist. The technique of the pen comes very close to registering the mental process of the artist. The pen strikes the paper with its black line. It describes the general contour, the textural contour, the kind of living edge that signifies. It goes further and describes the more important edge, the profile that projects toward you. Then the line follows with textural notations, the roughness of this, the graininess of that, giving a textural face to those vivid creative, expressive contours.

The Attack

You are in class to learn how to draw. But of what use is it to learn how to draw unless you have some real purpose in becoming an artist. Charge your mind with things you want to do, pictures you want to paint. I have heard students speak contemptuously of an artist whose work showed what he "tried" to do. Why, there is nothing more desirable than to have something you want to say and to be able to say it so that you convey your concept to others.

You can't get in the habit too soon of going ahead in a vital way. You need thorough but not dull, academic and mechanical studies to acquire self-control. You must know how to make exact plastic representations of things so you can freely draw your concept of the thing at will. First, good training, then a certain amount of artistic looseness should be your aim. The early works of the masters are quite tight and thoroughly drawn. Later on they loosened up; but having had that foundation of drawing their work is never empty.

The ultra-moderns find it exciting to paint an apple. Let the ultra-moderns find symbols for you and they are yours. Then use them to paint your pictures.

If you are surveying you are not learning how to draw. That is a stupid kind of correct drawing which when mastered would be of no use to you. That is what they teach in our art academies. Really good academic drawing, the result of a thorough training in the tradition of the old masters, is another matter entirely. We haven't had any of that kind of drawing in this country. The reason I wanted an artist like George Grosz on the teaching staff of the Art Students League was because he had had that thorough training in academic drawing. It sticks out all over his work, and yet he can draw like a wise child.

When you draw, your intuition is a sort of guide. You must have a pre-conception in your mind and your hand puts down this concept as if guided invisibly, placing the drawing on the paper as if it were tracing what was already there.

In a good drawing you always feel that the artist chose the ideal place to work from. But that isn't it. It is the feeling of authority which lies behind the good drawing.

Day after day, week after week, you struggle with the problem of drawing freely. Then one day suddenly, the barrier breaks,

DRAWING

snaps,-you can draw. You have now become an inventor and are no longer an imitator.

A good drawing has immense vitality because it is explanatory. In a good drawing even its faults have become virtues.

When a drawing is started too quickly it will go on slowly. Work it out mentally for ten minutes before starting; arrange the design in your mind before you put a single mark on paper. If you do that you may be able to put down more, more truthfully and more thoroughly in half an hour, than in a week of stupid, correcting labor. Go after design, character, realization.

Line

Line is the most significant graphic means we have. It is entirely a sign, a mental invention. You don't see lines in nature, only contours of tones. Unless you try to imitate the outside edge of something as the eye sees it, you are making a sign every time you draw a line.

Lines can mean form, depth, shadow and light. Look at the work of the Japanese and Chinese. Notice how the variation of size and strength of the line indicates form and texture.

The line defines the construction of the form, the geometrical shape. The good line does more than describe the outside edge, it contains the form.

The most important outline is an inner line, the contour of the form nearest the person working. The line you would see if you were ninety degrees away from your present position in looking at the thing. This is the "outline of experience," the line that you know mentally about the shape, its projections and recessions.

Think of the line that explains the cross-section of the form. Sometimes draw lines all over the surface, like the lines of latitude and longitude on a globe.

The edge is the consequence of the interior activity. Draw through the form. Reconstruct the shape as you know it. Get at the fundamental geometrical shapes. Try to use line significantly.

Avoid outlines suggesting angular form around bulbous modelling. Keep the line and the sculpture saying the same form.

One ornamental line will weaken every curve in a picture.

There are many line conventions. Parallel wavy lines say water,

and they will do their best to say water wherever you put them.

One of the most important line devices is the set of parallel lines used to indicate the surface of a plane, the direction in which it is going and its place. Study the classical line technique of the masters: Dürer, Hogarth, Titian, Leonardo, Rembrandt, and Leech. Observe the system with which they used lines to represent flat and curved surfaces; some to say form, others texture. See how they used lines to say light and shade.

In a Rembrandt there is one line which defines the general shape, then sets of lines that carve the form. On top of this there is a descriptive line which passes to and fro, emphasizing a form here, bringing out the texture there; then the enveloping films of shade.

The fine line is positive and explanatory. It may be as severe as a Dürer or as sensitive and free as a Daumier.

Line is the most powerful device of drawing.

Tone

Unless used to imitate light and shadow shapes, a black tone is purely a symbol. The tone is a sign for the "thereness," for the presence of a surface. It may be used to cut in back of a plane, or to pull it forward. A change from light to dark or dark to darker tone indicates a change in the movement of the form. A graduated tone helps to carry a form around. Certain conventions, formulas of tone interval combinations, are devices for making concave and convex surfaces.

Notice how a series of positive tone changes may be used to make the round plane of a cylinder go from front to back. Those

FORM: Light and Shade

THE CUBE: Form, Texture, and Light

BLACK AND WHITE TEXTURAL PROGRESSION

Light and shade (form)

Plus texture in the light

Light increases with color-texture

Linear graphic additions

tones are signs for surface, they are used to build the solid. They are signifying sculpture, not modelling.

Forms may be built entirely with masses of tone, the boundaries of which make contours. The culminating surface or facet of the form may be a dark or a light. The lightest point of a form does not have to be the most projecting point. It may be struck with a harsh black for the sake of realization or design.

Don't copy the tones you see in nature. The light and shade is only an accident, the real shape is what counts. Study the shape, analyze it into its big geometrical planes. Pick up your tones and build with them. Practise drawing with paint. Mix up a set of positive tones and sculpture with them.

Make many studies of the five simple solids, finding different ways to draw them. Don't rely on one or two little form conventions. Concentrate on the reality of solid substance.

Texture

One of the essences of beauty in graphic art is the significance of texture. The signifying of texture, the sign for texture, is what counts. When I put dots and granular markings on the surface of the drawing of a cube, I expose the way to think about texture—not necessarily the way to do it. There are more subtle ways. The texture in a great work of art may be hidden as are other drawing symbols.

Texture is the detail of sculpture. Texture is bulk. Low relief is texture. Pike's Peak and the Grand Canyon are just texture on the surface of America. Texture: All the way from the feeling of a baby's skin to the shape of a chair. The people and easels rising from the floor are the big textures of the floor. The lines of the boards, the spots of old paint and dirt and the general neutral color of the floor, are the minor textures.

Sign-made texture brings the form into sculptural existence, makes it "realized." By realization I do not mean realism. Realism

GIST OF ART

is a kind of fact-painting. Realization is art existence. It comes when you make something more real to the mind than it is in nature.

In a Cranach or Dürer every knuckly detail shows an appreciation for something not seen by the eye. It was their way to realization to find warts and hairs, wood-grain, grass, and pebbles to give surfaces textural life. A Titian is so inscrutable that you can't see how he did it.

If you haven't a sense of realization, if you haven't the strong desire and yearning to make things on your paper that will satisfy the mind, you won't go very far as an artist.

Find tones, marks, textures that will clinch the sense of "thereness." Have them at your command, so that when you find yourself losing the feeling of realness you can strengthen your statement and thereby bring it up into existence. Don't depend too much on the textures in nature to keep your sense of reality alive. Exaggerate.

Keep the unity of surface. The surface completely covers the bulk of the thing. Keep your sense of substance alive. Try to make the form tangible. Earnestly scrutinize your own hand with two eyes, then look at your picture with one. Describe the difference between bone and fat and muscle and cloth. Don't do it imitatively by copying the kind of tones and highlights you see. Use the character of the material as a point of departure for some significant statements of what you feel about it.

There are carving textures and color-textures. In a black and white drawing, color-texture is made with selected tones, textures or linework that suggest the surface of the whole form. It is not necessary to put texture all over as though you were embroidering the surface. It may be done with delicate crayon tones, or pushed to the full gamut of black charcoal.

Smeared tones deny existence. Filling-up tones are not texture makers. Texture is drawing the form with more realization than

DRAWING

can be achieved by merely describing the plain sculpture of the thing. Melodramatic technique, sloppy oil paint or scribbling pen work do not make the dry existence of the thing—the kind you can get with a few harsh charcoal marks.

You may start the drawing with some nebulous rubbed charcoal grays or water color wash, and then bring it into forceful existence with crisp pen lines and rough dark textures. It may be done with all the sensitivity of a silver point. It may be said in ten minutes with a pencil, or in five years by a very wise painter.

Crude contrasts of black and white do not necessarily make for realization or power. The power that counts is significant drawing. All the greatest work has a combination of strength and delicacy.

Light and Shade

We see what the form is and what it is doing by means of lights and shadows. No matter what the light is doing on the form, the form remains the same. Light cannot obliterate or destroy the shape and weight of the thing itself. We can see that the thing exists, its shape, easier in the light area than in the shadow area. The eye can focus on a light area more easily.

Use the lights and shadows you see in nature to help you define the form. You may follow the light and shade very carefully, or you may pay no attention to the disposition of lights and shadows, in your drawing. But you must plan the light in your design. Light and shade is a device whereby you control the composition of the forms. Use it to carry the eye through the picture, to lead the observer in and out of the design. Decide how you want the large planes to come into the light, and let the modifying planes follow in the same scheme.

Don't just get a record of where the light was in nature, but of what the light did, what its quality was. Use light to emphasize the plasticity of the design. Let some forms slip away into the shadow and bring others up into greater realization. Rembrandt's drawings are not pictures of lights and shadows. No group of people could possibly be arranged and lighted to look like a Rembrandt. He designed with light. He blessed the composition with light and shade. Someone has said that he orchestrated his lights and shadows.

I like to separate drawing into two processes. First, we sculpture the thing with light and shade, make the shape; and then we bring it into realization with color texture. It may be done by drawing the form with little or no concern for the light and shade in nature. Then with signs, an indication of shadow back of a form here, some textural comments in the light there, the thing can be brought to life. The power of the sign is so great that you can put the very darkest marks in the light, strong granular markings working on top of white paper, and if the shadow side of the form is indicated with a rubbed tone that says shade, those dark marks will stay in the light.

Light and shade don't obscure. They don't cover up the form. Rembrandt's shadows are never dark: they are so full of light that you can always see the form in them.

The color of the thing keeps on going in the light. It is attached to it, an integral part. It is the continuous surface that goes around the form. Don't give up the light area of your drawing to blankness, chalkiness, because it looks that way. Make the thing realized, it helps the sense of light. Avoid keeping your lights too much separated from your darks. Keep them working together. The artist may think of the light side and the shadow side of the form, but he should think more of the thing being enveloped in light and shade. It is a good idea to think, not of light and shade but of light and less light.

Decide on a formula for the light and shade in each drawing and stick to it or the design will become cluttered up.

Some textures reflect more light than others. A black velvet drape absorbs a lot of light. But you know that there is just

as much light on it as there is on a flesh-colored model standing in front of it; the light makes it black. Don't be carried away by the contrast of values you see in nature.

Study Daumier's drawings. See how he expressed the feeling of light playing over the form. See how he used light and shade to design. In the hands of a master, light and shade is one of the great qualities of art.

Observations and Reminders

There is an objective value in all the fundamental forms. Horizontal and vertical lines have stability. Diagonals and curves express movement. A circle or spiral gives a feeling of continuous movement. Squares and triangles have strong architectural character. Each of the simple solids has its essential plastic form. The sphere moves around in all directions. The pyramid builds up. The cone builds up and passes around. The column of the cylinder combines the form of cube and sphere.

The fundamental principles of constructing form can be learned from drawing the cube. When you draw a sphere think of it as having a projecting nose, a front corner and then sides, top, bottom and back. Think of the curved surface of a cylinder as having front and sides. Perhaps think of it as a solid octagon or pentagon.

In defining form look for the major flat planes and the major curving planes. If you are drawing a road, the main form is flat modified by static textural surfaces. If you are drawing an orange, it is a sphere first of all, but look for the flat places in it. Find corners, facets, on the smoothly curving ball that will help the mind come to grips with the surface.

It is very difficult to make a perfectly smooth flat surface convincing. You have to find textural modifications to make it tangible.

Generally speaking, it takes three changes in tone to create a culmination, to establish a corner. A corner has three sides: two

sides and a top. You don't have "thereness", you don't have realization of the form, until you get the top of the corner.

You can't get realization without putting one tone over another except in the very simplest drawings.

When you are drawing think further around the sides of the object than you can see. If you are drawing a cube face on, you can't see both receding sides but you can think them. With drawing you can signify them. Get up and walk around the thing you are drawing. Analyze its construction. Draw from your memory of the whole shape.

One form demands another. If you draw a cube it has to have a place to exist in.

Build around and up to the most projecting or nearest point of the form, cut in back of the far side. You can sculpture with dark or light. With a line it may be signified by a slight relaxing or sharpening of the line. The feeling of sculpture, the to and fro of the form as it passes away on the far side and projects forward to the near corner, is expressed through the power of mental intention, resulting in significance.

Avoid having the contrast of darkest dark and lightest light at the contour of the form. It arrests the sense of sculpture. Where a light form passes against a dark, lighten the dark a little or put a tone on the edge of the light.

Sometimes relax the degree of sculpturing where the form passes out of sight. Keep the projecting forms more realized than the receding ones or they will fight to exist in the same plane.

The greatest feeling of sculptural realization is secured through sign-giving drawing, not through strong contrast of light and dark. If you want to emphasize the light in a picture, put light around the light areas. Contrasts of dark against light destroy the sensation of light on a surface.

Don't forget that every dark you put on the paper is detracting from the lightness of the paper itself. The tone of the paper can be made to look different when combined with other textures. Observe in a drawing that the white of the paper is a different color in relation to some gray washes than it is when broken or traversed by lines and sharp textures.

Keep the textures clear. Don't fill up the drawing with minor texturings that detract from the sense of light and shade. There must be some harmony in the textural descriptions. In many drawings there is a jarring jump between knowingness and naïveté. One area will be drawn with a very wise understanding and another with a more primitive texture pattern. Such work has a look of uneven competence. You feel that the artist stuffed texture into each area meaning to say bulk, but often resulting in junk.

Remember that the power of harmony is usually stronger than the power of contrast. True of repeating good or bad signs.

Perspective

Objects appear to diminish in size as they recede from the eye. A record of perspective is true only when seen from one point. If you walk across the room from a drawing or photograph that is in true perspective, the forms will become distorted. The tracks of a railroad appear to converge sharply. Visually, the top of a square table, which has four right angles, appears to have two obtuse angles and two acute angles. Anything seen within fifty feet of the eye is obviously distorted by perspective. A near hand appears larger than one further away. The neck will look as though it were not set half-way between the shoulders. The far side of the face appears narrower than the near side. The ears seem to be set on the back of the head when we look at the full face. The projecting features of a head seem enlarged.

The artist who is concerned with drawing reality, the subjective truth about things, corrects what he sees by what he knows. The old masters drew the neck in the middle of the shoulders because they knew it was there. Notice that you will seldom find a

GIST OF ART

record of perspective distortion in any of the great masterpieces.

Perspective may be used as a powerful sign for indicating the near and far in a composition. When you are drawing a street full of people, if you make all those in the foreground one size, those in the middle distance reduced in size, and those in the background still smaller, the change in scale carries the eye back. This is partly due to the fact that the eye follows similar forms. In the

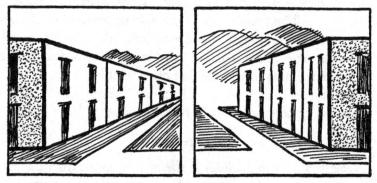

Visual Perspective and Foreshortening

drawing of the street itself, the use of converging diagonal lines to carry the eye back is a powerful and useful symbol. But the use of perspective in the drawing of the human figure is undignified because untruthful.

Cézanne made some use of isometric perspective. If he were drawing the top of a table, instead of letting the sides taper away, he drew them parallel, and drew the back edge as wide as the front. If you compare the drawing of a segmented cylinder drawn in isometric perspective to the one drawn with visual perspective you can see the difference. The drawing which records the appearance looks like a tapering form, a cut-off cone. The other retains its real bulk and character no matter from where you look at it.

In drawing a projecting or receding object, foreshortening rather than perspective is used to signify distance. If you are draw-

DRAWING

ing a figure with the arm extended toward you, reduce the size of the hand until it is its normal proportion in relation to the size of the face. The arm itself will be drawn in a condensed space. Mark off the position of the elbow about half-way between the wrist and the shoulder, as it is in actuality. Decrease the apparent bulk of the forearm, and increase the bulk of the upper arm. The more abrupt the foreshortening, the more you should increase

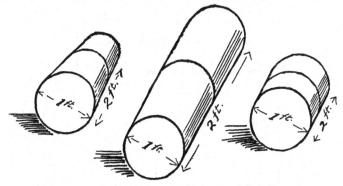

Visual Perspective, Isometric Perspective, and Foreshortening

the bulk of the far part of the object, to resist tapering and retain a sense of the fullness of the form. The same method applies to drawing a lying-down figure or the drawing of the head itself. Mark off the normal proportions on the side that is foreshortened. Resist the size of the projecting features, and increase the width of receding parts.

There is no scientific perspective in Oriental work. The Chinese have a convention that a picture is read from the bottom up. The things in the foreground are nearest the eye, those in the middle of the picture are further away, and those things at the top of the picture are in the distance. In landscapes they look down on the foreground, out at the middle distance, and up at the far distance. Conventions such as these have a lot to do with the power and vitality of Oriental art.

GIST OF ART

The vulgar idea that true perspective is a great and wonderful quality in a picture is a fundamental error. There is no such thing as truth in perspective. Visual fact, the record of a phenomenon, is not truth. This is, I think, obvious when you consider that per-

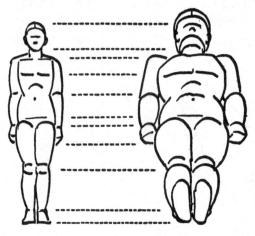

Foreshortening a Figure

spective changes its facts when the observer increases or diminishes his distance from the picture.

Use foreshortening-resist perspective.

Optical Illusions

Optical illusions are of great importance to the artist, particularly the mural painter. In designing a painting to fit in architectural surroundings, lines are greatly influenced by forms outside the picture.

When one plane is superimposed on another, overlaps, there is an illusion of space.

The line symbol of the cube may be seen as a projecting or receding form, solid or hollow, according to its light and shade.

A dark spot on a white surface looks smaller than a white spot

DRAWING

of identical size on a black surface. The sensation of light spreads more than dark.

Two lines the same length will appear of different lengths if arrow-heads are drawn on the ends, pointing in opposite directions.

A straight diagonal drawn back of an upright pole will appear to emerge too high on the far side. This is often corrected in Oriental work.

The actual center of a rectangle appears to be lower than it is.

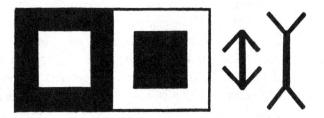

Optical Illusions

That is why we make the lower margin of a picture mat wider to get a satisfactory effect. The capital B is made with the lower loop larger.

When a series of tones are laid side by side, the edge of a light tone appears lighter and the edge of a dark tone darker at the coinciding edges, because of simultaneous contrast.

The effect of yellow seen around a purple spot, known as simultaneous contrast, is an optical illusion. This is a very useful factor in painting, as you can make a color appear brighter than it is by juxtaposing a complementary color.

Design

Composition is based on the law of harmony, the fact that like seeks like. The repetition of lines, forms, tones, and colors is a compelling sign which the eye must follow. Repetition is psychologically pleasing. Contrast is used to emphasize, break up monotony by variation. Contrast and change give a feeling of life, movement, tangibility.

Composition is the coherent organization of forms within a given area. There can be no drawing without composition. Good composition is the result of good thinking: some consideration of major geometrical forms; the balancing of spaces and volumes, lights and darks, lines, textures, and colors.

Design is an engineering problem. The well articulated design has the same unity, proportion, and dynamic structural excitement as a fine bridge. A fine design has scale. It could be reduced in size or enlarged, and still retain its beauty of measure. This is because of the proportion between the large masses, the minor masses, and the details. It is compact, yet spacious and easy to see. It may be comprehended at a glance, and read continuously.

The breadth of decision with which the artist decides on the dominant rhythms of his design should carry through to the selection of the most subordinate detail. The more complicated the forms and the more units in the organization, the more planning is necessary. Without system there is no design.

An artist should be able to take a space of any shape and do something with it. You can learn much about the principles of design from the study of geometry and engineering if you are able to get general ideas without becoming involved in detailed information.

Design is construction; it is also movement, flow.

Two-dimensional design, the silhouetting of light and dark masses, is important. But three-dimensional design, the organization of forms, volumes in space, requires more ability. Many artists should be designing textiles and decorating pottery. Real plastic design isn't the ornamentation of a flat surface, it is dynamic construction. If you haven't the creative impulse to work out your own concept without depending too much on superficial systems of composition, you won't go very far as a painter. Some general instructions to be followed or forgotten:

A good design has stability. It is at rest with itself. Sense the opposition of horizontal and vertical rhythms to the dynamic movement of diagonals and curves. Feel the weight of tones and colors; balance and counter-balance them against line and mass.

The center vertical line is an axis, across and around which the rhythms of the design play. You may emphasize a rising movement by using many verticals and pyramiding diagonals. You may emphasize the horizontal by contrast with the vertical, or by the use of many horizontal rhythms.

Base your design on some simple geometrical shape like the equilateral triangle, parallelogram, zigzag, oval, spiral, and so forth. Sometimes I have used letters like A, T, H, N, and others, in working out a composition; or again, I have taken a motif from an Indian design.

All lines tend to keep on going until they are stopped, or continued in another direction by an opposing line or form. Lines that move out of the picture frame must be balanced or checked by others that bring the eye back into the design. A composition that radiates from the center is hard to control.

The eye tends to come to rest at the center of an area. Any form in the middle of the design will tend to arrest the flow of the composition. A symmetrical balance of forms on either side of the central axis of the design will also check the movement. A long narrow space needs to have two centers of interest, held together by some positive rhythm. Veronese often composed with two pyramidal groups linked by a diagonal.

The eye focuses most easily on light areas. When you draw with darks you are emphasizing the light. Any tone that breaks up the continuity of the light hurts the design. Don't misunderstand this to mean no strong color in the light area.

You may design with positively held lines that bind each unit of form. Or you may see in a more sculptural way, subordinating the contours to dominating plastic rhythms. You may use patterns of local color, or subordinate local color to a large light and shade pattern. Goya designed with black and white pattern, Rembrandt with sculptural relief reinforced by light and shade.

In dividing up the areas of a rectangle, asymmetrical divisions are more interesting than even ones, such as dividing a space into thirds rather than halves.

The proportion between the length and side of a space may add to its fineness of measure. As: 2-3, 4-5, 3-5, 5-8, 5-7, etc.

The repetition of a measure always adds to the beauty of the proportions within the space. In Japanese prints you find this done a great deal. For instance, the short length of the rectangle may be repeated in a division of the long space. Or a smaller measure, such as a third of one side, may be used a number of times in selecting the length of lines or position of forms within the design.

A line at right angles to the diagonal is always fine. Squares hidden in the design are often good.

Parallel diagonals (often concealed in curves) give stability and a feeling of unity to the work.

Most of these plans and rules of composition were found by analysis of fine works and are therefore of some importance.

Space

Spacial recession is signified by the graphic device of superimposing one plane on another, the over-lapping of forms. Repetition of forms on a receding plane increases the sense of spacial movement. For example, a set of poles drawn on the surface of a field. Change in scale of similar forms is another sign that indicates the to and fro of space. Planes leading into the picture at a diagonal to the picture plane increase the sense of depth. Reverse perspective or foreshortening gives greater sense of spacial activity than eyesight perspective, because it is a positive sign for projection. The realization of projecting forms more than receding forms brings about a stereoscopic sensation of space. This is done by the use of tonal intervals, not light and shade imitation of the visual appearance. The use of color recessions gives more power to tone combinations in the black and white scale.

Contrast of texture increases the sense of space, by giving tactile reality, special identity to each form.

If one form is drawn directly above another they will tend to stay in the same plane. This is especially true if they are the same size and the edges touch. If you have one head in back of another, arrange them to overlap so they are not on a vertical line.

If you repeat a background tone or color in the foreground, they may appear to be in the same plane.

Low Relief

A fine composition is like a low relief. If there are houses and people in the foreground, hills and bushes in the middle ground, mountains and sky back of that, there need be only a few inches of modelling between one plane and another. If you look at a Mantegha fresco, you can see that the head of a man in the foreground is only half an inch in front of the mountains that are miles away. The very fact that one thing is superimposed on another is a sign for distance.

Think of the space in your composition as a stage on which no forms may project beyond the proscenium, or picture plane. Plan the dominating spacial rhythms that are to occur, whether they are to run parallel to the picture plane or diagonally into the background. Establish the ground plan. Make it clear that one group of forms is in a certain place in relation to another. Make a place that has front, top, bottom, sides, and back. You may not show a plane to indicate each one of these sides, but think it.

Design with large sculptural planes, chunks of form. Hold things together in groups. Tie the different places in the composition together by forms that pass from one plane to another. It may be done by establishing the surface of the ground with a log or overturned chair; or by the diagonal of a receding wall; or by the gesture of an arm that carries the eye across the space.

If you have forms in the foreground that are cut off by the frame, and not closely related to the objects back of them, they will have a tendency to come out of the picture. This is particularly true if there is a strong change in perspective between the planes. Always hold down the perspective of objects in the front plane.

There should be a harmony of relief in each plane. The sculptural proportions should be unified. If some forms are over-modelled and others held with a very low relief the result is inharmonious, unpleasant. Forms should not project forward of the picture plane, nor holes be cut in the back. Air pockets, atmosphere, destroy the dry sculptural existence of the design.

The form may be sculptured with no more relief than a Giotto, or it may be built as fully as a Rubens or Rembrandt. Both are great. Notice that a Rubens, with all its concern for volumes and spaces, has no air pockets. No forms project in front of the picture plane. The back of the picture is like the backdrop in a theater. The same is true of Tintoretto, Signorelli, Masaccio, all the masters of formal composition.

I like to have a book of Donatello's work around. His bas-reliefs are so full of significant drawing. The painter uses more signs. He can use light and shade to tie planes together, or push them apart. He can use color and pure line. A painting should not look just like a picture of a piece of sculpture.

Composition

Design your page. Don't let things slide casually off the edge of the paper. Establish the large masses of dark and light, the major lines. Fill the whole space. Get the big corners and their modifications so you won't have to put in all the little corners. Establish the big textural planes. Then go after the details that are vital to those plastic statements.

The details must be thoroughly known whether they are put down or not. A master may leave out the details, but you feel that he knows them and could have put them in if he had considered it necessary to his concept. You can't simplify without knowledge. The naïve simplicity in a Rousseau is the work of a child-like mind. A Rembrandt seems simple because it is a powerfully controlled organization, because he had great feeling and vision of the order of things.

A drawing composed of well-developed details never gets over that look. Get hold of a theme, not just a recurrent chord, a lot of little repeats and variations. Make a living organization. Go after the big rhythms not the embellishment of the theme, just as Isadora Duncan, when she danced, followed the big movements and paid little attention to the lesser ornamentation of the music.

A good composition has its light place, its dark place; a serene area, and an exciting area that is the focal point. The vividly realized parts of the design are set off by foils: flat areas against rich textures; straight lines against curves; holes against projections; halftones against animated darks and lights.

An El Greco, with all its nervous excitement and spacial activity, is just as wilfully composed as a Giotto. The solid rhythms are organized, emphasized, subordinated to express movement, and yet the thing as a whole is so stable that no form is out of place. It rises like a flame made of forms twisting and crossing a central axis. But what geometrical understructure; the powerful parallels, the diamonds and pyramids that knit those moving rhythms into a cohesive design unit!

In contrast, the work of Raphael or Poussin is planned with more method, more intellectual procedure. You feel a mathematical order, a severe system in the planning of lines and tones and colors. A system which, when imitated, loses its vigor. In all great compositions you feel this controlling authority. You feel a reserve of power even in the most exciting designs where the organization seems to be expressed to the full. In a fully realized Rembrandt painting or a pen sketch of five lines you feel that the means chosen were completely adequate, and yet something was said that is utterly beyond the limitation of the technique.

Don't think of composition as something you attend to once or twice a week. Be making complete statements all the time you are working. Composing is a continuous and controlling process. Don't think that you design the composition and then attend to filling in the details. The composition keeps right on going until you stop working. When you are filling in the last eyelash you are still composing, I hope. The final changes, lightening a tone here, sharpening an edge there, are changes made because, in your judgment, they improve the composition.

Keep the drawing unified. Do not use one technique in one area, another somewhere else. If you use light and shade the whole composition must be governed by that. If the design is planned in contrasts of tones, built up out of tonal massings, stick to that procedure. Then changes to linear and textural definition will give variety, but they must be carried out through the whole design in a related manner.

Design with textural realization. Emphasize the tangibility of the forms on which attention is to be focused. Get the feeling that some objects are hard, others soft; that some forms are active, others passive. Decide which forms and textures you want to emphasize. Bring out the character and gesture of the dominant forms. Don't let yourself be distracted from your concept by the many facts in nature.

Put down a positive concept. When you have carried through the fundamental relationships of the design, if you need to make changes, do so. Perhaps start all over again. But get an idea and stick to it. Select the quality you want to express and put it across.

It is a difficult problem to solve the influence of small areas on the rest of the canvas. There may be just one repetition too many of a line or tone that will make the whole design seem monotonous. Just one positive dark too many may destroy the sense of delicacy. Avoid habits of casual repetition. A telling touch will be weakened and its usefulness destroyed if it is used just once too often.

If in a drawing, a water color wash is used to say nothingness in one area, you have discounted the use of that tone to make texture in any other part of the picture.

I have seen students' drawings in which an area might be a corner of the Grand Canyon or almost anything but the foot it was supposed to be. Every part of a drawing should be so explicit as to stand alone, and be recognizable for what it is when separated from the rest of the design.

Get the solid geometry of the form. Avoid doughy construction. It destroys the measurements by which you realize the solid. You should know what a cross-section would look like.

If your sculpturing is mealy it will look moth-eaten, like a quilted fog with buttons ever so often. Get some vitality, some significant measures and positive tone changes to work on. A common fault we get into from going in for some of the modern tricks is to fill a picture with little culminations, little kinks, and no main kink.

A drawing full of units of the same size, scattered pell-mell like playing cards, has no coördination. It is hard to see. You go into it one way and have to stop and then try another. It is like a regularly crumpled surface with all the crumples about the same height and no dominating crumple. That kind of design has a decorative quality which belongs on a textile, not in a painting.

If the symbol of ease and the symbol of sculpture have been going together on a canvas, the symbol of ease by itself will carry a suggestion of sculpture.

There are two ways of drawing. You may start with a definite

GIST OF ART

linear statement of the form, and then work up the sculpture with tones and textures. In the work of men like Mantegna and Dürer you feel that the concept was completed in the mind before the artist touched pencil to paper.

On the other hand a man like Renoir would start feeling for the forms with some nebulous tones; a sort of textural description of the place. Then he would begin to catch hold of a corner here, an edge there; the plastic rhythms would emerge from this undertone. More drawing marks and clinching textures; a lightening here, a darker note there, until the forms were brought into thrills of culmination. In Rembrandt the two ways of thinking and working are combined. It is part of his mastery. But always there is a separation of the under-thing and the superimposed color-texture.

Crowds and Places

When you draw a crowd of people in a street or room or landscape, decide whether you want to say that the people dominate the place or that the place is more important than the people.

Think of the crowd as a bulk, a chunk of form that has top and front and back. Get the structure of the whole group as a shape, and then describe the shape by saying that it is composed of people. Study the way Daumier and Rembrandt drew groups and crowds. See how they got the gesture of the group. If you go through their drawings you will find many studies of the same group of people drawn from different positions and in different lighting. They drew the same places over and over again until they got a concept that fully expressed this.

A crowd is a mass, with heads, bodies, arms and legs. In drawing a large crowd eighty out of a hundred heads, arms, and legs are of no importance. Don't go in for melodramatic gestures. People don't act like opera singers. Get the character, the gesture of the crowd.

Use the background as a container for the people. Make it solid.

DRAWING

Get the textures of the buildings and ground and sky. Find some thing to say about the quality of the place, the real atmosphere, the feeling of light and color. Select details that bring out your point of view and suppress facts that interfere with the story.

Look at the character of the forms in a Van Ostade drawing. It may be a sketch of an old barn full of people dancing and eating. You feel the weight of the things, their textures, their relation to the place. How monumental the design is without being dramatic! Just common people in a scene from daily life. No need to draw parades and assassinations to find excitement in life, to cover up casual drawing. That man, Van Ostade, knew his material. He was an observer, appreciative of the things around him.

Look at a Breughel. Notice how he used geometric lines to lead the eye from one group to another. Ever so often there is a cluster of figures where some important lines pass and converge, or an angle turns. Notice how the line that runs through the design may be picked up by a pile of over-turned dishes or a single figure, and then pass across a space into a crowd of people—a sort of interior descriptive line. See how he uses a change in scale from the figures in the foreground to those in the middle distance, as a sign for recession. The ground is held simply as a place on which exist those exciting textures of the people and houses. But above all, how interested he was in everything. Every detail, whether a hand in the foreground or a tiny tree on the horizon, is drawn with understanding and human interest.

John Leech's drawings published in London Punch in the fifties and sixties of the last century deserve careful attention. In line drawing, I rate Leech the peer of any of the greatest masters.

When art students start to make compositions they habitually draw inflated bulbous people all blown up to a proper degree of semi-rotundity. The people in their drawings look like bubbles all over a piecrust. Go out in the street and see how simply the figures exist as textures upon the surroundings.

[79]

In a composition of an interior lit by a number of lamps, the student's tendency is to make the light sources blank white areas. But the sign for light is not carried out through the composition. You need to put in only a few things about the light, a few wellselected shadows, to give the whole area a sense of light. Just as a background has to afford some plastic support to the figures, so you must have some supporting remarks about the light to carry the light from the sources of illumination. Shadows don't help light in a light area: textural realization in the light, opposed to shade—gives real sense of light. The light and shade pattern is a matter of design.

Just because you were looking down from a window at some boys playing in the street, you don't have to draw them from above. It would do you good to project your mind's eye onto the street and draw them from there. If you do draw them from on top, you must know something about the cross-sections of the forms. Consult the work of the great Venetian mural painters. They could draw things from above and below, any position they chose. Observe the wise foreshortening in their work.

When you have a window in the picture through which you can see the scenery outside, don't let the forms float out of the picture. Don't just toss in any old clouds and hills, as though that part were a piece of someone else's picture pasted in back of the window frame.

There are paintings so lacking in composition, they look as if the artist had been throwing a lasso at nature and had corralled a little information, and had sent out another rope and another—all without any complete purpose or idea. The drawing consequently looks as dull as life does sometimes. Why draw the subject if you can't inject some of your own mental activity into the vapidity of nature as you see it? It is foolish to criticize and attempt to correct the little faults in a poor composition. The real fault is the artist's lack of interest, enthusiasm for the subject.

[80]

DRAWING

Purpose

Try to decide why you want to draw. Hamlet and Faust and Algeria were real to Delacroix. He made masterpieces of those subjects. But literary subjects are not to be recommended unless you feel them strongly.

Have a plastic, illustrative point of view about life rather than an artistic one. Draw what you see around you. It may be a corner of your room with a couple of chairs and a cat, or it may be a restaurant full of people that interests you. Make life documents, plastic records about life. Find what is vital, meaningful to you.

I like to see students get the healthy point of view that men like Hogarth and Leech and Cruikshank had. Do illustrations for a while. It won't hurt you. Get out of the art school and studio. Go out into the streets and look at life. Fill your notebooks with drawings of people in subways and at lunch counters. Two women gossiping over a table may be the motif for a picture.

Draw places you have seen from memory. I used to paint things I had glimpsed through windows while riding in the elevated train. Remember the kind of place it was. Get the character of the whole room as well as the human being in it. The sturdiness of a chair, the delicacy of muslin curtains blowing in the window. The tired look of the rug on the floor. The droop of the woman's hand in her lap, the tired folds of her skirt. Get the heat of the room.

Artists find ways to say sound and smell as well as sight and touch. The big artists do.

A sense of humor is not incompatible with being earnest. It gets you over that dull, serious feeling, "Now, I am going to make a composition." To have something humorous to say is a good reason for drawing.

Think of drawing as a way of talking about the things that interest you. The sketches we make in letters are often better than finished paintings because we are not trying to make works of

GIST OF ART

art. You know those wonderful documents, drawings made on scraps of paper by the lesser Dutch masters while they were wandering around market places and sitting in saloons—probably made by men who couldn't read a book.

Criticism and Taste

The trouble with most painters is that they don't start over again often enough. They get an eye or a nose or something else they like, and they don't want to risk losing it. You don't learn much when you work that way because you are just making that happy eye and nose over and over again. Dig into the work. Make a mess of it. Fight with the drawing. Put in everything you know and then eliminate. Make the thing ugly enough to be real.

Draw the same thing over many times. Push the intention through in one drawing or in fifty drawings. I have seen Glackens, that great painter and illustrator, make the same drawing over twenty times because he was never satisfied.

Have a degree of realization that you demand of yourself today. Next month you must ask more because, if you have been working, you will be that much more competent.

If you work along one direction instead of along several, you don't go ahead and so go backwards. Make studies. Make pictures. Make large and small drawings. Work with color. But always keep drawing. Bite off more than you can chew. It keeps you from getting in a rut.

Be sensitive to your mistakes. Observe your work. Put it on the wall for a couple of weeks. It may be that you can learn more from the study of your own work than from others.

Take advantage of where your subconscious mind leads you. Some of the best things in a drawing come unconsciously, intuitively.

Keep an open mind, but not so open that it becomes a dumping ground for everything that comes along.

Avoid things that prevent your sense of criticism from functioning. Melodramatic subject matter and clever visual technique keep the mind from functioning, from being concerned with reality.

One of the main things Henri taught was that the artist and student should be his own critic. If you are dependent on teachers you may lose initiative to judge for yourself.

People of extraordinary taste can't stand their own mistakes. They can't stand their own work while they are learning. They are rendered incompetent by too much critical sense, the wrong kind of critical sense. They are so utterly disgusted with what they do. "Don't look at that," they say; "just wait and see what I am going to do," they imply. These people are apt to find some little way of doing things, with a kind of professional technique. But they can never advance because of their fear of making a messy study.

To most of us it is more important to cultivate the ability to find something good in a work than to find its faults. It is much rarer to have a critical sense in that direction.

Study

Study the masters to learn what they did and how they did it, to find a reason for being a painter yourself. Copy the work of the great masters of form, the men who lived before the camera was invented. Men like Masaccio, Signorelli, Michelangelo, Leonardo, Titian, Rubens, Dürer, El Greco, Daumier, Delacroix, and the others. Find out how they constructed form, how they signified texture and space and light. Find out how they designed—what the process of thought was in building up a composition. Make diagrams in which you explain to yourself how the thing was put together.

Make careful drawings in which you study the articulation of the forms, maybe just an eye or nose or ear. Never copy by imitating the lines and tones, but recreate the thing from the large forms down to the fine delicacy of finish, as it was made by the artist. Sometimes copy a thing that is in tone with line technique, translate it into a different symbol. The important thing is to learn something while you are doing it.

Draw a fine piece of sculpture like Michelangelo's Entombment in Florence. The thing has three or four faces where it is like a drawing. Look at the planes, study them, then draw your analysis of the thing. It is better to make some diagrammatic drawings than a stupid, realistic copy. Perhaps work the thing out in clay. Get the geometric bulk of the thing.

The Chinese students practise for years. They don't stop practising when they become artists. They are always studying, copying the masterpieces of their great traditional art. They practise the symbols of drawing with the brush for years, striving to achieve the greatest meaning with the most economy of means.

Look at the drawings in Hokusai's sketch books. See how vital and significant the line is. You should know his work. You don't need to use his technique to learn something from him.

When Rembrandt's possessions were going to be sold at auction he was working up until the last minute making copies of his Oriental miniatures so he could have some memoranda of them. They are very beautiful drawings in themselves. But you don't see any mannerisms from the study of Oriental work cropping out in Rembrandt. He had a set of Lucas van Leyden engravings which he studied a great deal, but his work is always Rembrandt.

You cannot study music by going out and listening to running brooks and lowing kine. The way to study art is to look at art. See pictures. When someone asked Renoir which he would take if he had to choose between the museum and nature, he chose the museum.

Sometimes you learn more from an unfinished picture. You can see how the artist was working, what he was thinking about. Look at pictures by the lesser masters. You can observe methods that are hidden in the great works. Don't spurn all the works that the experts have labelled as not genuine. If it is good and you can learn something from it, what difference does it make who did it? There is too much fuss over the name of the artist. Nobody knows who built the great cathedrals, who carved the masterpieces of Gothic sculpture. An artist's signature is only a convenient tag for identifying the work.

Nowadays you can have quite a fine collection of color prints to study. Keep them up on the wall to observe in your leisure time. They are good in the large color relations of the design, but remember that they can never have the real technical characteristics of the original.

I suppose you don't really learn anything when you make a good drawing. It is like the flower of a plant. But a flower is just a flower. A new branch is far more important. Don't get discouraged. You are doing the important work when you are studying. There are a few great artists once in a while, the flowers, but they can't get along without the roots and branches. It is the humble root and trunk and branch that carries on the tradition from generation to generation through the centuries. We are just getting ready for the great artist of the century, the Will Shakespeare of our time who will come along and gather up all the material we have been working on. He may be wheeling around Brooklyn in a baby carriage.

Sketch everything. Pass nothing by because you think it is too trivial to observe. It may be exactly what you will try hard to recall from your memory some day.

Work from memory constantly. Store up information about things. Try to draw some place from memory and you will find how little you really know about it. Observe the construction and proportions. Define in your mind what gave special character to each form. When you remember something you make use of the archetype. You compare what you saw with the type concept you have formed. If a man like Dürer wanted to draw a hunchback, he drew his average figure, and then put a hump on it. The artist should have such complete knowledge that he could draw anything in any position. This ability comes through constant observation of nature and practise in drawing from the imagination.

Look at your drawings in a mirror. It gives you a fresh impression of the work. You can see distortions that are not intended, places in the composition that do not work.

When I have students in my class who have been trained in eyesight drawing and who have too much facility, I recommend that they draw with the left hand. By crippling themselves in this way, they are able to concentrate on the problem of expressing the real form, unhampered by their acquired dexterity.

Carry a notebook with you and make drawings that will be useful for your painting—informatory drawings—maybe the gesture of a couple of hands. The action of people walking down the street; feet in a trolley car; mail-boxes and street lamps; a pile of dishes on a table; the sleeve of a coat hung over a chair; all these are details, studies you should save as material for making pictures. Most important of all is to observe while you are drawing, so that you enrich your memory. Soon you will not need to refer to your sketches.

Such training is essential to the illustrator and, after all, there is an element of illustration in all great art. The work of Daumier, Rembrandt, all the great religious paintings—they were all illustrations.

CHAPTER VI

FIGURE DRAWING

IN GREAT WORKS OF ART the human figure has been the point of departure for an exciting, beautiful design; the motive for plastic design. At least, that is how it seems to me.

Works of art are made of wood and bronze and oil paint, not flesh and blood. I don't like a nude that looks too much like human flesh. I think it might better have a dry, hard look, be sculptured with color-textures like a piece of bronze.

A good figure drawing is a "living wooden image." I sometimes tell students to make wooden Indians rather than to imitate the visual realism of flesh.

Most of the pictures of nudes which people hang in their homes are pornographic. Perhaps this is why so few people buy them.

The important thing to bear in mind while drawing the figure is that the model is a human being, that it is alive, that it exists there on the stand. Look on the model with respect, appreciate his or her humanity. Be very humble before that human being. Be filled with wonder at its reality and life. There is a human creature that lives and breathes and feels, a thing with a mind and character of its own—not a patchwork of light and shadow, color shapes.

Sometimes when I come into the classroom I look at the model and see that she is shivering with cold or suffering in some difficult pose she is trying to hold too long. You look up at her and back at the paper, tick-tock, back and forth—all you are looking for is some detail of the appearance of the figure.

Be kind to human beings. Don't make caricatures. It is easy

GIST OF ART

enough to be cruel. Find the worthwhile things first. Get the gravity, the strength, the repose of the model. We all have faults—some we were born with—we must try to think graciously of faults in others. You cannot be too human, but do not be sentimental. Be yourself.

The reason Rembrandt and Daumier were greater artists than some others is that they were more human. If you think of a human being when drawing from the figure, you will make much finer drawings.

Try to get some personal point of view into your figure drawing. Anatomical perfection isn't exciting. A thorough working knowledge of anatomy is useful in helping you to realize the human figure. Do some dissection if you like, but remember that you are learning facts.

We should know enough about the figure and have sufficient command over the graphic tools to be able to "write in the figure"; to be able to draw the figure in fifteen or twenty minutes as easily as a writer could tell you that there is someone standing on the model-stand in a certain position.

Get a general sense of the human figure by drawing from life and from memory. Find a practical understanding of the average human figure. Seek an adequate symbol for the figure, its construction and proportions. From this concept in your memory, you can draw special figures, with different proportions of measures and volumes that are the basis of variations in character.

It might be well for the student of drawing to take up sculpture for a while to get a sense of the complete figure, the solid construction of the body. It certainly would be good for sculptors to draw more. Most sculpture is a kind of bad drawing over which you can stumble in the dark.

Study the master draughtsmen and sculptors, from Giotto and Donatello to Delacroix and Barye. Their work has almost no concern with what the figure looks like. Each man had a formula for what the figure is. They differ in proportion and interpretation of structure. Study the work of many artists to learn what they thought about the figure and how they said it.

Accuracy of anatomical fact is not essential. I guess Giotto didn't have an anatomy book, but he had structural understanding. A man like Blake did not hesitate to make up his own anatomy. He is like a man who learns Spencerian penmanship and then writes in his own hand.

Anatomy

Anatomy is the study of the structure of the body. The principles of construction are the same in dog, horse, human. But anatomy is not the study of learning how to draw a certain joint in a certain position—as taught in most artists' anatomy books. Use a surgeon's anatomy, or Fritz Schider's *Plastisch-Anatomischer Handatlas*.*

Demonstrations of building the muscles on the skeleton with clay are very valuable. This is done in most medical colleges and some art schools. Thomas Anshutz used to do it at the Pennsylvania Academy. He and Eakins were real students of anatomy. They did a great deal of dissection. The trouble with dissection is that you work from the superficial muscles to the most important ones. When you see the figure built up in clay by a good lecturer, you get a better sense of plastic structure and function.

You have to know about the interior construction of the bones and muscles that support the figure. In the drawing it is only necessary to show the muscles that make important changes on the surface forms. The point is to have a sound knowledge of construction and function so you could draw the figure without the model.

The more anatomy you know and the less your work shows it the better. If a knowledge of anatomy is all your drawing shows it might just as well be a sheet of paper covered with chemistry symbols. Don't let anatomy ride you, correct it by humanness.

^{*}English translation, An Atlas of Anatomy for Artists, reprinted by Dover, 1954 and 1957.

GIST OF ART

Proportions

In starting to study it is more important to learn the average construction and proportions rather than the particular. It would be well if an art student could spend some time sorting out bones to learn their proportions and character; to gain a sense of the size of the head to the hand and foot; the lengths of arms and legs; the sizes and articulation of joints.

The height of the figure is roughly the same as the distance from fingertip to fingertip when the arms are outspread. The middle of the normal figure is at the junction of the pubic bones.

The head is contained in the average figure about seven times. The Greeks often used the proportion of eight heads to the body which lends a fine sensitivity to their work.

The foot is about the same length as the height of the head. The hand is about the size of the face.

The eyes are set in the middle of the head. If this proportion is changed it is very noticeable. From the chin to the nose, the bottom of the nose to the eyes, and from the eyes to the top of the forehead, are generally equal. The ears are usually the same size as the nose. Notice the unpleasantness of a very small ear.

From the apex of the chin to the outside of the eyesockets can generally be set in an equilateral triangle. By wilfully disturbing this you can change the apparent size of the head and determine the type of face.

It is possible that a very fine sense of proportion is all that an artist needs in the way of taste: Like knowing whether the distance from the lower lip to the nostril is longer than from the nostril to the eye. A fineness of measures in the two-dimensional proportions is important, but plastic proportions, the quality of volumes, is much harder to get hold of.

No great work of art ever contained accurate dimensions. There are no sure rules for fine proportions. Every work of art has its

FIGURE DRAWING

own wilful, harmonious measures. El Greco may have distorted the normal proportions of the figure, but he carried out his point of view all through the forms in the design.

We study the human figure because it has fine proportions, beauty of construction and probably because we are human. We may decide to paint landscapes, still lifes or animals, but we find the greatest understanding of beauty of form and proportion from the study of the human figure.

Anatomical Facts (to be remembered, if possible)

The spine is the axis of the bony structure, to which are attached the rib cage and the pelvis. The neck is set in the middle of the shoulders, no matter how it may look in perspective. The bilateral construction of the body is important to remember when you see visual distortions. Both arms and both legs are the same size. The features, eyes, ears, on opposite sides of the face are the same size.

Study the bones and the joints. Build the figure from the skeleton out, with those muscular supports which vitally interest you in the action of the pose.

Learn the shape of the rib cage; the set of the pelvis, its function as a supporting base to the contents of the torso. Notice which parts of the spine are movable and why: stiff where it becomes part of the pelvis, free in the lumbar region, stiff where the rib cage is attached, and then movable in the neck. See how the head is set on top of the spinal column with a kind of swivel joint.

Learn how the hip joint fits into the pelvis. Study the model when he is standing on one leg and again with the weight on both legs. The hip joint is a ball and socket joint, similar to the shoulder. Study its rotation.

Learn how the clavicle and scapula function; see how the arms are hung onto the body. Find out how the radius and ulna rotate. Draw the wrist joint, the bony mass of the hand, the delicate joints of the fingers. Get into the joints. You can't know too much about anatomical construction so long as you are master of the knowledge. Don't be overwhelmed by the facts. They are tools, sources of information you draw on to express something you want to say about life.

The knee is a joint. If you were a clever mechanic you could build one, take it apart and put it together again. Draw to say that you understand how the thing works.

The foot is built like a bridge; it has a function, to support the figure. It is made of bones and joints and tendons, not putty. The toes are the consequence of the muscular outfit of the feet. If the toes look as though you had counted them in your drawing there are sure to be too many.

Draw the skull. Really study it. Know it from the front and back and top and bottom. Go to a Natural History museum and study the skulls of different races. See the difference between oriental and occidental faces; it is in the skull.

Look for the structural continuity in the figure. The bones are the support to the muscular system; they do not support the weight of the body. The body is held upright by the tension and balancing of opposing groups of muscles.

Every time the position of the body is changed, there is a redistribution of weights to keep the figure in equilibrium. For instance, when the weight is on one hip the opposite shoulder is raised and the spine is curved in the lumbar region to accomodate the asymmetrical balance of rib cage and pelvis. The figure is a series of weights balanced around a central axis. When the figure is resting at ease on one leg, the back of the neck is always on a vertical line with the arch of the foot bearing the weight.

Study the balancing of weights as the model walks around the room, the opposite arm thrown forward to the leg in advance. The body keeps composing itself.

Drawing is a matter of articulation. You can learn a lot about it from the study of the human body. Notice the opposition of ver-

FIGURE DRAWING

tical and horizontal forms, the branching of arms and legs from the torso, the fitting of solid into solid at the joints. Look at the sequence of forms, as the fullness of the forearm tapers to the wrist, and the spread of the hand into fingers.

Study the big muscular forms. Learn the more important ones first and don't try to concern yourself with modifying actions until you have grasped the fundamental ones. Think of the muscles as groups of contracting and expanding rubber bands. Notice how they act as levers with the bones for fulcrums.

Find the function of each great muscular system. See the way the arm is attached to the trunk by muscles, from the neck all the way down the spinal column in back and to the rib cage in front, as well as by the bony joint of the clavicle. Almost all the muscles of the trunk belong to the arm. The long supporting muscles of the torso hold the body erect, and pull it forward, back, and sideways. Study the fan-shaped attachment to the pelvis of the leg muscles that swing the body and legs in walking.

Get the attachment of the hamstrings to the condyles of the knee; the tension of the Achilles tendon. All the muscles of the calf belong to the foot. The bones and pads and muscles of the foot are arranged as shock absorbers, to keep the body in equilibrium when in action, and to hold the weight. Notice which muscles show on the surface when the foot is flexed, extended, rotated. Learn those little things such as which side of the ankle joint is higher.

Solve the leg. Curves are the result of structure. The curve of the leg is just the outside edge of the bony support and its superstructure. If you know anything real about anatomy, about the skeleton, and the continuous organization of the muscles, you won't draw the figure with a lot of bulbous curves. If you don't want to use your mind enough to learn about the structure of the human figure, or if you haven't got that kind of a mind, draw something else. Or if you must draw the figure, think of it as a series of cubes. It is better to think of it as a series of cubes modified into cylinders than to think of it as cylinders first.

Study the bones of the hand, the bony mass that makes the curve and shape of the palm. Draw the bones of the fingers; get familiar with the character of the joints. Think about the wrist. Find a sign to say that the arm joins the hand at this point. Never mind if it doesn't join your way in the anatomy book, make a joint. Make a wooden joint first and after a while you will learn how to make a more complicated living drawing. Leave out the little bumps and dimples and hollows until they mean real structure to you. When you know more about anatomy you can draw the construction of the wrist from the inside out. And then when that knowledge has become part of your subconscious equipment, you will be drawing the wrist without thinking about how you are making it.

Don't just bat out four fingers and any old thumb. Some hands are square, others like flames. Fingers may be blunt, curved, angular. The hand is a very human thing, like a little animal. It can tell a great deal about the person. There are working hands and delicate hands. Each finger is different, even the fingernails have a characterful shape of their own. The form and curved plane of the fingernail belongs to a particular finger. You may draw the whole finger with two lines, but you must have sensed its complete structure. Even if a hand is fat draw it firmly. Find something to say that will give it the texture of a human thing.

The head is first of all a cylinder, set on the column of the neck. Think of the nose as a pyramid or half a cone. The mouth is the surface texture of a large form, a truncated cone that passes into and under the cheekbones following the line of the jaw; the jaw, a triangular bone with upright wings attached under the cheekbones. This is the only free joint of the head except where the skull is attached to the spine.

Study the big shape of the skull. The curve of the back of the

FIGURE DRAWING

cranium. See how the forehead moves into the temples and joins the brows. The eyes are two spheres set in the eyesockets. Learn the articulation of the muscles at the back of the neck and those which attach the head to the clavicle. Notice how the shape of the neck changes when the head is twisted. Study the big trapezius muscle that is attached to the back of the skull, the scapula, and the spine. Get the muscular formation of the jawbone, watch it while someone is eating or singing.

The features don't make holes in the skull. They happen very simply. They are the natural consequences of the structure of the head. The face is just part of the big plastic form of the head. Think of the features as textures on the surface of a cube. They may be very complicated, but keep them subordinate to the head itself; keep the low relief concept plain.

The eyes are set deeper beneath the brow in men than in women. The male skeleton is more angular than the female.

I solemnly swear that all the above facts are useful to the artist. I also depose that they are better relegated to the sub-conscious, after serious study and practise.

The Pose

Pose the model so you can see the sculptural geometry of the figure. In class you should have a variety of standing, sitting, and lying-down poses so that you can become familiar with the structure of the body in different positions.

North light is best to work in because it shows up the serene structure of the forms with a minimum of accidental shadows. Remember, however, that the light and shadow shapes you see are not the thing itself. If the model were surrounded by equally strong light on all sides above and below, no shadows would be visible. The model would still be there to draw.

If there were some way of having the model-stand turn around or else to have light move around the figure, you could see that the shadows are not part of the figure, but only lie on it. If the stand turned around, you would have to form a mental image of the whole pose, and then decide on one view that you wished to draw.

Most students can't tell you what pose the model has been holding in the last half hour because they have been so concerned with the way she looked. Understand the pose. Take the position, yourself. Walk around the model and see what is happening on the side you can't see.

Find some line of gesture, some plastic ridge in the pose that interests you. Have an architectural, dynamic reason for drawing.

Draw the figure as a set of blocks jointed together. Get the axis of the pose, the balance of weights. Get the character of the big proportions. Make a drawing a day that way for months.

Think of the figure as a column, a solid octagon. It has a front face, sides, and the sides that pass around out of sight, and a back. It has a top and bottom. It has weight, it stands on the ground.

Get into the pose. Feel the strain of muscles. Don't take it so easy. You should feel as tired as the model is when you are through working. Get the relation of the supporting leg to the spine and pelvis, the shoulders and head. Draw the neck in the middle of the shoulders, even in the profile view. Make both legs and feet the same size even when one is far away from you.

Think of the figure as a solid, a modified column of bulk, surrounded by light. Set it up on the model-stand like a monument. Get the rise and positive gesture of the pose. Carve it from that upright cylinder you have established on the paper.

Pretend sometimes that the model is a bunch of sticks, and bend it into different positions and groupings.

The big design of the body is texture. The muscular sculpturings, features of the face, fingers, toes, breasts, are just minor textures. Support the plastic existence of the figure by finding some spacial recessions that interest you in the background. Per-

FIGURE DRAWING

haps begin by putting in the corner of the model-stand, then a few marks for the floor to give the stand a place to be. Then the back edge of the stand and the walls rising and passing back of that. Don't make holes back of the figure; find "thereness," make plastic comments about some corners in the background. Corners, projections, recessions, that will support the figure.

Get the floor there. Establish the plane and then give it surface, texture. Do it with the boards, do it with the smudges of paint on it, do it with a shadow, if you wish, but get it there. Put in a box or a pair of shoes to give it place and interest. Make it say floor, something that furniture can rest on.

At times add something to the pose that will give it more the look of everyday life than the art-school-pose-look. Put in the corner of a bed or some furniture or part of a room. Be making pictures and compositions; add something to the pose beside those miserable draperies hung on the screen. Use your imagination. Make a place. Put in something to tell a story.

Instead of the regular model-stands I like to have a set of boxes that can be arranged in different heights; also some pads so you can have all kinds of lying-down and semi-recumbent poses. A set of steps is good for action poses.

It would be desirable to have two models posing in the class room. One holding an all week pose, the other taking short poses. You can't make much of a drawing in less than ten minutes, but action poses are good to study from. If the model has had some training in dancing you can have short poses that are arranged in sequence to show how the body works in action.

In these action poses look at the model for at least a minute before starting to draw. Draw a diagram of the action. Get the swing of the spine, the muscles that are essential to the position. Perhaps you may not draw at all. Just as well, if you are really comprehending the pose.

Turn the thing into geometric action. Draw it as strongly as

you think it. Don't just map the directions of lines, saying, in the case of a twisting pose, "Now, let me see. One leg comes out half way down the arm and the other comes out of the wrist." Draw as though you felt the shapes like a sculptor. Some drawings of the body in contorted positions seem to say, "Isn't it remarkable how little like a human being a human being looks in this position!" *Explain* the three-dimensional structure.

Have The Courage of Your Convictions

Look for a reason to draw when you are making a study. Don't creep up on the drawing as though you were going to poison it. If you can't help yourself, make it bad, but learn something. It is not what you draw that counts, but what you learn, what you add to your subconscious equipment. Any drawing is worthwhile which teaches you something while you are making it; because you observe nature and practise with the graphic tools.

Never mind if it isn't the right form, the shape that you would like to be able to make some day, but make it realized. Make it positive. Define it surely. Then you can see where it is wrong. You can carve into it. If your definition is timid how can you know whether it is good or bad?

Don't get into an easy habit of dashing off smart looking sketches. Drawing is the ability to put down on paper the thing your mind desires to express. It is not putting down the "right" line, for no such thing exists. It is putting down the line of your mental intention. A drawing is a document. It tells what you thought, what you knew and felt about the subject. If a drawing has only one good quality it is worthwhile. The problem is to get a dominant theme of realization all the way through, to establish a critical basis for correcting minor faults.

A good drawing shows that the artist had an easy familiarity with the forms. It has a quiet, serene condition that I call "the art life." After you have that you lose your dependence on the facts in nature. Until you wake up the creative spark, the impulses all come from the subject. Keep your serenity when the full vitality of the picture is nearly reached. Get the excitement and keep the excitement, but let your execution be controlled. The mind finds what the heart feels and calmly dictates it to the hand.

Plan what you are going to say, and then work with no hesitation, as though you had an etching needle in your hand. Don't use the eraser until you have to. Correct a poor line with a more positive one. Don't fuss around timidly.

It takes more knowledge and more vision to keep the livingness in a drawing worked on for three hours than in one made in twenty minutes. One of the things that makes an artist is the ability to work more slowly and still keep the look of impulse. Most good drawings are a combination of speed and advance calculation.

Slow drawings that are worked on by the week become drudgery and look tired and old. Put in the major darks and lights at the same time that you swing in the line structure. Work all over the paper and do not stop to fill in details until you have the whole design established. Keep the lines and tones working together or you will lose unity.

Take a point of view about the subject. Decide what to put in and what to leave out. If you were to put in all the facts you see in nature, even accurately, it wouldn't be worthwhile. It wouldn't be art or truth.

Train yourself to use memory and imagination, or your drawing will show that the model and not your spirit dominated the idea. Memory drawing helps to give one a realization of the Thing. The only trouble with it is that one tends to draw the way someone else did. One loses the impulse from nature and draws with too much formula.

On the other hand it is the figure on your canvas that matters. Your drawing will be judged by it. Remember that, when you are over-worried about likeness. After you have arrived at what you want in one area of the canvas, the model is only there to go back to as a source of stimulation. The canvas is now more important.

Have a special prejudice about the composition of the figure that you can carry through to the completion of the drawing. If it is a neutral pose, decide whether you want it to rise or to spread out.

Pick out some forms that are characteristic of the figure. If the pose builds up in a triangle, look for triangles and pyramids and cones in the figure. Have some plan in seeing the forms.

Leonardo, Ingres, and Delacroix built their forms within ovals and cylinders. They had a plan of beauty which they followed in the selection of lines. Rubens' treatise on drawing says that all forms are contained within squares, triangles, and circles. In your analysis of things it is a matter of personal selection which forms you decide shall be fundamental. Dürer sometimes used cubes or cylinders. He made many interesting experiments in cubism, others on laws of numerical proportion. The Italians were constantly concerned with theories of beauty based on geometrical plans. When a man is a great master this interest in mathematics serves to discipline his thought rather than to devitalize it.

Be sure that you approach the drawing of the figure and the accessories with the same attitude. Keep one tempo all through the drawing. If you get the surroundings too complicated the drawing won't be able to speak, it will stutter. Find some areas in repose, some simple spaces. This doesn't mean to let go of the sense of existence in the background, but let it be a foil for the figure.

Some figures seem to have round tops, you go right over them into space. Realization has something to do with establishing and defining the thing, stopping it and defining the space around it. You have to keep control over the spaces, keep them in touch with the plastic relief you have set up. An air pocket, real space, does not belong in the order of realization of which art is made. Concern yourself with the body as a thing in action that you understand. The figure should be well-knit. Go after form, not

the minor flats and rounds, but the significant planes. Go after continuity, rhythm. Emphasize bones, grooves, posture. Clarify the planes. Get the geometric rhythms of the figure without letting them interfere with the human pulse of the thing. Then find a few muscular moments to chat about. Don't try to put in every muscle. The drawing won't exist. Say one or two human things about the figure that will bring the drawing to life.

If you want to bring a knee forward, do it with a sign: maybe by putting a dark in back of it; perhaps by putting a culminating dark on the front of the knee. Draw it forward. Invent a way to say projection. But you can't make the knee come forward unless the whole figure has bulk and existence to support the plastic corner of the leg.

Find some textural turn to make a culmination in the drawing. Feel something about the vitality of that corner projecting toward you that will make it possible for you to describe it even more strongly on your paper than it exists in nature. Find a texture-symbol to say projection.

Even if you can't see the other arm, you must know what it is doing and you must make us know what it is doing.

Note the plastic texture of the figure. Something that looks as though it were made of steel wool or clock springs mashed together is just an art school technical trick. Get the difference between bone and fat and muscle. Get a dominant fleshy texture to run through the whole drawing of the figure. Don't make the same kind of texture on the drapery and furniture as on the figure.

Don't linoleumize your work. Let the surfaces have vitality, the homely tremor of life. Let some free nebulous tones work under the culminating textural activity. Don't polish it up like a hardboiled egg. Get some nervousness into the texture surfaces. This

[101]

doesn't mean to make them haphazard, but get some livingness into them. Live art is what you want to make.

Be a little afraid of using the side of the lithograph crayon too much, for fear of becoming one of the "eggshell" school of drawing, that rounded oval cult which quite mechanically rounds off every object. I prefer to see you make a drawing that is tull of corners, kinks.

Get some nerve into the line. When the describing line is always of one width the result is dull and furniture-like. The hands and legs partake of the nature of furniture instead of being human members.

Sometimes the outline looks like the edge of a very good drawing that has been cut out of a piece of paper. And then very stupid sculpturing goes on inside of that line.

You may place the drawing with some light, nebulous lines, but avoid the vagueness of a searching outer edge. Don't look too much for where the leg is going to be, look for what the leg is and what it is doing. Define the edge of it with lines, if you wish. If you are sculpturing with lines or tones that is no excuse for a careless containing line.

An outline drawing must have a sculpturesque point of view. Sometimes, after you have been making a labored, texture-covered drawing, lay a piece of tracing paper over it, and translate it into line. Do not trace the edges but make the drawing over many times until the line concept is complete. Look out for the wiry outline, the cracker-like edge. Make it a life-line, a clumsy, living thing. Look at the work of Daumier. See how his line defines and describes, how it flows—nothing casual about it. Then there is Ingres, master of an exact line that is vital, significant.

When you can make a fairly adequate figure, start digging into the separate parts of the body, making special studies, thorough drawings of them. Make hands and feet as well as the head and torso. Perhaps draw one part of the leg in action, or study a foot

FIGURE DRAWING

that is gripping the floor. Draw the head from underneath or from the top. Be familiar with the forms in all positions.

Sometimes change from line technique to brush and wash; change your tool from the pen to charcoal or lithograph crayon. At other times use paint. Tempera is good to study with because it has a dry, sculptural quality. The advantage of paint is that you can draw light into dark as well as dark on light. This can be done in charcoal by using a kneaded rubber, but not so freely.

Make things and not appearances. Think arm—think of the inside, how it is made. Construct the arm in your mind. Form the idea, arm, in your mind and then play with it. Imagine the arm in different positions. Turn it over in your mind. See it with the elbow flexed, or the fist clenched. Go through all the possible actions of the hand, see what happens to the muscles of the forearm and upper arm. Study your own arm in the mirror. Never mind how many muscles make an action or what their names are, but get a feeling for the mechanics of the action. Have an innate sense of the contraction that has to occur at the elbow when the forearm and hand are pulled up to the shoulder.

After you get the idea, arm, in your mind start to think of different kinds of arms. When you have nothing to do for a few minutes, get in the habit of running through your knowledge of things. Imagine a whole set of arms: bony ones, muscular ones; firm arms, arms that are quiet. Then set them in action.

Have that kind of knowledge of the whole human figure. Be able to play with your general idea of the human body, to modify it at will. Having an idea of the geometric scheme of the human frame, be able to visualize it in different measures. Be able to dress it up with a muscular and fatty tissue make-up that is in keeping with the skeleton you are thinking about.

It is this kind of knowledge that Daumier was referring to when he said, "If you show me an ear I will draw you the head."

GIST OF ART

The Clothed Figure

A clothed human being has just as much life as a nude. You don't have to make it look as though it were a nude showing through clothes. No muscular information comes through a heavy suit of clothes, only the big masses of the form show. Don't forget that the folds and wrinkles are very small details compared to the big plastic bulk. Subordinate them to the design of the whole figure.

In drawing drapery, notice that the cloth lies flat on the point of contact with the form underneath. You see the shape of the under-form there. The folds run from one point of contact to another, falling free or taut. You must understand the purpose of the fold, how it follows the gesture. Study the system the folds work on, diagram them. Find out how different materials fall and crease, angularly, softly, crisply.

Avoid clever little quirks, dinky folds. Just use those wrinkles which explain the solid action of the figure. Leave some out, and put in others where they will explain the gesture. Try not to let your concern with the folds labor the work.

Make many thorough drawings of the clothed model. Charles Keene's drawings in *Punch* may be studied. Make studies of cloth draped over chairs, and other things. Learn how to draw a dress falling over the bent knee. Notice how you can see the form of the leg along the thigh and calf, how the trouser hangs loose with points of contact.

If you are drawing a foreshortened drapery as over a projecting knee, put more wrinkles near the front. Put the small wrinkles near the front, and larger ones on the far side. It adds to the realization of the bulk by resisting perspective. The same is true of drawing a striped suit. Make the stripes on the near side of the form smaller and closer together and more bitter than those on the far side. Emphasize tangibility on the front corners.

FIGURE DRAWING

Study the model in action poses. Make sketches in restaurants and on the street. Get the character of clothes, the hang of a coat that has been worn.

Draw shoes and gloves, hats, overcoats. Find out how a collar moves around the neck. Make your people belong in the clothes.

Shoes seem to be one of the hardest things for the art student to draw. Or are they too easy? At any rate students are seldom able to draw a shoe so it doesn't look like a magazine advertisement. Draw the sole of the shoe first and then construct the foot or shoe on top of it. A foot is just a modified pyramid set into a cylinder, the ankle. Get the form first, then its character.

Character and Portraiture

The essential reason why one head differs from another is a matter of proportion. That is why we know one friend from another on the street, even from the back.

In drawing, you may get the two-dimensional proportions accurately, but when you work with volumes, some of these change.

It is inconceivable that a great artist should paint a likenesslikeness in the cold, hard sense.

Portraiture has something to do with plastic proportions, a sculptural feeling for the understructure of the head. Something so simple and so deep that the greatest portrait in the world would only come near being a portrait. John Butler Yeats, who painted the best British portraits of the Nineteenth Century, said, "a perfect portrait is an embodied dream of the sitter."

Lots of people think the mystery in a Rembrandt is in his philosophy, that he was a great psychologist. But that isn't it. It is the great realization that makes his things so mysterious.

A good portrait keeps going right on through the neck and shoulders and the way the folds occur on the sleeves. It is a great plastic gesture that passes through the bulk of the figure and the arms and hands, and culminates in the head. Character is just as much a motive for creating a work of art as it ever was. But it should not be the kind of sentimental, visual realism artists were trying for in the Nineties.

Mild caricature of the face defeats the purpose of caricature itself. Characterization of the moment is nothing. Real character runs all the way from fine caricature to the delicacy and grandeur of a great portrait—from Rowlandson to Rembrandt.

When you look at the sitter, first observe the average human proportions, and then look for modifications peculiar to the individual. Decide whether you want to bring out those characteristics by under-statement or emphasis. When the selection is well made the result is beauty and not just character.

Distortion is sometimes an interesting motive. Exaggeration is another matter. It is falsifying fact, and increasing the importance of fact at the expense of truth. Cheap and offensive.

Try to see the model in a new way when you sit down to draw. I don't mean, to see a new species of animal, but find something fresh to say. Make a drawing with a different flavor. Make some that are ugly, others handsome. Make them healthy, sensitive, powerful. Go deep into the character and find noble proportions in the structure. Use only those details and facts that will contribute to the realization of your concept.

Be kind to people. They wouldn't be alive if they were not fit to live. People are funny enough without our being cruel to them. Some think Daumier was a caricaturist, a satirist, but he was never cruel. His people may look like elephants or earthworms, but exaggerated as they may be they are three times as human as people could ever be. They all belong to the same human family. The same thing is true of Rembrandt's portraits. They are all family portraits, pictures of himself. He was finding himself. If you go deep enough into life you find yourself.

Students find it hard to create on a portrait because they are so concerned with superficial likeness that they are afraid to use their

FIGURE DRAWING

imagination. You must find something that strikes you about the person; put it down as your point of view. Find something that is a dominant plastic gesture: the impulse of the forehead; the "forward to the nose" concept; the set of the eyes in relation to the cheekbones that may show the special character of the individual.

Beauty is not the only thing that inspires the real artist. Some people are so ugly that they are interesting. Take a sculptured portrait by Despiau or Epstein. Every four inches there is an ugliness that no portrait painter would dare put in, but the whole thing is beautiful.

Daumier worked from the skull outward. In his drawings, he searched around until he found the general shape of the head; next he decided what emphasis he wanted to place on the proportions; then he clinched his idea of the person. You don't have to do it that way. You may come to the subject with a preconceived idea of the proportions you are going to use.

Do not make the forehead a mere blend of three or four tones. The fact that they blend keeps it from being a solid. Think of the cubic structure of the form, think of the bones that lie under the skin. Draw the forehead through the temples and join it into the bridge of the nose and the angle of the cheekbones. Draw the big shape of the head and then let the hair grow on it delicately at the edges. The hair doesn't burst out like porcupine bristles.

Look out for magazine-cover hair, slimy, oozing tones with greasy highlights. Make the hair a shape that has weight and texture. Then make it soft with a few well selected comments. They may be a softening of edges at the forehead and around the contour of the head, a few delicate lines here and there.

Never make the shadow under the neck as dark as it looks. The cast shadow painted by most portrait painters looks like a hammock slung under the chin. As for the highlights which are the stock in trade of such "professional painters," the last refuge of

[107]

GIST OF ART

an empty mind-I am too much in earnest at this moment to joke about them.

The artist does not see both eyes alike. There is always "the eye" and the other eye. But you shouldn't know that he felt that while he was working. It adds life and plasticity to the drawing if the eye in the light is darker than the one in the shadow. It gives the head vividness. The eyebrow is the last thing. It is just a color and texture accident, happening on the edge of the eyesocket.

Look at the grand design in a Rembrandt portrait. Nothing theatrical about it, nothing grandiose. Just his serving girl standing in the window with one hand resting on the sill and the other on the wall. How grave and rich and human it is. The simple folds of her dress, the hang of the sleeves. The indication of some lace. The texture of hair and flesh and cloth. A bit of ribbon used to describe the neck and shoulders. With what humanity he painted not only that humble human head and hands, but the place. Painted with such understanding that the girl has nobility. Painted and recorded a mental reality no eye could see.

CHAPTER VII

PAINTING

PAINTING IS DRAWING, with the additional means of color. Painting without drawing is just "coloriness," color excitement. To think of color for color's sake is like thinking of sound for sound's sake. Who ever heard of a musician who was passionately fond of B flat? Color is like music. The palette is an instrument that can be orchestrated to build form.

I am interested in the use of colored tones to build solids and as an added means to composition. The great painters separated form and color as a means to realization. They did it by underpainting the form in semi-neutral colors and bringing that sculptured low relief into plastic existence by superimposed color glazes.

A painting may be a thing, the sculpture of the thing, or it may also have color-texture. The painting that has only color has nothing; the painting that has only sculpture has a great deal. A Persian miniature has handsome color, color used to emphasize the design and texture of two-dimensional forms. A Masaccio fresco has little color quality, but tremendous form. A Rembrandt, a Titian, a Rubens, has great form and color-plastic realization.

Drawing is more abstract than painting because line is more abstract than color. It is difficult to retain significant drawing when we use color because we have the means to imitate what we see in nature. We forget to use color as a sign in the same way that we use black and white as a graphic symbol in building form.

Chase used to say, "See it in paint." I beg to differ. He and Sargent belonged to the school that saw nature as active oil paint. But you must learn how to transcribe your graphic thoughts into

[109]

the medium of color and paint. The craftsmanship of handling paint and the complications of the additional color symbols make a good painting much more difficult to achieve than a good drawing. It takes a great deal of discipline to see your way through the process of building up a picture from the first rough lines to the final result. There are many procedures and formulas, from which you must work out the one best suited to your temperament. There are many things you must know about your pigments and vehicles in order to get the qualities you want, and to make a painting that will be permanent. It is part of a painter's job to know his craft. Whether his own works endure may be of little importance, but he should carry on the tradition of good craftsmanship for others.

There are many kinds of good painting, but one thing is true of them all: it is the power of drawing which makes a painting great. Carpaccio, Bellini, Veronese, Breughel, Rembrandt, Delacroix, and all the others were great painters because they were draughtsmen.

It is a bad idea to have one painter, say Rubens, as your ideal in painting. You become convinced that there is only one way to paint and shut yourself off from learning things from the other masters.

Find your own technique. Form your own color concept of things in nature. I have no rules for fine color to give you. There are some facts about the craft of painting and the use of the palette which may prove helpful to you. The important thing is to keep on drawing when you start to paint. Never graduate from drawing.

Form and Color

I think of a good painting as being a colored low relief with no air pockets. First there is the formative under-substance, the shape of the form that the blind man knows through the sense of touch. This is made with the neutral half-tones that carry the sculpture of the form. Clench your fist and bear down on it with the other hand. That solidness, that bulk, must be created on the canvas. It should be sculptured, not modelled. It may be done with two or three tones, or with three hundred.

This under-substance is given realization by super-imposed color textures, force colors. Look at the skin on the hand: not just the color of it but the tactile indications of freckles and veins and wrinkles. See the way the blood flows quickly and slowly. There is the life you must force into your painting with significant colortexture. Use the whole gamut of the palette if you wish. Use it wilfully and consistently.

Hold your hand up to your canvas. If the painting has no more signified substance than the living hand it is only eyesight work and could be done better with color photography.

You can't see the separation of form and color in nature. It is a mental concept. When you are conscious of the principle you will find yourself looking at objects and seeing the form and color in different sequences of thought. Toshi Shimizu, who studied with me, told me that Hokusai, the great Japanese draughtsman, called this "the principle of the Thing and its color Skin." If you have a white egg and paint it red you change the color complexion, but you do not change the form.

I harp on this idea because I believe it to be the root principle of form realization. No doubt it is the main reason for the special vitality of the Renaissance masters. Their color is beautiful not only because it is harmonious, but because it is significant.

Titian, Veronese, and Tintoretto were the first great colorists. Renoir found out that Rubens was right and Rubens found out that Titian was right. They belong to the same tradition.

Ingres was a draughtsman; his paintings have sculpture. Courbet was a painter; he painted with tonality, by massing lights and darks and textures. But Delacroix was a great colorist. He probably knew more about color than any other modern master. He orches-

[111]

trated his colors as a musician composes a symphony. But Rembrandt was the greatest master of drawing and color-plastic realization.

In El Greco and Chardin the principle of realization is the same. A gray and white low relief of geometrical forms brought to life with top colors.

Most pictures painted within the last seventy-five years were made "directly" with opaque oil paint. In other words, the artist was painting form and color at the same time. Good pictures have been painted in this way, but none of them have the plastic realization that can be obtained when the form and color are painted separately.

Delacroix was one of the few men of the Nineteenth Century who understood the principle of separating form and color. In his Notebooks there are constant references to the problem of making a picture realized, the technical problem of making powerful form. Even in his day the tradition of craftsmanship was so lost that he had to learn what he could about technique from the scenery painters. Many of his early pictures have darkened and cracked, but the later ones underpainted in tempera are as fresh as the day they were painted.

Renoir, too, had a long struggle to find the proper technical procedure to express his concept of form. In his later work, he too underpainted the form in black and white, bringing it up to color with glazes.

A few artists in Germany carried on the technical tradition of underpainting form and glazing color. The artist who is interested in his materials can learn a great deal from Max Doerner's The Materials of the Artist. In the past ten years a number of men in America have been experimenting along the lines of the old methods and taking advantage of modern scientific discoveries. We are slowly building up a new knowledge of sound craftsmanship, for both easel and mural painter.

[112]

Having painted for thirty years almost entirely in the direct method, and becoming more conscious of the plastic character of form and the fact that color was a separate quality, I tried to make the separation in my painting not only a matter of thought, but of technical process.

Working in solid oil paint, I started the painting in a general tone that defined the sculpture of the forms. Then I worked up the form and color with stronger statements of value and color. But I was unable to get the real separation of form and color because the opaque paint of the later stages of the painting blended and covered up entirely the sculpture of the thing which had been painted in first. The thought was there but the technical process was inadequate. So it was a conscious desire to paint form and color separately that led me to the procedure of underpainting and glazing. I learned a great deal from Renoir's later work at this time. It was through an analysis of his work that I became conscious of the same principle in the work of the old masters.

My first departures from direct painting were rough impasto underpaintings made with white lead, glazed with oil-varnish medium. The forms were built up in pale semi-neutrals and hues. I let this oil underpainting dry for two days and then glazed it with transparent colors, working quite quickly and not fussing the glazes. It was my hope that the glazes would dry with the top paint skin of the impasto and not cause any cracking. Ten years later no cracking has occurred.

Learning about the advantages of a tempera underpainting which would dry overnight and not darken as oil paint does, I started to use it, At first I had much trouble to find the right medium. I found zinc white was unsatisfactory as a pigment. Later, using a casein emulsion and lead or titanium white, I have been able to work freely without any fear of cracking. I feel pretty certain that all the heavy, staccato impasto paint in the old masters'work is made with tempera. Certainly the brilliance of

[113]

Flemish and Venetian pictures is the result of the underpainting in tempera which glows through the layers of colored varnish glazes.

A picture which is underpainted with tempera seems to have a light of its own. Like a stained glass window, the light is reflected back from the white ground through the vitreous color glazes. The forms retain their bulk even in candlelight. When you look at a direct painting in a dull light it seems to have no form at all.

Rembrandt's "Jewish Bride" has all the great qualities. It has great plastic realization because the form and color were painted separately. First it was painted as a low relief, built up as a piece of sculpture, with pale tones of gray, naples yellow, and vermillion. The textures of the materials, the flesh, the hair, the background, were loaded up in the lights, drawn with paint. Then some broad washes of color-texture that describe the colors of the things with more force. Greater emphasis on the light and shade to carry the design. These glazes reinforce the sculpture of the thing. On top of these are more tones that bring the form and color into greater realization. Then the culminating tones, the full darks and top textures. There is no imitation of the shadows in nature, no imitation of the colors in nature. The form is made more significant with color-texture. It is more real than the things looked, it is more real than the things could ever be in nature.

Texture is what vitalizes the form. The great painters use color to amplify the sculptural texture of things. Sculptural texture may be achieved by defining the thing with minute details as in a Mantegna or Cranach. It may be done more freely as in a Rubens. He was a master of painting materials, the surfaces of things hard or soft, dull or shiny. But a greater master was Rembrandt. More than any other he used realizing, essential textures, to make the form plastic. He did not use every detail but described the nature of the thing with symbols. There is the dry realization of a Breughel and then there is the signified texture of a Daumier. One

PAINTING

has sculpture, the other has also color-textural description.

We should be able to paint textures at will, not fumble around with paint trying to imitate the way a thing looks. An artist in the old days knew how to use paint to describe things: metal, wood, stone. He knew how to make water, smoke, fire; how to paint bone and muscle and flesh and hair.

A fine painter can paint the quality of light as a thing. Sunlight, daylight, twilight, moonlight, any kind of light; fog and rain; the lights of city streets and interiors. The sense of light can contribute to the realization of the forms and the character of the place.

We have no tradition of painting today. The old masters had methods and formulas. A student was apprenticed from seven to fourteen years to learn his craft. It meant that there was less chance for individual expression, but the work of minor men had infinitely more power than most of our best talents can achieve today. We have been so wrapped up in personal expression that we have lost the power of disciplined technique.

The old masters had definite formulas for making forms and textures. They had color systems. For instance, Rubens had certain color themes which he repeated constantly because they worked in building form and making satisfactory compositions. He used to keep his colors mixed up in jars, well-regulated intervals of darks, half-tones, and lights in each color scale. If he had an order for a mural he could turn the sketch over to his assistants with some notes about using the usual sets of tones for blond flesh color, dark flesh color, green drape, gray horse, and so forth. When everything had been laid in by the assistants he would come along and finish it with a few drawing marks and culminating color tones.

The important thing about those color systems is that they were used as a means to realization. Those men knew that certain sets of tones laid together would make solid form. Once knowing that a chord of color tones would make form, they could transpose it at will to any section of the palette. A knowledge of these means of realization was part of their equipment.*

Cézanne used to say that one should have forty-eight tones set on the palette all the time. He found a set of color-tone intervals that would make form for him. Lots of people are imitating his way, using little Cézanne-isms. Renoir had his way. Titian and Rembrandt had their ways of doing it, and they are so inscrutable that one can scarcely find the formula. But in each case the system is there.

In all fine painting there is an understructure of semi-neutrals and hues: the skeleton of the color composition that carries the form. The full colors are the final skin.

In a picture that is underpainted and glazed you can see the monochromatic form painting that lies underneath the color. More important than the beauty of full color glazes are the optical grays, the half-tones made when the color glaze lies on top of the pale neutral tones that sculpture the form in the underpainting. If the form has been laid in with gray and white everywhere, these gray tones come through the local color glazes and keep the form statement a thing apart.

More color power may be obtained if each form is underpainted with pale tints of the local color, the root hues of the color scale. Still more color power and variety may be had by underpainting a color with tones in an adjacent color scale. Flesh is often underpainted with terre verte which has more color force under a glaze of raw sienna than has a black and white gray. The more you open up the colors in the underpainting, the more control you have to use to keep the painting a harmonious unit.

In direct painting, the color harmony is best planned on the

^{*}Thirty years ago under the direction of Charles A. Winter, experimenting led Robert Henri, George Bellows, Randall Davey and myself to the use of an arsenal of fortyeight tones, each in three shades, and all in separate stock jars. From these we could rapidly select a particular palette. We used this extension of Maratta's colors for several years. See page 122.

PAINTING

palette. Every stroke of paint laid on the canvas should be right in color, degree of neutrality, and lightness, or it will not stay in key with the rest of the work. When glazing over an underpainting you are free to change the color without re-drawing all the time, as you have to do when painting directly.

Color Powers

I think it is very important for the artist to have a working knowledge of the use of the palette. The palette is an instrument, like a piano or violin. In the hands of a master it may be a complete orchestra. To stumble around in full colors and raw white is as stupid as it would be if a musician were to play the piano wearing boxing gloves.

The most obvious use of color is to give variety to a two-dimensional design worked out in black and white pattern. If the gray tones are translated into two or three colors, the eye moves from area to area of red or green, just as it follows light and dark tones. Likewise a drawing in black chalk on gray paper may be given more variety of color-texture if brown is used to describe different materials or to accentuate the design. Daumier and Toulouse-Lautrec used color in this way when drawing. The spotting of colors in different areas of the design is a decorative device, and while essential to color composition, it is not the most important thing about the use of color.

A significant factor in color is the quality of projection and recession which colors have when laid together. If you look at the spectrum, the hot brilliant oranges and yellows advance toward the eye, while the cool greens, blues, and violets recede. Colors of full intensity advance more than neutral hues. The artist makes use of this dynamic, architectural power of color to build form. By relating one tone to another, he can force the projection and recession of planes in addition to the drawing of form made with black and white symbols. Color changes alone do not make form. The sculpture of the form is made by significant tones in the black and white scale, the light and shade definition of the thing. Without changes of value, changes of color alone will not make form.

If you were painting a lemon you could make the form move around if it were full yellow at the most projecting point, with sequences to yellow-green and green or yellow-orange and orange provided that within those color changes there were tone changes to signify the sculpture of the thing. You might paint a lemon with a set of tones in the yellow-purple scale. The moves toward purple would carry the form back.

The most projecting point on the spectrum is yellow-orange; the most receding, blue-purple. Pure yellow has a tendency to turn into light.

Yellow-orange, orange, red-orange, and red seem to be the most tangible colors. This is partly because the eye favors yellow, it sees things easier in yellowish light. Purple is the least tangible color; and many people are not sensitive to the color, cannot see it. Yellow is also a color of intangibility.

Think of a pure color as having the power of black. Some of our pigments are stronger than others, as yellow is lighter in value than red, but if we had such a thing as pure strength colors, they would all look black in the tube. Each color has its own character, weight, insisting quality.

Color tones have to be balanced against each other. A change in the black and white scale or a move toward neutrality, or a shift in color may change the weight of a color, change its place on the form.

The important colors to know about are the neutral, indescribable tones so loosely called grays and browns. These are the tones that set off the projecting, positive colors; these are the tones that construct the form. It is useful to have some system in naming these tones and a knowledge of their composition.

PAINTING The Color Triangle

I have found the Dudeen color triangle introduced by Charles A. Winter, a very practical color diagram. The triangle represents color mixtures in pigment form more accurately than does the circle. At the three points of an equilateral triangle are the primary colors, red, yellow, and blue. From these are mixed the secondary colors, orange, green, and purple. In pigment mixture, the secondaries are less intense in color than the primaries and consequently closer to the point of neutrality, or center of the triangle. All colors within the outside edge of the triangle are tertiaries.

The triangular diagram shows the full intensity colors around the outside edge, drawn down to the point of neutrality by admixture with the complementary colors of each color scale. Tints with white might be shown by imagining a series of triangles built up above, each section containing more and more white until the top layer is composed of the palest tints. Above this series of triangular diagrams lies white; below it lies black.

White pigment slightly neutralizes any color it is mixed with. Black is not a color, and black pigment deadens any color neutralized by it.

The complementary to a color is its opposite on the triangular diagram, a color which contains none of the other's factors. Purple, made of red and blue contains no yellow, and is that color's complement, and so forth. Notice in the triangular diagram of color that yellow-green is not the complement of red-purple as inaccurately indicated by circular diagrams. In pigment mixture the complement of yellow-green is about two parts red-purple, one part purple. The distance between a secondary color and the point of neutrality is half that of the primary color (its complement) and the point of neutrality. These limitations of the color scales in pigment mixture make the triangle a more practical diagram than the circle for the artist's purposes.

GIST OF ART

In order to distinguish between colors of the same color scale at different degrees of intensity, we refer to them as color, semineutral and hue. If you mix yellow-green and yellow-orange, you get yellow semi-neutral. If you mix green and orange you get yellow

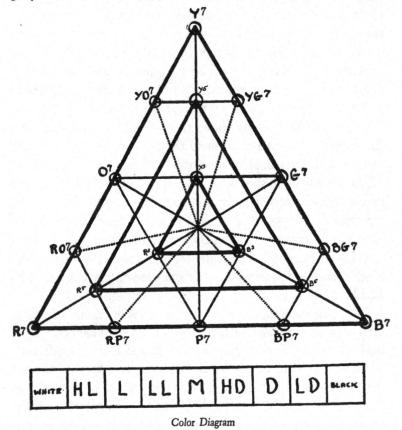

hue. Thus we have two interior triangles, the semi-neutrals and the hues.

For brief color notations we may call full color Y7, semi-neutral, Y5, hue Y3, etc. This gives one an accurate and simple way of making color notes on sketches.

PAINTING

To describe the degree of white in a tone a scale of heights is useful. High light, light, low light, middle, high dark, dark, low dark. Abbreviated: HL, L, LL, M, HD, D, LD.

The ability to recognize that vermillion, light red, and burnt sienna are all in the same color scale is of the same use to the

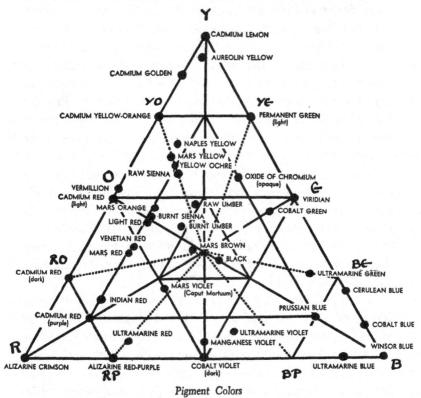

artist as the musician's ability to recognize C sharp in one octave and another. The artist should think of orange and blue, red and green, and so forth, as two ends of the same color.

It is good to keep a color diagram up on the wall.* Think about

[121]

^{*}When you make your own, mix all the tones with a little white so that you can see the color in the semi-neutrals and hues.

color diagrammatically. Know that blue hue can be made by mixing blue with orange or green with purple. Think of blue and its related colors, blue-green and blue-purple, as well as blue, an isolated color moving to orange.

A color-tone has three factors, which may be changed: color scale; degree of intensity (or neutrality); and quantity of white.

True yellow is a relatively greenish color, like a lemon cadmium. Alizarine crimson is a true red, which makes a perfect red-green scale with viridian. Orange is not the color of the fruit but a color corresponding to vermillion or cadmium red light. A pure blue lies between ultramarine and cobalt. The new Winsor Blue is a fine, powerful pigment, neither too green nor too purple. Purple has to be mixed by eye. You can test it by pulling down lemon cadmium until you get accurate semi-neutral yellows.

When Hardesty Maratta made his colors I used to get his sets containing complete semi-neutrals and hues accurately mixed. His paints were carefully mixed from the primary colors so that some element of yellow, red, and blue was carried through all the tertiary colors. Since yellow in mixture has a tendency to lighten colors, the hues were lighter and less powerful than those you can make with the earth colors.

Home-made hues can be made as follows: Red hue equals Indian red plus viridian. Blue hue equals ultramarine plus burnt umber. Yellow hue equals raw umber plus a little cadmium yellow.

Useful semi-neutrals to keep on the palette, as well as the earth colors, are: Green equals opaque oxide of chromium plus ultramarine; purple equals caput mortuum plus ultramarine; yellow equals raw sienna plus a little opaque oxide of chromium pulled up by cadmium yellow. Indian red plus a little viridian is a good semi-neutral red. Light red or burnt sienna may be used for semineutral orange. Ultramarine and light red pulled into the true blue scale by a little green make a good semi-neutral blue.

When making hues and semi-neutrals, test them out with white

PAINTING

as it is hard to see what colors they are when full darks. Hues are most useful on the palette when mixed with some white.

Some artists who grind their own colors mix up these color intervals in tubes so they can be renewed on the palette without constant mixing. It is a good idea to keep the palette fully equipped with semi-neutrals and hues all the time. It keeps one from dipping into raw color. It is also more economical because these

Arrangement of Palette

colors are made almost entirely of the inexpensive earth colors, which are also the most permanent pigments we have.*

I like to use a large table palette that has plenty of room for mixed tones. Metal is preferable because of its neutral color and because old paint can be burned off. Some artists prefer white glass. A large enamel baking tray makes a good palette. It can be *The Mars colors are artificial earth colors and very powerful, permanent pigments.

[123]

GIST OF ART

filled with water (which keeps the colors from forming skins), if you want to save tones for later work. A good, light hand-palette can be made of common corrugated cardboard covered with parchment paper.

Colors should be laid out on the palette in an orderly way. I prefer to put the full intensity colors around the outside edge of a large rectangular palette. Starting with yellow-orange in the upper left hand corner and moving to yellow and yellow-green around to the right, so that orange and blue come opposite each other at the middle of either side. The neutral tones are then laid along the lines of their color scales. The spaces in between are used for mixtures with white.

Color Composition

One or more colors may be held as dominants. The dominant color may occur in a focused, intense culminating area as an accent of positive color. Or it may be a pervading tonality, a color that modifies all the other colors on the canvas. Thus you may use green as a precious color, a jewel-like note, by setting it among some fine neutrals. Or you may paint a picture with a great variety of greens set off by some tones that are held very simply.

I once mixed up seven or eight completely different greens which, when put on the canvas, all looked the same. This was because I had changed all the surrounding tones so there was no constant foil for them to work against.

Colors are very sensitive to the power of harmony and contrast. While you are working, all the tones are influencing each other. When you put a strong red next to a more neutral color it will bring out red in that tone, if possible. If not, the neutral color will look more green than it really is, because of simultaneous contrast.

The effect of a color is entirely relative. A neutral orange may look green or yellow when laid among some blue-purple notes. A neutral green may look blue when laid beside yellow-greens. This

PAINTING

is particularly true of neutral colors, which seem to have little color unless laid together with definite intervals of value and intensity.

Two colors of equal strength tend to arrest each other. When of equal intensity and value, they fight to dominate each other and disturb the eye. Thus a contrast of blue and red-orange is more effective than blue and orange because the complementaries are opposite, static.

Two colors juxtaposed or superimposed will make a third color appear. The more complicated the color scheme the more difficult it is to control the influence of one color on another.

The simplest use of color in painting that is concerned with solid forms is definition of each thing with a positive local color. The early Italians and Flemish used it in this way to reinforce the pattern of the design. When the form and color are separated, the local colors may be held positively, or they may be subordinated to the light and shade design. In a Rembrandt, a black velvet sleeve may be struck with light or a white collar be drawn with dark tones to keep the forms related to the design. Likewise with color: a red hat may be drawn in the shadow with neutral purple and dark yellow-orange while coming up to full crimson in the light, if these are colors that help to bind the design together. Color tones help to weave the separate forms into a unified concept. Whether you wish to emphasize the form of each thing as a unit, or the design of the thing as a whole, you must decide which direction the work is to take and stick to it.

A painting with strong, color-textural realization is kept under control by foils of simply held color areas. A foil may be a neutral color or a positive one, a half-tone, light or dark, depending on the requirements of the design.

Rembrandt often used masses of light and dark as foils. In color he generally would hold some area, say a cool neutral half-tone, as a foil for the palpitating color changes of the other surfaces.

Rubens used big areas of full intensity local color (oranges, reds,

blues, greens, and several positive neutral half-tones) as foils to bring out the color in the flesh. Flesh tones that appear to be strong oranges, greens, and rose are made with earth colors, and grays scumbled with yellows. They are laid side by side, with strong intervals in the black and white scale and alternations of warm and cool tones. The color in those semi-neutrals is brought out by the surrounding colors. The colors in a Rubens don't vibrate. Each tone is a positive sculpturing color-texture that takes its place on the form.

In a Renoir, the flesh generally is held as a simple color area surrounded by a background of palpitating color-changes. The colors are so subtly woven in and out that the eye can pick up yellow and read it all through the design, then green, and so forth. His paintings are almost always dominated by a culminating red color-texture.

All of Titian's and Rembrandt's pictures were painted in the orange scale with exceptions—that is, painted in the orange scale with other color notes used as accents.

Delacroix was a great innovator in the use of color. He broke away from the hide-bound system of working in tones of the earth colors and opened up the whole palette. He learned things from Constable and was stirred to the use of full colors by his trip to Algeria; but perhaps the most important things he learned about color came from a study of Chevreul, the great color theorist. Chevreul demonstrated many of the optical properties of color, color recession, simultaneous contrast and its influence on color harmony, and so forth. Delacroix experimented with these ideas and used them to increase the power of color in realizing form. He worked out his compositions in color on the palette. He used color system but was never dominated by any one formula. Each picture was painted with a specially designed palette set with key notes, colors of specific composition as to intensity and height. He could then draw with paint, vividly and subtly.

PAINTING

Form and Local Color

The color of the thing, the local color, is at its fullest intensity in the light. The color in the shadow is more neutral. If the material is opaque with no surface color-texture, the shadow is a neutral of the same color scale. The reflected light appears brilliant in contrast to the shadow, but is not as high in color intensity as the color in the full light. The reflected light is affected by the color of the surface which is reflecting the light. Full, strong sunlight somewhat neutralizes colors containing no yellow. These are facts which the painter may use, or change at will.

When you analyze the local color of a thing in nature, walk around and study it both in the light and shade. Think of the form and color separately, and decide what neutral is the sculpturing tone of the shadows that lies under a skin of color, the complexion. It may be raw umber and white, terre verte and white, or black and white that you see lying under raw sienna to make a certain color of flesh. Even if you are going to paint directly try to think of the neutral sculpturing tones in the shade and light.

The fundamental color recession formula for building form is a series of intervals from a light note of high intensity color moving to darker notes of more neutral tones in the same scale. A variation of this would be to move from orange to yellow hue instead of from orange to orange hue.

Another symbol is the alternation of warm and cool color-tone intervals. When combined with changes in the scale of heights and intensity of the colors, this is a very powerful symbol. For example: yellow semi-neutral light, yellow-orange semi-neutral low light, yellow hue middle, yellow-green semi-neutral low light, and so forth.

The symbol of warm and cool recession which is most neglected is the one which is inherent in the spectrum itself: the fact that red-orange looks cool next to orange, recedes from orange; yellowgreen projects more than green; green more than blue-green. By using this symbol for warm and cool, projection and recession, you can make a color cooler, more receding, without making it more neutral.

It is very important to bear in mind this principle about the spacial recession of colors. If you are painting a street at night, make the lights in the foreground yellow-orange, running in a sequence back to red-orange in the background, with similar changes in the colors of the buildings. If you were to put a strong yellow-orange on a plane in the background that is made with neutral purples, it might jump out of place. Orange would look like yellow-orange with those tones and stay in place.

The student should spend a great deal of time mixing tones on the palette to learn their composition. Studies should be made of the simple solids. At first use the monochromatic symbol, tones in one color scale. Then practise with the other color symbols, working out your own means for building form. Sometimes work with tones in the limited inner triangle of hues. Find out what the colors are and what they will do for you.

Color Harmony and the Use of Set Palettes

The twelve major color divisions of the triangle, yellow, yellowgreen, green, etc., may be compared to the twelve half-tones of the musical scale. Chords of color-notes based on well-established numerical harmonies may be used for the dominant colors of a composition. Groups of colors selected from the twelve notes of the spectrum arranged in intervals of 3-4-5, etc. have inherent harmony.

Most systems of color harmony have been based on the combination of complementaries. Such combinations are static because the complementaries are opposites that equalize each other. The use of triad chords based on thirds, fifths, and sevenths as in music, brings out the dynamics.

[128]

PAINTING

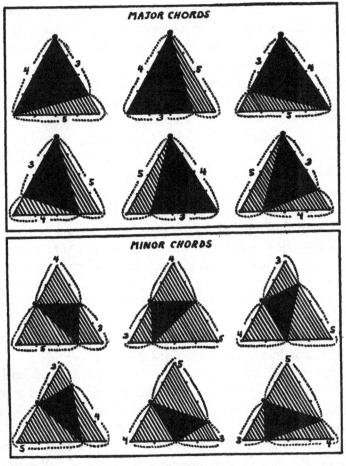

Color Chords

A palette limited by a triad, such as red, yellow-orange, and blue-green retains the elements of the twelve color scales. The dominant colors are emphasized by omitting other full colors from the palette—those other colors being represented by notes of lower intensity. A minor chord contains no full primary color.

For instance, in a palette limited to the triad of purple, yellow-

orange, and green, when you draw lines on the triangle between those points you cut off all the positive blues, blue-greens, and blue-purples. The top corner of positive yellow and yellow-green is omitted. The whole section of reds and oranges is cut off. But you still have a relative blue in blue hue, a relative yellow in yellow semi-neutral, and a relative red in a low red hue. With this controlled palette you have a means that is less imitative than the full gamut of colors.

In selecting colors for a picture I do not choose them at random. If I like the color of an orange smock and feel that a background of yellow wall would not contribute to that orange, I may shift the yellow note to yellow-green. In choosing another important color for my palette (using a 3-4-5 triad), I may decide arbitrarily on blue-purple or purple—whether I see that color in nature or not —because it would be harmonious and useful with those other colors.

I lay these notes on my palette, and make some in-between mixtures that lie along the lines of the triangle of which orange, yellow-green, and blue-purple are the outside points; also semineutrals and hues which lie in that color range.

Then I make further decisions, establishing a scale of heights. Perhaps the orange is to be middle height, full color; the yellowgreen to be light, and slightly modified by some blue-purple; the blue-purple to be low dark, containing no white at all. Then I mix up some tones for other areas of the canvas, hues and semineutrals that are related to the dominant colors, and well separated in color and height interval so they will hold as positive notes against each other. I select these tones to bring out the color character of the dominant colors, to act as foils. I now have a tone on the palette for each area of local color.

For modifying tones, tones to mix with the general color of each area, to sculpture with, I now mix a set of lights, darks, and half-tones that are varied in color and intensity. Perhaps, three

PAINTING

tones to lighten with: a cool one of white with a little blue-green semi-neutral; a warm white containing a little raw sienna; and a neutral white. Then medium lights, darks and so forth. Bearing in mind the need to modify that orange smock with a yellowish tone, a greenish or reddish tone, I now can say what I want about it.

With these set tones, I paint as though I were using colored chalks, not dipping in raw white or raw color. All modifications are made by mixing these notes together for sculpturing gradations or texturings.

After working for a while, I may decide to extend the orange note to yellow-orange and red-orange to increase the color-range. I mix up more tones on the palette that will be related to the set scale of heights already established.

With a very limited palette it is hard to do much color trilling, use of color recessions. Now that I have a range of color from yellow-orange to red-orange, I can use those colors to force the projection and recession of the form more powerfully than I could with the tones made up to sculpture. If I mix a little yellow-orange with the orange to paint a projecting form, and mix some redorange with the orange to paint a receding form, the general color will still look orange, but those color changes are acting as strong signs to make the form move back and forth.

Such modifications may be so subtle that the eye doesn't know they are there, but they have great significance. The principle can be used in painting the round cylinder of an arm, in charging the color of stripes on a drapery, or in the painting of two forms of the same color in different planes. If you are painting a still life of some red apples, make those in the foreground move toward orange, those in the background move toward red-purple. This saves your changes toward the more neutral tones for sculpturing each individual form. I do not mean that you should always do this. It is a perfectly good sign to paint a house in the foreground with vermillion and one in the background with venetian red.

[131]

An infinite number of color combinations may be worked out by practising with set palettes. It is something I advocate as a means of control rather than a method of obtaining richly orchestrated color. It is a means of discovering new color relations when you get too much in the habit of using one formula. Even the artist who is underpainting and glazing can learn things by making sketches and studies with set palettes arranged for direct painting.

If you organize your palette from nature you get a greater variety of color sequence than if you limit yourself to a preconceived logical scheme. If you are painting from memory, make color notes on your drawings that will help you set your palette. Analyze the color of a thing into the fundamental root tone, the sculpturing tone, and the color-texture. If a street looks greenish underneath a surface of dirty orange you may put down some specific remarks: G₃-M under YO₂-HD. When you paint your picture, you may decide to transpose those tones into another color scale, but you have some notes about the relative color qualities that will help you.

If you use the same kind of color tone to dig a hole in one place and to make form in another, they will fight to say the same thing. If the greenishness of the flesh is too close in color and value to a green area in the background the tones on the flesh will make holes through to the plane of the background.

When part of an area is cut off by a surrounding form, as a piece of background seen through a bent arm—let that cut-off area partake somewhat of the surrounding form in color and tone. If the background is a dark blue, lighten the area and move the color more toward the warm side of the palette. Otherwise the simultaneous contrast of values and colors will break up the plane of the front form.

Where the edge of one color comes against another, don't just smudge the paint together. Decide whether you want to emphasize

[132]

the edge with greater color contrast, or to relax the form by making a move toward a common color.

Keep the separate color areas of the design related to each other. Use semi-neutrals and hues that partake of the color-nature of different positive color areas. This is sometimes called painting one thing into another, putting some color from the neighboring form into an area whether you see it there or not. Harmony is based on the principle A:B as B:C. The common factor makes for harmony of tone and color.

Light and Color

The sun is our source of white light, which is made up of all the colored rays of the spectrum. A pigmented surface absorbs certain rays of light and reflects others. Thus a green leaf absorbs red rays and reflects green rays.

It is well to remember that a beam of light cannot be seen unless the atmosphere is charged with dust, smoke, fog, or other suspended particles.

Direct sunlight has a neutralizing effect on color. The most intense color generally is seen in the reflected light; that is why grass often looks greener in the shade.

In north light, the artist's working light, the color of the form is most intense in the lightest areas. When the light is subdued, as in twilight, oranges and reds darken faster than greens, blues, and purples. A blue dress, the same value as a red dress, will look lighter and higher in key than the red one.

Moonlight is just sunlight reflected from a button in space, the moon. I painted a moonlight landscape once. I took eight tones from black with a little white in it to white with a little black in it. Then I mixed a tone for the local color of each thing, as seen in daylight. I painted the picture in daylight, modifying the colors of the things with those eight black and white tones. It is knowing how much white you want in each tone that counts. The picture

[133]

has real moonlight. It is mysterious and moonlight is mysterious.

In painting night-lighted subjects, it is very difficult to carry the color of the light through the picture; to carry not only the tonal quality but also the color character. It may be done by mixing all the lights with a colored white.

If you see two objects, one red and one green, under a red light, the red object will look white and the green object will look black. The red-colored pigment reflects all the light and the greencolored pigment absorbs all the light.

If you are painting something under artificial yellow-orange light, first mix tones for the local colors as they are in daylight. Then make a set of tones from white with a little yellow-orange in it to yellow-orange with a little white in it. Use the set white with the least color in it to modify the lightest things, such as white tablecloths. Use the set tone with the least white to modify the dark colors. A set of semi-neutral and neutral tones in the yellow-orange scale may be used to modify the color of the forms in the shadow. This principle is true for artificial lights of any color.

Drawing for Painting

I like to see students, especially those who are thinking of painting, make drawings with texture all over in the light, drawings that look like bronze; drawings in which the form is defined completely. Drawings that are fully realized are the best kind of material to paint from. They may be done with wash and pencil, or charcoal, or pen and ink linework.

There is a better chance of getting an exciting painting from a labored study with texture than from a fine drawing without it. One finds oneself trying to imitate the drawing symbols of the latter rather than inventing a way to say it with tones in paint.

It is always wise to make a black and white sketch before painting. It helps you to keep your mind on the design and structure of the forms, and to avoid being carried away by color niceties.

Say that you have a drawing to work from. You could mix up a general tone for the white of the paper, different in each area of local color. Then other sets of tones for the grays and near blacks. Then some tones to work on these the way pen lines and granular markings work over the washes and smudged tones of the drawing. You may use lines to say lines, or translate the drawing into tones and textures.

It would be interesting to take a Rembrandt drawing and translate it into color. You might lay in the broad tones with neutrals and semi-neutrals, and then drive into it with colored lines. Use color sequence in the linework. It helps to turn things, makes formal changes more comprehensible.

Get a set of colored pencils or crayons, one that has good neutrals and semi-neutrals. Make colored drawings with them, using combinations of two to five or six colors at a time. Make the form with a low key color and then put in the top textures with a fuller-intensity color. You can put in the color-textures with linework, so the lines act as glazes over the under-form. See the difference between a tone that lies all over the surface of the white paper, and one made of lines between which the light of the paper shines through. If you use a number of pencils, well separated in color, you can get strong color sequences. Such drawings are good material to paint from.

Also make drawings with water color, using changes in color to signify changes of plane and color-texture. Water color is best used as a drawing medium, combined with pencil or penwork.

A painting should not look like a colored drawing. The thing that looks like a tinted drawing is a minor kind of painting. But one of the things we are apt to lose in our painting is the quality that a drawing has, because the white paper surface keeps on going under the washes and granular tones. The continuous surface of the form under the color is hard to retain when we are painting.

[135]

GIST OF ART

Underpainting and Glazing

The principle of underpainting and glazing is the separation of form and color. The form is painted in opaque monochromatic tones very pale in key. On top of this sculptured low relief, transparent and translucent colors are laid or rubbed in films, like water color washes. This is called glazing. Because light is reflected through the films of color they are more luminous and intense in color than if the same tone were imitated by mixing white with the same color. Thus the gamut of color power is greater in glazed painting than in direct painting.

The underpainting may be made of pigments ground in oil or varnish, but it is preferable to use tempera emulsion. Tempera dries completely in a few hours and does not darken with age the way oil does.*

The glazes are applied with an oil varnish medium. The paint surface stays wet enough to be worked on for about twelve hours and is dry in twenty-four. The glazes eventually dry to a tough durable film that cannot be removed without turpentine and a stiff brush.

The underpainting should be a positively sculptured low relief. I like to have the lights thick—but not too thickly painted, to give some "bite" to the glazes and to get a sense of texture in the light. Only by experience can you learn how dark in value the tones should be. Generally speaking what we call "pastel" is dark enough.

The underpainting should be neutral and preferably cool in color. Positive colors may be underpainted with shaded tints of the full color. This is especially true of blues and reds because the oil glazes darken or fade. Reds are best underpainted with vermillion or cadmium. Greens with yellow, and so forth. The colored undertone supports and gives luminosity to the glazes.

[136]

^{*}See Chapter X, Notes on Painting Technique, page 166. Tempera painting requires considerable experience with the medium.

Many of the old pictures were underpainted with a black and white gray. This has a tendency to deaden the colors. Blue hue has more life. Terre verte is the most useful color for underpainting flesh. Sometimes I have used raw umber for figures in artificial light; or a tint of cadmium red when I wanted to get the rosy feeling under a golden skin.

Rubens and Rembrandt often used black, naples yellow, and red ochre. Veronese underpainted with a great deal of full color, which is one reason his things have retained their freshness. Sometimes the underpainting was made on a toned ground of gray, terre verte, or Indian red. The forms were built up with white or white and gray. If the toned ground is washed thinly over the gesso it does not detract from the luminosity of the picture. Unfortunately, many artists used dark red grounds which have come through the top painting, darkening the whites and changing the color.

There is reason to think that the old masters used a great deal of system in planning the underpainting colors. Instead of using a neutral of the local color glaze they would underpaint with a hue of an adjacent color scale: as flesh is often underpainted with terre verte, a semi-neutral yellow-green three notes away from the yellow-orange of flesh color. To carry this out systematically, one would underpaint a red-purple with a low orange or low blue, and so torth.

The underpainting does not have to be monochromatic in each area. One might use blue hue for the dark, purple semi-neutral for the half-tone and red-orange color for the light. A controlled use of color intervals in the underpainting simplifies the glazing a great deal.

Avoid putting dark neutrals in the underpainting. They are impossible to paint out if you want to change them to colored darks in the subsequent painting.

When the underpainting is dry (and "isolated" in the case of tempera), you are ready to glaze. Use a sable brush and wash on the colors as you would water color. Work in the glaze with the brush, rag, and fingers until it is smooth. Part of it may be removed with a rag. If the underpainting is rough the color may be lifted off the surface of the lights by dragging the rag across the impasto. When the glaze is freshly applied it may be completely removed by an absorbent rag. When it has set you have to use turpentine. If the underpainting is made with oil, you must be careful not to dissolve it with the turpentine.

The first glaze should carry the gist of the local color in a fairly light key but of not too neutral intensity. I almost always have some white in the first glaze because it works well on top of the opaque underpainting. This scumble brings out fine optical grays as it lies over the under-tones. Then I modify this general color statement with some color-textural changes that do not alter the tone very much. I work them in with the thumb until I get a drylooking, palpable surface. After this I reinforce the cool, neutral tones of the underpainting with similar tones higher in key. It is very important not to paint out the underpainting which carries the form. Don't lose the cool tones that come through in the light to define the form.

At this stage I let, or I ought to let, the painting dry overnight. Then I decide on some positive color-textures, and try them out all over the picture. You can't tell whether a color is going to work unless you carry it out to some conclusion. Other colors are affected, new relations are set up. I try to work with some system: first going through with warm tones and then with cool ones; carrying yellow notes through the design, green notes, blue, and so forth—weaving the thing together and forcing color intervals to work in building the forms. If these tentative notes work together I leave them as textures and drawing marks, or else rub them into the under-glazes to make tonal gradations. If they are not right they can be wiped off the dry glazes underneath.

When an area gets muddy, or the underpainting has been

PAINTING

choked by too much scumbling, clean off all the glazes down to the underpainting. Build up the glazes as you did in the beginning. Do not think you can imitate a tone made of three or four glazes and scumbles, with a single wash.

Always think of drawing, getting the forms realized, emphasizing the design.

If you are working from the model be careful not to imitate what you see in color-texture—get beyond that.

At this point it is sometimes good to build up the forms with white, to improve the drawing, renew the luminosity of the lights, and put in details. Thick scumbles of white may be laid over "dead" areas and drawn into with impasto. Remember, however, that whenever you paint a light tone over a dark one, the undertone will come through in time. Always make important changes in isolated tempera and scrape away the dark paint if possible.

It is very important to work color glazes over these built-up whites to bring them in harmony with the substance of the form. So often they look like plaster highlights. Many of the old pictures look as though there were no color on the form in the light because the restorers have stripped the glazes off the built-up whites.

You may achieve the effect you want with two or three glazes over a positively sculptured underpainting, as El Greco did. You may start with a nebulous underpainting and define the form later with clinching color-textures, as Renoir did. You may start with a colored tone drawing on the white gesso, glaze with an opposing warm or cool color, and then build up the impasto lights. Many of Rubens' sketches were made this way. Sometimes he carried them out to complete paintings. You may combine direct painting with glazing by laying in the drawing shadow-tones in transparent paint and building up the colored lights with impasto.

It is always wise to have some colored whites, semi-neutrals, and hues containing white laid out on the palette. The presence of white in the glaze keeps it from getting glassy. Try not to slip into the habit of glazing with raw colors. Beautiful neutral tones, the optical grays, can be achieved by working semi-neutrals over color glazes and vice versa. Don't neglect to use the semi-neutrals on the cool side of the palette.

When glazing with hues and similar neutral colors, it is almost necessary to have some white in the glaze to bring out the color. It helps to keep the glazes from getting dirty and stringy.

The textural quality of the paint itself must be felt. The contrast of transparent and opaque tones must be worked out to suit the texture. Often it is necessary to work quite opaquely on top of the glazes to clinch the form. Don't get so tied down to a procedure in glazing that you are afraid to throw it overboard. Don't get so flattered by the beauty of rich colors that you hate to dig in for the form. Keep your mind on the problem of making tactile form. Use the color-textures to get realization.

Linework

I have been experimenting with the use of colored lines on top of some of my glazed pictures. Lines are symbols in black and white, and if they are different from the general tone of an area they also have color significance.

I like to use linework to give added significance to the surfaces in the light and to increase the sensation of light and shade. It is possible with sets of lines to force the color power of the painting without cutting down the lightness as much as has to be done if the color changes are all indicated with tones. For instance, neutral red lines can be drawn in the shadow of a green form to say something about the surface and shape of the thing without using a dark solid tone, without losing the green color skin. I can draw on the green form in the light with low yellow linework to say positive things about the direction of textural planes. A glaze of low yellow all over the light will not do the same thing.

PAINTING

Rembrandt's rough underpaintings, in which the graphic brushwork describes the textural existence of the form in the light, serve to make significant texture in a similar way. The glazes caught in the interstices of the paint show up the textural planes.

You don't want too definite glazes to work over when you use colored lines. The paint must be dry so you can wipe off lines that don't work well. The lines may be used to say things about planes and textures, carving statements. Or they may say things about the place, say that one thing lies in back of another, that there is light and shade there. Generally, semi-neutral and neutral lines work more subtly than those of full color.

Sets of lines can say something about the direction and nature of the light. They are used by great fresco painters as a sign for shade. I always think of shade as being full of light. That is why I like to use the word shade rather than light and shadow. Shade seems to play over the thing, envelop it, better define it, while shadow seems to fall on the thing and stain the surface with darks.

Strong outlines are usually unnecessary in painting. Drawn lines on the surface give texture and help to create the existence of the solid form. Outlines are a compromise in place of a real consciousness of the form rounding away from the eye to the side that is out of sight.

I do not advocate the use of linework in painting unless the artist feels a need for that kind of realization. If you get strong enough realization without using linework then it becomes superfluous. The painting will look like a complete aquatint that has been worked over in etched lines. The lines look wiry, stand off the surface. Nevertheless, I do believe that more use could be made of linework. And I firmly believe that the Titian who made great pen drawings could have made marvelous use of line texture on flesh painting. Signorelli laid in his forms with tones and then drew on them with positive linework. His things are certainly among the most powerfully realized paintings in existence. Some of the paintings I have made with linework do not photograph well. It is very difficult to get the cool underpainting, the tone glazes, and the linework to photograph harmoniously. Many paintings do not photograph well even with the proper color screens, but it doesn't necessarily mean that the work lacks a fine black and white design. A photograph of a painting is a poor thing at best. Surely a painting that could not be photographed would be an exclusive piece of creative art.

Quality of Paint

Whether working in direct paint, or glazing with transparent films over an opaque underpainting, do not forget the qualities of pigments as a means of getting textural realization. Things that are inharmonious technically may do a great deal in a very subtle way to destroy the sense of existence and color relations.

If a painting is all done in translucent colors it is apt to look milky. If all the tones are transparent it will look glassy. If all the tones contain white, as in most direct painting, the work has a tendency to look chalky. It is for this reason that many Cézannes look as though they were made of plaster. One of the greatest difficulties in direct painting is to get the proper changes in the black and white scale working with the color intervals.

When you want to change from one tone to another it is very important to know how much more or less white you need, or if you want to change that factor in the tone at all. It is one of the great stumbling blocks to fine color.

The sense of continuous substance is lost and the quality of light is choked when the painting is not harmonious technically. If one form is painted directly, and another glazed, they will not stay in the same place.

It is wise to have some system in building up a picture. Rubens used to load up the lights impasto, and keep the shadows transparent. I often prefer to glaze the impasto whites with trans-

PAINTING

parent color to get full luminosity, and scumble the shade areas.

It is entirely a matter of relationship whether the tones in a particular canvas work well together. If the shadow side looks dense it may be brought to life by some light opaque marks. Or it may be made to look lighter by some crisp transparent glazes. Perhaps the real trouble is not there but in the light side, which may be too transparent, or too milky, or not sufficiently realized. It may be just a change from transparent to opaque paint that will turn the edge of a contour.

A Holbein or Ruisdael is equally realized everywhere. Rubens made the thing most real at the culminating corner, between the light side and the shadow side. I prefer to emphasize the realization in the light and let the form, the textural detail, relax in the shadow.

In Rembrandt's portrait of a man in a gold helmet the texture of the helmet is most strongly realized in the light, where the hammered metal is built up in the underpainting. The glazes over this are very transparent and full in color. The shadows of the metal are transparent and translucent, to get the quality of the shiny surface. The flesh is glazed underneath with scumbles and top-surfaced with opaque marks and transparent glazes. This contrast in technique brings out the difference in textures and adds to the livingness of the result.

Figure Painting

Almost all flesh is in the yellow-orange scale. If you include Indians and Negroes you can say that any figure lies between redorange and yellow-orange. The reason for brushing aside realistic human coloring is to say something that isn't tame, more graphic.

You cannot have too much practise in painting the figure just in black and white, or with white, burnt sienna and blue hue. Many studies with palettes limited to the earth colors and blue are invaluable in training the student to draw with paint. You may work directly or underpaint with terre verte and other hues.

The figure is essentially one color. Remember that when you notice a phenomenon, such as the darkness of a man's weatherbeaten face above the collar line. Decide on a formula of tone intervals to paint the flesh in each study. Keep the continuity of the complexion, include your exaggerations.

Remember that the arm is the same color on both sides, that both arms are the same color. If you want to make one project more than the other, use color sequence; but do not observe visual perspective in the drawing. For instance, if you have a general flesh color of raw sienna and white, you can modify that color with a little full yellow-orange for the projecting arm, and with vermillion for the receding arm. The general color will look the same. Carry out the change in color in the color intervals; stick to the formula you have decided on for the complexion.

The whites of the eyes are much closer to flesh color than you would suspect. Paint them with the underlying flesh tone. Use different color-textures on the eyeball and the skin to bring out the color contrast.

When the model has been posing for some time the blood runs down to the extremities and gives the flesh a red-purple look. Don't imitate the color. You can observe the change in color quality. It helps to make the figure rise if you consciously paint it more rose at the bottom moving toward yellow in the upper parts. Support this with color sequence in the background.

Don't draw between the fingers and toes with black. Feel those forms as part of the hand or foot. Draw with colors that partake of the color nature of the flesh. A semi-neutral red or orange will define the form without breaking up the plane. Use color sequences, drawing between the near fingers with more advancing colors.

There is a relative yellow in the flesh, a yellowishness. In a rosy figure it might be painted with a move from light red to a semineutral yellow-orange. The greenishness in flesh complexion is really a move toward low yellows. Semi-neutral reds look purple against orange tones. Likewise, the blues of flesh color are neutrals of the orange scales which carry as positive color-changes because of simultaneous contrast.

When you want to get a cool figure you don't have to move to blue. A contrast of alizarine glazes on a terre verte underpainting can look cool.

The figure is influenced immensely by the background. To bring out angles in the figure, put angles in the background. Do the same with curves. In color, use red to bring out rose in the figure, and so forth. But do not neglect the use of contrast.

A piece of drapery is like a necktie, hot stuff to paint, and one of the easiest things for a painter to kid himself into thinking he can do. Don't be fooled by the color. Go after the shape and character. Hew the forms together with colored tones.

Highlight culmination is a poor substitute for plastic performance. Don't hesitate to put a color dark in the light, to bring the form into existence.

The easiest place on the figure to achieve existence is on the knee. The hardest place, the torso. You have to come to grips with the form. It is easy to do it by running to recognizable reds and oranges, but it can be done with other color scales.

I think a photograph of a rugged piece of sculpture is a most edifying thing to a painter interested in realization. Look at an Epstein. It has twice as much modelling as the thing in nature. Notice the amount of dark texture in the light.

[145]

CHAPTER VIII

LANDSCAPE AND MURAL

A LANDSCAPE IS THE PORTRAIT OF A PLACE. The face of the earth is an adequate and dignified inspiration for very great works of art. It is not necessary to paint contemporary life, the American Scene, or historical events to produce living contemporary art. Ruisdael, Poussin, Constable, Courbet, Cézanne, and Renoir found nature alive and vital. Of course, you must paint the life around you, paint the things that you know. For one person that may mean the streets of New York, to another it may be a Kansas farm. Social movements may interest some, portraits still others. Chardin found life in china mugs and the fruit on his breakfast table. Yet his compositions are monumental and the realization of his forms intense.

To make a good landscape you must sense and express the scale of things. A few rocks may be as important as a mountain range if you get a fine relationship between the texture of rocks and foliage and surrounding forms. Plastic measures as well as a sensitive selection of things varied in size and shape are vital elements.

Don't walk miles looking for a "subject", somebody else's subject. Look down the road and use your imagination. Get some excitement from the reality in front of you, the geometry of the forms. Get a kick out of the textures of materials. Nature is full of plastic measures, textural measures, color measures: the delicacy of grass tufts, the rough surface of sandy earth, worn round rocks, the bulk of river banks, the character of running water, the quiet passage of mountains against the sky, the fullness of clouds.

Feel the power of nature, the force that threw up mountains

LANDSCAPE AND MURAL

and urges plants to grow. Feel the sunlight and wind. Keep your humanity. Get the nerve of life in your line when you are describing inorganic things.

Get the volume of the hills. Don't just caricaturize the forms. There can be an element of homely humor in a landscape. It is a very subtle thing.

A poetic painting of a fog on a moor is just about the limit in "no-thingness." Poetic in the "ic" sense. Poetic in the sense of Whitman is something else entirely. He was dealing with things, things used as symbols.

In what you now dislike, even hate, lies your advancement to greater understanding. If you get my meaning you will see that I am talking not only about works of art, but things you see in nature. Subjects that don't seem to have meaning for you now may come to interest you if you think about them. Things that seem ugly may come to mean beauty to you.

I like to paint the landscape in the Southwest because of the fine geometrical formations and the handsome color. Study of the desert forms, so severe and clear in that atmosphere, helped me to work out principles of plastic design, the low relief concept. I like the colors out there. The ground is not covered with green mold as it is elsewhere. The piñon trees dot the surface of hills and mesas with exciting textures. When you see a green tree it is like a lettuce against the earth, a precious growing thing. Because the air is so clear you feel the reality of the things in the distance.

A landscape may be conceived very formally, as in a Poussin, or with a more intimate point of view, as in a Renoir. Cézanne was most of all concerned with painting solid forms, the architecture of the place. His pictures often lack texture, some look like colored plaster. Courbet on the other hand, sought to get the difference in quality of rock and earth, foliage and water. He did it with drawing and color and the very texture of the paint.

[147]

Ruisdael is perhaps the greatest landscape painter of them all. He carried out a completely realized design, formally composed and yet with a great feeling for the reality of things. You feel the character of individual trees, the textures of bark against grass. His marines are so rich in concept and full of wise observation of the sea; yet simply painted. He knew what happened to waves in a storm and knew how to paint water as a solid form. His skies are real, substantial, yet full of light. It takes great mastery to put over such a fully realized concept of nature without losing the design and mood of a place.

In a Renoir landscape the form is not equally realized everywhere. He says something about the nebula of a group of trees, the feeling of a place bathed in sunlight. Then he gets hold of a corner, comes to grips with the forms, snaps the things into realization. Renoir let the thing relax and then brought it out into culminating points. Some parts of the design were more exciting than others and he wanted to focus on them.

The drawings of Dürer and Breughel are chockfull of knuckly remarks about rocks and trees and clouds. But under all the detail is a large design.

Some Constables are full of textural detail, and in others he condensed the minor forms to emphasize the design. You must find your own way to see nature, whether in detail or in the large design.

Van Gogh saw nature differently. But his work doesn't look the way nature looks. He used what he saw as a point of departure for an exciting design. He drew in color, but his colors are an enlargement of the color relations he saw in nature. His linear technique is used to separate color and shape.

Look at one of Corot's Italian landscapes. It may be a study only fourteen by ten inches in size, but how architectural the composition is. What beauty of scale and fine tonality! The sensitive gradation of tone intervals, his control over them, has something

LANDSCAPE AND MURAL

to do with the quality of the light. The color quietly important.

Study the great brush drawings of the Chinese and Japanese. Observe their conventions for perspective, form, texture. When we try to imitate those conventions we lose the content, because those artists were part of an ancient tradition. Our tradition changes rapidly, our schools of thought come to fruition quickly and decay again. We see differently. As Walter Pach has said, "Orientals search for the ideal, occidentals for the particular." Our forms no longer have any philosophical symbolism, and that is a kind of symbolism which when borrowed is an empty thing.

I think it is best to do landscape trom nature at first, to become familiar with the forms. You may make careful studies on the spot and re-do the composition in your studio, but get the sculptural rhythms from nature.

Select the things you like. No great painter ever set out to say that he loved every square inch of the subject he was painting.

The artist looks at a mountain and sees a picture. The cowboy looks down at a canyon and thinks of how many days it would take him to get across it on a pack mule. We need to get more of that concern with distance, as being made of tangible obstacles not vapor, into our work.

You don't need to paint haze and atmosphere to get distance in a landscape. Use the symbols of line, tone, and color. If you want to observe the haze at the horizon, paint the hills as real forms and then paint the haze around them. Or state the forms more delicately than those in the foreground, but no less firmly.

Some perspective is almost always necessary in drawing landscape. But be careful to resist perspective in the foreground. Remember that the closer things are to you the more they are distorted in size. Think of the things in the foreground as being in one plane, those in the middle distance in another plane, and so forth. Use change in scale between the planes as a sign for recession. It is so powerful that you can draw things ten miles away

[149]

as though they were half an inch back of the forms in the foreground, and the back things will stay back.

Use changes in texture and color to make things project and recede. If you have a bush in the foreground the same size as a hill in the background, make it a positively different material. Let some planes slip off into the shadow, bring others up into the realization of the light.

Get light in the picture by keeping your shadows light. Dense shadows destroy both the form and the sense of light. If a cast shadow doesn't help to define a plane, or function in the design, it has no value except to tell the time of day and the source of light.

Study the way things grow, how they are made. A weed grows like a tree, only in its own character. The principles of growth are the same. Feel the roots in the ground, the rise of the trunk, the radiation of the branches, the weight and delicacy of foliage. Observe the difference between a rigid tree trunk and the giving line of vines and weeds. Study the formal nature of the whole plant and its related parts. Know why an elm tree is different from a pine.

When a great draughtsman like Daumier wanted to draw a tree in an illustration he didn't have to rush out to the country to see nature. His memory was stored with the observations of many trees. He knew how they looked under different conditions, in wind and rain. He knew the character and smell of the forest. And he knew how to represent the kind of tree he wanted in any position or place because he was familiar with the forms.

Go after the character of natural forms, the humble and grand character of nature. Be sensitive to the proportions and changes. Select the fine relations and eliminate the accidental ones. Correct what you see by your mental image of the normal thing.

If you set up new rhythms in place of those in nature, which in some cases is a fine thing, they must be sufficiently distinguished to warrant the license. Sense the dignity of things.

[150]

LANDSCAPE AND MURAL

Have a special interest, a positive prejudice about some clump of trees or one particular knoll, an excitement about them that can spread through the whole composition, and so fire the rest of the things that you are only mildly interested in.

Think about a stone wall as you would about a crowd of people. Get the big planes, sides, top and the bottom that rests on the ground. Build it out of the earth, make it a heavy thing. Then pick out the gesture of the wall, describe the rocks that make it. Hew the shapes of those stones, get the sharpness and granular surfaces, get the worn-down, settled-into-place quality.

Don't think of the sea as color. Make it a solid that can support a boat. Think of "wetness" as color-texture.

Study cloud formations. Don't be satisfied with rococo, Spencerian clouds. Observe the flat bottoms of heavy rain clouds, the fine patterns of mackerel skies. Hope to be able to paint clouds in a picture without having them in front of you. Use them to design.

When I used to paint landscapes directly, after selecting the subject I would take half an hour to set my palette. Then I would pick up those set tones and draw with paint. Instead of imitating the colors in nature, I decided on some quality of color that interested me and set a limited palette, with which I could represent relative greens, reds, and other colors. Using such set palettes I could work very quickly, and often made two $26'' \times 32''$ canvases a day.

When painting landscape in the mixed technique, it is best to make a small study in direct paint first. It gives you a memorandum of the color composition, with some color relationships inspired by the subject. Sometimes I make a drawing on the spot and work up the underpainting in my studio. I come back to the subject and glaze it from nature. If the underpainting is made out of doors with the idea of glazing in the studio, I make it in semi-neutrals and hues that will remind me of the color when I am away from

[151]

the subject. I always make written notations of the colors: the fundamental local color tones, the color-textures, and jot down some ideas for the use of color sequences—some prattle about my feeling for the scene.

It is tradition to repeat some foreground color in a blue sky to keep it from falling out of the picture. Some modifications toward green, orange, red, will work subtly to make the sky more palpable. It is better to paint the sky as a solid back drop than an air pocket of blue color. See how Veronese used geometrical rhythms in the sky to complement the design of large figure compositions.

Don't mix pure white in the sky to lighten it. That makes it look opaque. Use white with a little orange or yellow-orange, and so forth. Use whatever color change will help to make the horizon line a place where the form passes back rather than a painted edge.

The bluish purple haze you see in trees is just a neutral green, which seen next to a green that contains more orange or yellow, looks bluish or purplish.

It is a very poor habit to pull all colors back with blue. Bluishness all through the canvas is a sign for atmosphere. The neutrals of any color scale will pull a tone down toward neutrality.

You can use a great range of color sequence to make signs for distance. A green in the foreground can be made to look like yellow-green when placed in the background among cooler and more neutral tones. You can paint a brown field all the way from semi-neutral yellow to semi-neutral red.

Plan the color sequences. If you have a fence in the foreground, fields in the middle distance, mountains and sky in the background, use some arbitrary color changes. Let the fence be in the yellow scale, the fields orange, the mountains with some low red notations, some purples in the sky. The colors do not have to be full intensity to make the sequence work.

It is too easy to get in the habit of letting the distance fade away

LANDSCAPE AND MURAL

in pale neutral tones. Remember that you have the whole gamut of the black and white scale to work with as well as the powers of color change. You can put positive colors in the background if you hold them there with more advancing colors and greater realization in the front planes.

Murals

I don't see why any artist who is at all accustomed to graphic expression couldn't draw up some sort of plan for a mural. A feeling for geometrical design, a knowledge of form sufficient to carry things out on a large scale, and technical ability are necessary. A conscious use of foreshortening helps to give plastic realization to a design which must be seen from a considerable distance.

Too many artists are trying to paint their own pictures. There should be more emphasis on the apprentice system practised in the old days. In the average art school a student has no opportunity to study with a master artist who is working out the problems of mural design. Too much theory about the technique of mural painting doesn't get one anywhere. Practise on the wall is what counts.

Under the old atelier system boys were apprenticed in workshops to learn their trade. They were educated not only as craftsmen, but in draughtsmanship, mathematics, architecture, engineering, and many other things. If a boy showed no talent he did the work of preparing panels, grinding colors, tracing working cartoons, and so forth. Those with some ability became assistants, and were allowed to fill in underpaintings from the master's sketches.

Some of the assistants specialized in painting animals, figures, still lifes, or architectural backgrounds. I sometimes say that Rubens must have had an assistant who did nothing but paint fingers and toes. Such details in his work are almost too well done. That remark is an aside, and is in no way meant to belittle Rubens'

[153]

method of working. I seriously believe that we must have some return to the Renaissance system of education before we will have a healthy tradition of art once again. The artist who wishes to paint small pictures for himself could not get a better fundamental training than by working as an assistant to a master painter. A musician does not attempt to compose sonatas or symphonies until he has had years of training in theory and practise with his instruments.

The government projects have done a great deal to stimulate mural painting in the last few years. Unknown artists have had an opportunity to get experience and do the kind of work that interested them. Small cities and villages have put some kind of art on the walls of their public buildings. It has awakened the public's interest in art, and that is a healthy thing.

Some of the best things have been done by local artists. That is what happened in Italy. Paolo da Francesca was just a native boy painting his home town church in Arezzo.

After all, why be so fearful lest a wall painting be not good. The point is to get the painting on the wall. If fifty artists have a chance at the walls there is a greater probability of getting five great murals than if only five artists are commissioned at high prices. Then let the people decide. Perhaps have the walls repainted every ten years. That is what they did in the old days. Didn't Michelangelo paint his Last Judgment on top of a Perugino? Not that we are glad to have lost the Perugino. It just isn't a good idea to think mural painting is sacred because it is big.

The American Indians have a fine sense of geometrical decoration. It would be a grand thing if they could develop a school of mural painting with as little outside criticism as could be. From their first efforts in that direction it is obvious that you have only to give them the wall and they soon learn how to cover it.

Rivera and Orozco assimilated the European tradition and then came back to paint in their native land. It is an amazing thing

LANDSCAPE AND MURAL

that they were able to combine their own racial tradition of art with that of the European, and produce great work in such a short space of time. Such an assimilation often takes centuries. I am proud to say that the work of our Indians and the Mexican artists was first shown in the United States by the Society of Independent Artists in 1920 and 1923, respectively.

My own experience in mural painting is very recent. This winter I painted a mural for the Treasury Department for the Bronxville, New York, Post Office. After making a color study to scale, I threw this up on the canvas with a projector. Studies of details such as hands and faces were also thrown up with the projector. Note that I did not put any photograph in the projector but only drawings which were made as mental concepts. In this mural I worked out problems of foreshortening with great care. The railroad train which recedes into the picture is drawn with acute foreshortening. The further you walk from the canvas, the more the cars stretch out in ordinary visual perspective. The horse drawn face-on could not possibly be seen by the eye in that way. One trouble with a great many contemporary artists who are using photographs for documentary detail, is that they are drawing directly from the photograph—repeating all the visual distortions.*

Another criticism I find is that the color in many of our present day wall paintings is meager and timid. This may be the reasonable consequence of a desire to be inoffensive to varied tastes. Another characteristic is a kind of melancholy spirit, maybe this is the real spirit of the time. Still we must be thankful that we have this healthy art infant in the United States and give it room to grow. Above all we must not take away its bottle.

^{*}It might be well to remind you that when you look at an average reduced size reproduction or photograph of a painting your eye is seeing it at what would be a considerable distance from the original. Viewing a print six inches wide of an original picture six feet wide from a distance of eighteen inches is the same as looking at the original from a distance of eighteen feet!

CHAPTER IX

MEMORANDA

A Word to the Aesthetic Consumer

I HAVE SAID that the language of art is similar to that of music or literature, the technique of which can be learned. Moreover, I believe that anyone who seeks real enjoyment of art or music must have some knowledge of the language, just as we study grammar in order to learn how to read and write.

The fact that the grammar of art, the use of graphic symbols to make visual images, has been lost to the general public and even the artists during the past hundred years or so, has built up a feeling of mystery around art. The devices of art, the tools of expression, are no more mysterious than are the words of everyday speech. Those few artists who have carried on the tradition of concept-painting, have had to contend with ignorance on the part of public and critics. The making of art has been regarded as an eccentric act, rather than a normal function of primitive and civilized man.

The thoughts and technical means set down in this book represent the experience of one individual, and are therefore not intended to be comprehensive or authoritative. I make little claim to original thought, but rather wish to pass on what I have become conscious of.

It is true both for the consumers of art as well as the producers, that knowledge of the technique must be assimilated before we are free to enter into communication with the author's concept. A knowledge of words increases the enjoyment and understanding of prose or poetry. That one's interpretation will be keener is of

[156]

MEMORANDA

little importance; the vital point is that we are enabled to appreciate the meaning because our own grasping of the idea passes through a process similar to that of the creator. Thus, a conscious study of art increases the appreciator's ability to derive spiritual nourishment.

The artist has a creative attitude toward other works of art. His life is enriched by the good things he finds in the world, nature or art. His critical attitude is constructive. He goes through life picking out the worthwhile, using his critical sense to discard the things which are poor and false. This charitable attitude toward the inevitable faults in a living thing permits the artist to enjoy all kinds of work. The minor critic, on the other hand, is so pleased with himself for finding faults that he is unable to appreciate the underlying quality of a work.

Consumers of art make a great mistake in attempting to imitate the "authorities". They are deluded when they think that the evaluation of faults in a work corresponds to appreciating it. I might go so far as to say that the ignorant person who says, "I like that picture,"—even if it is a bad painting—is getting more æsthetic enjoyment out of it than a sophisticated person who is merely looking for the faults. Perfection in a work of art is no criterion of real value because technical perfection is the only standard on which there can be agreement; creative thought, breadth of understanding and its communication to others, is something which cannot be measured.

The integrity of the work is what counts. A brief sketch or a humble study that conveys a sincere thought is more to be admired than a grandiose attempt to imitate a superficially important picture. The artist who knows that he is honestly following his own talent is happy in his work. He feels himself part of the stream of art and is content with his ability, whether he is contributing important original work or only carrying on the tradition.

The consumer and buyer of art would do well to cultivate this

[157]

frame of mind. With some understanding of the technique and the courage of one's convictions, less importance would be attached to the "success" of the best press-agented names. The true consumer is like the creative artist. He observes, studies, and digests; his perceptions are quickened and his taste is fortified by real knowledge. He is then able to enjoy a work of art for what it is, a document of human, spiritual communication.

I do not recommend that the consumer should study the technique of art all at once, and then feel equipped to understand. He should do as the artist does: seek knowledge when and where he feels the need of it, assimilate it, use it, and then study again.

Sundry Suggestions

(Inspired by twenty-four years of looking at students' pictures)

Go buy yourself a lemon and a plate. You will learn more about painting in five weeks by yourself than in five years in class.

Thomas Eakins used to tell his students to paint an egg, a lump of sugar, and an earthenware plate on a plain linen towel. We need to do more of that kind of studying into the real nature of form and texture, the problems of painting things as we know them.

If you become discouraged, work on another canvas for a while. Don't give up or throw away your failures. Sometimes you can come back to them with a courage you don't have on a canvas that is going well.

Have the courage to begin each day by scraping. If you are glazing, do not hesitate to clean off the color and re-draw the form in tempera.

If you are interested in copying, go to the museum and do it. All the masters learned by copying. I would like to be able to come to class one week, and demonstrate how Rubens painted, Rembrandt the next, and so forth. I should be able to do it.

A sketch should be carefully painted with a great deal of

[158]

MEMORANDA

thought. The color is of least importance and made too much of.

Analyze your motive for painting a study. Studying is thinking, but the adding up of facts is not necessarily thinking. A good study is a search into the nature of the thing and the problem of expressing it in graphic medium.

Don't confuse painting the thing exactly the color you know it is, with painting the thing as it looks.

Before you start to paint come to some conclusions about how you are going to see the color. Have a prejudice about the color. Form a campaign on your palette. Mix up some positive tones and draw with them. Do not be led astray by the casual color-changes you see in nature.

Sculpture the thing with broad tones, tones well separated in interval. Hammer the thing together. The point is to paint firmly. Knit the tones together to make the form and the place it is in. Stroking in shadow-shapes isn't constructive painting. Get the plastic inter-play of tones that will make the dry reality of substance.

I don't know why a square plinth isn't the best thing in the world from which to paint a column.

Find the most realized place in the canvas, and try to realize the rest of it as well. Find the change, the step in interval that will turn the corner, vitalize the form.

Keep up your black and white courage in painting. Interpret the black and white darks of a drawing into colored darks. Have the courage to strike the color notes hard. Think of them as musical octaves—high, low, middle.

Get some bitterness of color-change. Colors don't clash when they can be made to work together on the form. Look out for saccharine colors. Get the textures harsh enough to realize the form.

Bear in mind the color quality you want, and draw into your tones with sequences and changes of value that you have decided on with mental conviction. Organize your thoughts and materials.

If the color is too strongly imposed, not part of the form, it will be more important than the form. Any color will look like a stain when it is out of place. The right color keeps its place on the proper plane.

Look out for crude whites and raw color. They stand out as paint areas. Don't flounder around in color. It is worse than bad language. Use it step by step to build form.

You cannot conquer wrong color with right. It is a matter of good thinking. Think of the neutral colors as carrying the form, the positive colors as color-textures. You lose the significance of the neutrals if you start with positive colors and paint them out.

I am no longer attracted by what the clever brush does. Breadth of thought and not breadth of brushwork is what counts. Broad brushstrokes can record a narrow mind. Crude niggling also may have no breadth of thought.

Avoid graceful wavy brushstrokes. Look out for the one that is too suave in its movement, juicy with paint, like some horrible person in a crowd. The commercial brushstroke.

Keep your mind on the sculptural solidity of the thing, the cubism of the form. A brushstroke describing the shape of the thing, a vital, daring brushstroke is good. But the invention of a brushmark shape isn't invention.

Van Gogh's paint is always drawing. Each mark of the brush is significant. You may think that he tossed his paintings off very casually, but let me assure you that he must have scraped many areas over and over again before getting the drawing to suit himself.

Small brushwork is an endless job if you have no idea what you are after. Men like Chardin or Vermeer may have worked many months on one canvas, weaving tone into tone and building up textures with the utmost care. They never lost sight of the things they were after. A Memling is fresh, though studded with detail.

[160]

Draw with the brush. Carve the form. Don't be carried away by subtleties of modelling and nice pigmentation at the expense of losing the form.

Every inch of the canvas is important. What you insist on calling a background and think of as a place to get covered with paint —that is a place, a real thing. The surface is no less real than an arm covered with hair and freckles. The background must be a plastic support to the foreground.

Because you see a bland, light-swept area in nature there is no reason for having one on your canvas. There is no change in the solidity of the thing when the light strikes it. The form and color are there.

Some pictures look like brush-developed photographs: clouding of one tone into another; the eye saying "Yes, but"; oiliness; pictures full of gray air, hazes, fogginess, slime; no concern with the dry existence of things, the definition of things. Even water has a definite form and surface. Get the "thereness" of fog or steam. Atmosphere in a painting is nine-tenths fear.

A tone that floats through the canvas like mist over a marsh destroys the dry sculpture of the forms. You may be able to get rid of that pervading smokiness by making one or two positive modifications. The problem is to find out where that tone is cropping out once or twice too often. In a picture which is painted with a close tonality, the modifying color that weaves through the design to hold it together, must be very carefully controlled.

On the other hand, when you are working with positive contrasts of color, the color harmony may be thrown out of key by mis-related values in the black and white scale. It is always wise to keep tones set on the palette which have been arranged in intervals that will function properly on the canvas.

Little highlights sprinkled onto the canvas cheapen the concept. One or two well selected textural accents will bring life to the whole composition. Some paintings have no color, no sense of the twelve colors. A fine painting always gives one the feeling of color powers in reserve, even if it is painted with only vermillion and blue. A painting without color quality would make one feel that vermillion and blue were the only colors in the world; one wouldn't feel that there were also yellow and green and purple on the palette which the artist had not chosen to use in the particular canvas.

While I am not at all interested in color for itself, I am a little tired of these half-dead color schemes constantly repeated by so many contemporary painters. One feels that all the colors are pulled down by black. I call them chain-gang pictures. "Give us light red, Indian red, and black," they say. "Give us the ball and chain." I like to see my students practise with the palette of hues and then open it up, use the force colors. You can't get powerful color-plastic realization without using the whole gamut of the palette.

There are students who, when painting heads, come to the cheek with a loud whoop and plant a rose there. "I know what color this is going to be! This is a red cheek and that is yellow hair!" Be sure of the colors that are less obvious. I would be perfectly willing to make a study in neutrals and let someone else paint in the blues and reds.

There are others who find oil paint romantic. Their palettes looks that way. By a romantic palette, I mean they have no control over it. Well, Delacroix was what they called a Romantic, and he had absolute control over his palette. He had an orderly palette, set, tuned for work. In fact, it was the job of one of his assistants to set the palette every morning. Could one imagine a musician tuning the piano every time he was going to play? To play your colors by eye is worse than playing the piano by ear.

Some canvases are immersed in color. They exist as spots of color and not as forms. Stuttering color vibrations do not contribute to the realization of the thing, because they are not put in purposefully. In the work of Seurat, you can see the dots of neutral colors carrying the form and then the dots of more intense color that make the color-texture. It is a totally different principle than that of the Impressionists who used broken color to imitate visual effects.

Don't imitate the color in nature. Of what use is it to get the colors that a perfected camera could record more accurately than the human eye?

When you find that your work is losing clarity of structure and sensitivity, some study of fine architecture may help to discipline your thought. If you feel that your pictures are suffering from over-stylization, artificial simplicity, observe things in nature with great care. Forget that you are looking for picture material. Perhaps describe the forms to yourself as though planning to write. Refresh your concepts of things, your archetypes, by looking at nature not as something to be analyzed into geometrical shapes but as a world of interesting things. Observe the texture and character of places and people as any human being would, without thinking of how you would transcribe your thoughts into paint. All vital work springs from a background of human observation.

There is no ideal balance which the artist should cultivate between his interest in art and nature. The creative process is an organic thing which cannot be dissected. An artist's way of working is regulated by his individual personality. The problem of expressing what his mind and heart see in nature must be knit with the problem of formal expression, while he is working. At other times he may be more aware of nature than the means and end, and vice versa. When there is lack of coördination between the object, the mind, and the hand, there is no concept and no art results. The work will only be scientific or emotional observation, or abstract formula.

The artist has many problems to solve in his life. He must grapple with economic difficulties as well as human and artistic ones. It is indisputable that modern life offers little encouragement to the fine artist. On the other hand, obstacles of some sort seem to be a necessary incentive to creative work. If the artist is free to work all the time, the work is apt to go up a tree. Only a strong personality seems able to survive the privilege of having unlimited leisure.

When you are too satisfied with your own opinions, when you find your work growing stagnant, arouse your interest by looking in new directions. Change your medium, look for new subject matter, or go to the museum.

Sometimes we come to a fresh appreciation of the great masters through a sympathy for the work of lesser ones. If we are sensitive to the real principles of art, we get a kick out of finding them in work that previously has passed our notice. This ability to grow within ourselves is a vital quality. Without it there is no chance of maturing. Question your own judgments, which include those you have accepted from others.

We are so apt to form generalizations which prevent us from finding new sources of information and inspiration. For instance, there is the idea that the Germans' creative talent is psychologically limited to music and literature. We recognize a few graphic artists like Dürer, Bosch, and Cranach. Why forget that great painter, Grünewald? His work goes far beyond cruelty or sentimentality in its tremendous realization.

Giovanni Bellini is a fine artist whose work is often overlooked because Giorgione and Titian came after him. Carpaccio is another whose contribution has been eclipsed by the importance of his near contemporaries. We too often think of the Van Eyck brothers as inventors of oil painting, rather than artists. The trouble with studying the history of art is that we put tags on an artist's work and forget to renew our acquaintance with it.

It is a deep secret, but Millet really is good. He has been a bad influence because his work was popularized for its pictorial "charm". Underneath the obvious subject matter is grand plastic design and profound feeling for character. Théodore Chassériau is important in his relation to Ingres and Delacroix.

I mention these examples to point out a matter of principle. You can often find your own direction and means through the work of lesser, but no less genuine, masters. Botticelli, Watteau, the Le Nain brothers and the like may help you more than Michelangelo and Leonardo. Find your own direction and follow it through.

There is a real necessity for work done today to convey the artist's spiritual and material contact with this time. What importance can your work have if you take a point of view and technical method which if you should succeed in doing ten times better than you could hope to do, would then be one tenth as well done as it was done four hundred years ago?

CHAPTER X

NOTES ON PAINTING TECHNIQUE

ANYTHING YOU PAINT underneath another tone is bound in time to come through to some extent. The most opaque pigments are really translucent and become more so as the binder changes with age.

Since the oil binder of pigments darkens with time, you should paint on a white ground which can reflect light through the layers of oil paint and counteract their darkening as the paint grows more transparent.

A white gesso ground made of glue and whiting retains its brilliance longer than an oil ground. Pictures painted on panels stay more brilliant than those on canvas because the gesso is thicker.

All paint films contract when they dry. A picture should be painted "fat over lean": the paint that dries fastest and hardest on the bottom, working up to paint that dries slowly in the upper layers.

A layer of oil paint dries with a skin on the top which prevents the paint underneath from drying. Paint dries by oxidation and this skin prevents the underneath paint from breathing.

Varnish dries evenly through the paint film. If there is too much varnish in the paint it may crack and be difficult to paint with, but some varnish should be used in all oil painting so the paint films will dry evenly.

A good medium for direct painting is: one part oil, one part varnish, and one part *turpentine*. Stand oil is better than cold pressed linseed oil. Do not use poppy oil. It may look lighter than

NOTES ON PAINTING TECHNIQUE

linseed oil but it dries very slowly and darkens more than linseed. The addition of a little venice turpentine makes the medium more crisp to work with.

When working directly you should either paint all at one time or build up the paint films very carefully, letting the picture dry between each sitting. Always mix the medium with the tones on the palette, to get even distribution of oil and varnish through the paint films. Add a little more oil to the medium in each successive layer of paint. You have only to look at the direct paintings made in the last sixty years to see how much damage has been done already by the sloppy use of medium. The paint is stained as though with tobacco juice and the paint films are cracking all over.

Get the habit of keeping your palette and brushes clean. Wash brushes every day with a mild soap and dry thoroughly. While working, clean the brush with turpentine and wipe with a rag before making each positive color change. It is a bad habit to get texture by the mere accidental use of a brush full of dirty oil paint. Keep the cup of medium clean. Do not use medium which has been standing open to the air a long time.

When an area starts to "sink" give it a coat of good retouching varnish. Cheap retouching varnish forms a hard film over the paint layer which prevents it from drying.

You should wait at least one year and preferably two before varnishing an impasto oil painting.

There is no really satisfactory varnish. Damar darkens least but it is soft and sometimes becomes sticky in damp weather. Mastic is harder but darkens some and also has a tendency to bloom. Copal dries very hard and becomes insoluble, but darkens a good deal. Because of its insolubility I have often thought of putting a thin coat of it over each of my glazed pictures so restorers would have trouble removing the color as they have done to so many old paintings. A final varnish of damar could be removed easily and renewed without disturbing the protective film of copal. If a picture has been permanently varnished and you want to do more work on it, you should remove the varnish from the areas you are going to re-paint. If it was done in oil, you can never be sure that the re-painted area will stay in tone with the rest.

Never rub oil over a painting to bring out the color. It leaves a greasy film that will darken. The final varnish brings out the colors, but its real purpose is to protect the oil paint from absorbing moisture from the air. A wax varnish dries mat.

Canvas must be sized with glue to prevent the oil from burning up the fibres. Some chemists say that the canvas should be sized with a hot glue that can penetrate through from front to back. Then it is important to put a coat of varnish or shellac on the back to prevent the glue from absorbing moisture from the air. Moisture is bad for paint films and makes them swell and contract, causing cracking.

Commercial canvas is primed with an oil ground. If you prime your own, use a half-oil ground which will stay whiter.

Gesso grounds for oil painting must be sized to prevent the oil from sinking into the ground, staining it and making putty.

Sketches may be made on paper or cardboard sized with glue or shellac.

Do not use zinc white in oil painting or for tempera. It is very chalky, apt to crack, and requires more oil binder than lead white does. Consequently, it will darken more. Lead white is the most reliable. When ground with oil it becomes like horn after the paint is dry. Titanium white is chemically inert and a very intense white. Sometimes it chalks a little but it is otherwise reliable.

Most oil paints are ground too fine, which reduces the color power and makes the pigment take up more oil. Some pigments are heavier than others and require some filler to keep them suspended in the oil. Too much filler makes the pigment like butter and increases the oil content. (If you have the time and interest, grind your own pigments. Use oil and some varnish.) Always

NOTES ON PAINTING TECHNIQUE

use the materials of a reputable firm. Cheap colors are full of extenders, poor in color power, and will not stay permanent.

Generally speaking, the transparent pigments are ground very fine and take up a lot of oil. The opaque pigments require less oil for easy handling and dry faster. Remember this, and do not put a thick layer of white lead or Indian red over a layer of alizarine, ultramarine, viridian, and other slow drying pigments.

Most of the permanent colors may be mixed together. But alizarine should never be mixed with the earth colors, raw sienna and raw umber. It is considered safe in mixture with burnt sienna and burnt umber, but it is wisest not to mix it with any colors at all. Since it is a very useful glazing color this is important to remember. Doerner says that it may be mixed with cremnitz white, but other authorities disagree with him.

When tube paints contain an excess of oil, this can be removed by squeezing the pigment on a blotter. In about half an hour the superfluous oil will be absorbed.

Gesso Grounds

The old masters generally worked on wood panels which had been well seasoned. These are expensive and hard to obtain so the modern artist uses a wood plyboard or panel of compressed wood fibre. I have used Masonite Prestwood for the past ten years and prefer it to plywood, which has a tendency to crack and warp.

If you use Prestwood, both sides should be roughened with coarse sandpaper. Gesso will chip off a smooth or non-absorbent surface. Both sides of the panel should be sized, and care taken to work plenty of glue into the edges and corners.

Glue has a strong "pull", so there must be an even number of size and gesso coats on both sides of the panel or it will warp. I generally glue theatrical gauze to the back with a strong casein glue, which counteracts the warping as effectively as several coats of gesso. The back may then be coated with shellac or wax. Because glue paints contract so much, it is important to remember never to put a stronger coat over a weaker one. If you do, the top coat will tear off the underlayers, cracking or peeling like old wall paper.

General proportions for making size: One ounce of rabbit skin glue to eleven ounces of water. (For sizing canvas, one to fourteen.) Good quality white flake glue may be used.

Soak the glue in water overnight and heat in a double boiler. Never let glue boil, as it loses its strength.

Glue is stronger in cold weather than in hot.

A good glue should set to a jelly of stiff consistency. If it separates it has become rancid and is no good. When it is the right strength for size it is tacky when rubbed between the fingers.

If you add a few teaspoons of whiting to a quart of glue it will keep for a long time in a covered container. The whiting keeps the glue from souring.

To make gesso: Add about eighteen ounces of bolted whiting to a quart of warm, liquid size. Whiting makes a tougher gesso than precipitated chalk. A little titanium white may be added to the whiting if you want a very white surface. The amount of whiting may be varied. Stir it into the glue until the liquid looks like heavy cream.

Size the panels on both sides with warm size. Be sure that the size gets into all the pores of the surface. Let the panels dry overnight.

The first coat of gesso should be applied quite warm. If it is rubbed in with a piece of hard turkish towel you will have less trouble with air bubbles. All the air bubbles must be rubbed out, as they form pock holes in the gesso.

The next coat should be put on as soon as the first one starts to dry white. Be sure to add two or three teaspoons of water to each quart of gesso before starting the next coat. This counteracts the loss of moisture caused by evaporation. It is also necessary

NOTES ON PAINTING TECHNIQUE

in order that each successive coat should be slightly weaker than the one underneath.

The first two coats may be put on with criss-crossing brushstrokes. After that, if you are covering a large panel, paint the surface in squares as large as one brush-load of paint will cover easily. Work one coat in one direction, and the next coat at right angles to it.

After the first three or four coats use a medium fine piece of sandpaper to get rid of specks of dirt and other foreign substances. Add two or more coats and let the gesso set. When the surface is dry to touch, go over it with a fine sandpaper to get rid of irregularities. If you like a rough surface, you can put on the last coat or two with a cold gesso. The brushmarks will stand up. Rubens often worked on a gesso with sweeping brushmarks criss-crossed on the surface. Its texture shows through the glazes.

Do not gesso in a cold room. Many air bubbles will arise when the hot gesso comes in contact with the cold surface of the panel. If you dry the panel with too much heat the gesso will crack. The outside surface contracts faster than the layers underneath.

If you have some old gesso saved in a pot and want to know how strong it is, warm it up and paint out two or three coats on a piece of sized wood. Let the sample dry and sandpaper it with OO paper. If the surface becomes very shiny there is too much glue. If it powders very easily there is too little.

Gesso for frames, wooden boxes, and other things which must stand up under hard usage, should be made with a strong size. You can use proportions of one part glue to six parts water. Size the wood well on all sides and let it dry overnight. Add as much whiting to the glue as it will take and apply the gesso hot. Let the first coat dry overnight and then sandpaper. Add a little water to the gesso and put on a second coat. This dries very fast. The surface can be roughened by scratching.

Gesso for canvas must contain some oil (or other plasticizer)

to keep it from cracking. Add boiled oil drop by drop to a heavy, cool gesso and beat well until the oil is absorbed. From a quarter to a third oil by volume will make a good half-oil ground. I have sometimes added white lead, stiffly ground in oil and diluted with turpentine, to the regular gesso to make a half-oil ground. Use about four parts gesso to one part oil pigment of equal consistency. Pour the oil paint into the gesso very slowly, and stir well. A halfoil ground should dry several weeks before being used. You can add more oil to the gesso, but why do so as the oil will only make the ground darken like regular oil paint.

Tempera

Water-soluble binders like glue and gum arabic are called distempers. Tempera is an emulsion made of a water-soluble binder and an oily binder. Egg yolk is a natural emulsion and is often used as the base for an emulsion containing oil or varnish. Pure egg tempera is very delicate and difficult to handle. It cannot be used for impasto work.

Casein is another natural emulsion, which has very strong binding power. When used alone as a binder the pigment dries very mat, and becomes waterproof.* It dries so fast that it is easier to handle and more suitable for impasto work if some varnish and oil are added. If too much oil is mixed with casein the paint will vellow.

The advantage of using an emulsion for grinding pigments is that you have the strong binding power of the water-soluble glue (which dries fast and does not darken the way oil does) plasticized by an oil, varnish or balsam. The plasticizer makes the paint less brittle and easier to handle, because it does not dry so fast as distemper.

The beauty of the tempera medium is in its fine dry pastel tones and brilliant colors. It may be applied in delicate washes, *If you want to make gesso or glue tempera waterproof, give it a coat of formalin (4 per cent formaldehyde).

NOTES ON PAINTING TECHNIQUE

or built up impasto. The tones can be worked together in subtle gradations, or applied crisply in the finest of detail. It can be used to paint pictures very complete in sculptural detail, as by Mantegna and Signorelli. But if you wish to get great luminosity of color and strong color-textures, it is necessary to glaze over the tempera with transparent oil colors.

The medium has none of the greasy qualities of oil paint. The surface dries quickly, so you cannot push the paint around. At first this seems a disadvantage but it really helps to keep the drawing clear-cut. The tones dry slightly lighter than when the paint is wet. Sets of graduated tones have to be kept on the palette so one can be sure of getting the right tone in the right place on the canvas. Because the binder has a lower refractive index than oil, the pigment layers are more opaque than oil paint of the same thickness. While you are working out the drawing of the form a very thin wash of tempera will cover up tones that are to be changed. If the paint gets loaded up from much re-drawing, it can be scraped off with the palette knife.

An emulsion that contains more than half water-soluble binder may be diluted with water. This is preferable for underpainting. If you want to build up with tempera on top of oil glazes, it is wise to use an emulsion that is soluble in turpentine. In this case, the emulsion is made by adding a small quantity of casein, or other water-soluble binder to the varnish and oil.

One may also make a "mixed white" for underpainting or building up. To do this you grind a batch of white pigment with casein and another with oil. If you want to thin with water, use two parts casein-ground pigment to one part oil-ground pigment, by bulk. Grind them together well with the palette knife or muller. If you want to dilute with turpentine or thin glazing medium, use two parts oil pigment to one part casein pigment. These proportions may be varied slightly. If you mix equal parts the paint is hard to thin and has a tendency to cheese.

[173]

It is best to use mixed white for painting on canvas as it has more give than plain tempera. It stays wet a little longer than tempera and permits freer brushwork. Titian and Veronese probably used this medium, perhaps Rembrandt.

A very oily tempera will not stick well on the gesso surface. As the paint tends to crawl, the brush will sometimes pick up the paint underneath. Too much oil in the emulsion will make the paint darken as in regular oil paint.

If you are making an oil-in-water emulsion, add the oil part to the water part. Shake well in a bottle or beat with an egg beater until the mixture looks like mayonnaise. A good emulsion can be diluted with water easily. If the emulsion is to be a water-in-oil combination, put the oil and varnish in the bottle first, and add the glue or egg second.

Casein solution can be made with powdered casein or cottage cheese. It is very important that the casein should be fresh as it loses its strength. It smells sweet when fresh. Take six level teaspoons of powdered casein and stir in two ounces of cold water. Then add four ounces of hot water and one teaspoon of strong ammonia water. (Do not use household ammonia as this often contains other chemicals). Stir the mixture while it effervesces, and let it stand twenty minutes. It should then be translucent and feel tacky like glue when rubbed between the fingers. It should be about the consistency of thin honey. If it feels granular it is no good.

To make a casein emulsion: To two parts casein solution, add one part medium consistency varnish and one-quarter part stand oil. A few drops of venice turpentine will help the emulsion to form quickly. Shake well. This emulsion is quite strong and may be diluted with water for grinding pigments. Always grind a little pigment with a new emulsion and let the sample dry to see if the emulsion has the right binding power. It should not crack when built up in a quarter inch impasto.

NOTES ON PAINTING TECHNIQUE

The proportions of varnish and oil may be changed, provided you bear in mind that the casein part must be more than the oil part or it will not stay emulsified. If the casein is too watery, it will not accept the oily constituents easily. When the pigment is ground in a good stable emulsion, it stands up like oil paint. There is something the matter with the emulsion if the paint separates into water and pigment, or if the paint curdles.

If you grind the pigments in water first, use a strong emulsion. Otherwise, add a little water to it. When grinding large quantities use a muller and ground glass. Smaller amounts may be ground with the palette knife. Be sure to get the pigment evenly ground.

As tempera dries fast on the palette, large quantities should be kept in covered jars, or muffin tins covered with wet blotters. You can keep the paint on the palette moist by spraying with water every half hour. Do not try to re-grind paint that has dried.

Some pigments require more binder than others, which you can tell from the feeling in grinding. Terre verte is one of these. I prefer to use oxide of chromium with a little raw umber. This has more color power and is less transparent than terre verte.

Pigment can be kept ground in emulsion for some time before it becomes moldy. If a little oil of cloves is added to the emulsion, it will stay sweet longer. Do not keep it in a hot place.

A very simple and practical use of tempera is to mix a jar full of Titanic white* with emulsion, and use all other colors in dry form, in small jars on or near your palette. They can then be quickly brush-mixed with emulsion or white or both.

In using tempera I recommend that the student work first with black and white, or raw umber and white, to get the feel of the medium. A set of tones should be mixed on the palette, say five in number, ranging from white to medium dark. Many studies of the simple solids should be made with this limited means. Then paint with the hues, and work up to the use of the full palette.

[175]

^{*}Prepared by Lewensohn Co., N. Y. C.

Lay in the first drawing very thin, and then build up tone on tone until you get the sculptural form as desired. Use sable or bristle brushes, and dilute the paint with water. Learn how to mix from one tone interval to another to make a graduated tone. You have to work quickly and surely, keeping the edge of the tone wet to work the next brushstroke in. You can also modulate tones by hatching. When you are skilful you can match dry tones.

After you have worked out the drawing of the form, keeping the paint very thin, you can start to load up the lights. This gives textural support to the glazes.

If you want to make complete pictures in tempera, you can use the full gamut of the palette, and carry out the drawing in great detail. It is a waste of time to put too much detail in the underpainting, as it is obliterated by the glazes. Details should be added later with a mixed white.

Use your studies for experiments in glazing. Make them in different colors, different tonalities.

When the underpainting is completed, let it dry over night. It must then be "isolated" to prevent the oil varnish glazes from sinking into its semi-absorbent surface. This may be done with gelatin* (one teaspoon of cooking gelatin to six ounces of water). Spray the gelatin on with an atomizer or use a soft brush. You have to work very deftly or the water may dissolve the tempera. Some artists prefer to isolate with a thin damar varnish or diluted shellac. Let the painting dry thoroughly before glazing. Moisture left on the surface may cause blooming.

Glazing

General formula for glazing medium: one part stand oil, two parts heavy varnish, and two to three parts turpentine. This may be adjusted to suit. If there is too much oil the glazes will slide. If there is too much varnish the surface gets too sticky. Too much $\overline{*A}$ little grain alcohol added to the gelatin solution will preserve it for future use.

NOTES ON PAINTING TECHNIQUE

turpentine in the medium will dissolve the under glazes. A few drops of venice turpentine in the medium makes it more precise in handling. The medium should stand several hours after being made up, so the turpentine will be absorbed by the oil and varnish.

Even when glazing you should observe the principle of "fat over lean." If you are putting many glazes on top of one another, add a few drops of oil to the medium now and then.

In glazing, work with as little medium as possible. The blackened blues and madders in the old pictures are caused by an excess of medium. If you are covering a large surface, the glazes should be mixed in jars so an even amount of medium is carried through the paint layers.

If some part of the glazed painting sinks after the second glaze, give it a light coat of retouching varnish or thin damar. When the glazes get too glassy, let the painting dry and rub them down with pumice.

If you build up in white with an oil-in-water tempera on top of the glazes, you must isolate the new areas with gelatin or varnish. It is better to use a water-in-oil tempera or mixed white. They are sufficiently non-absorbent not to need isolation.

You can build up impasto with either white or color. The tempera will work well on wet or dry glazes. A half dry glaze that contains a little venetian turpentine is fine to work into. You can use broad strokes of tempera or the finest hair-lines.

You can also paint thin veils of tempera over whole areas that have gone dead, and then re-draw with solid white. Sometimes I work a little tempera white or dry pigment into a wet glaze to make a scumble. It makes a useful textural contrast to scumbles made of glazes containing white oil paint.

CHAPTER XI

ETCHING, AND DIVERS MEDIUMS

ETCHING IS A WAY OF DRAWING—purely a drawing technique. The line is a symbol which expresses without equivocation the thought of the artist. The beauty of an etched print is in its significant linework used to define and describe things.

A quality of etching, which gives it a special character shared with line engraving, lies in the fact that the ink lines are raised in relief when the bitten plate is run through the press and printed. The raised surface of those lines gives them more textural significance in a very subtle way.

Popular etching in the last century degenerated into the parlorprint type of thing. In Whistler's Venice vignettes we see precious lines surrounded by an expanse of tone, reaching the boutonniere stage, a butterfly in the corner of a plate. I agree with Whistler, however, that it is bad taste to make an etching over ten by fourteen inches in size. As for Zorn's eminent men in line-storms, that use of linework is an imitation of paint marks copying light and shadow shapes.

The classical linework of the masters was used to make things and texture and light and shade. An etching without drawing and composition is nothing, just a technical tour de force. Look at the etchings of Rembrandt and the line drawings in *Punch* by John Leech. Any kind of linework you don't find in their work is hardly worth having.

The classical line technique used by engravers before etching was popular is important, but need not be imitated. See how they

ETCHING, AND DIVERS MEDIUMS

used sets of parallel lines to define the planes, the direction of the forms. They had formulas for making flat surfaces and curved surfaces. Linework moving in one direction describes one movement of the form, a counter-direction further defines. Wide lines and thin lines, parallel and hatched, textures and dots--all used to sculpture form.

In etching, the line is more sensitive and richer in character than in engraving. In the fine Rembrandt plates there is a great range of texture, from fine drypoint to the clean engraved line; the rich etched line to the velvety line of drypoint with the burr. He used those contrasts significantly, letting the shadow side of the form slip away into fine cross-hatching and bringing out the texture in the light. He used contrast of texture to bring out color, to emphasize the design.

Well-done cross-hatching is made with clean parallel lines so that the interstices are even. The contrast of strongly bitten lines lying over finer ones, positive textures lying over under-textures, gives brilliance to the hatching.

The difference between an etched line and an engraved line is that the etched line is made wider and deeper by acid biting, while in engraving the metal is lifted out of the line by the tool itself. The sides of an engraved line are smooth, those of an etched line are rough, so the latter prints warmer. Different acids bite cleaner lines than others. Dutch mordant makes a straight-sided groove, nitric acid a more horseshoe-shaped and ragged groove. Retroussage brings the ink over the surface of the line and gives a richer print. When overdone, the line is blurry. Leaving some slight tone on the plate when wiping, enrichens the print. When overdone, the result is melodramatic technique.

You can learn the technique of etching without any great difficulty if you have some feeling for craftsmanship. The Art of Etching by E.S. Lumsden* is a good book on technique. But there is no end to the problem of drawing with the needle. One needs to

*Dover reprint, 1962.

make many drawings with pencil and pen. Study the master line draughtsmen: Dürer, Rembrandt, John Leech, Ingres, et al.

It is not a good idea to make an etching from too perfect a drawing. Often a wash or crayon study is more inspiring than one worked out in lines. You have to invent ways to translate the wash textures into line.

I generally make drawings for an etching on transparent paper so I can alter and improve them by tracing. I make the drawing the size of the plate. When I get what I want I transfer the main outlines to the smoked ground. (Vermillion powder rubbed on the back of the drawing makes a nice tracing). I don't like a tracing on the plate that is too full of detail, because I find myself trying to copy the traced lines rather than inventing a concentrated living line to define the things.

Always keep your etching needle properly sharpened to a rounded point that will not tear the surface. Draw with even pressure, bearing down just hard enough to remove the wax ground and to expose the metal beneath. When you draw with uneven pressure some lines will bite faster than others.

After drawing the most important contours and the positive linework that is to sculpture the forms, bite the whole plate in a half water, half nitric acid bath. Most etchers control the strength of the bath with great care and time the biting. I work almost entirely by instinct and judge the depth and character of the biting from experience. Be careful to keep removing the bubbles from the lines which are formed by the action of the acid. Use a feather or brush. Look out for places where the ground may break down, especially where there is a lot of cross-hatching. Where there are the most lines the acid will bite fastest, because heat is generated as the acid attacks the metal, and the acid bites faster when hot. Keep stirring the acid around in the bath. Take the plate out now and then, wash it with water and dry it. Hold it up to the light to see how deeply the lines are being bitten. Also

ETCHING, AND DIVERS MEDIUMS

feel the depth of the line with your needle. Only experience in printing can teach you to judge the biting.

When the more delicate lines have been bitten sufficiently, stop them out and bite the rest of the plate a little longer in the bath. Before doing this more lines may be added. After this biting, stop out some more, and fill in further new linework. After some experience with the bath tray biting, try "spit-biting." Apply saliva with a brush to all or such parts of the plate as you wish to bite. The acid is applied with a bulb-topped syringe and poured off after biting. A plate may be finished entirely in this way, in fact most of my etchings were so made. Depending on the difficulties I may run into, I work on the first state a long time, or pull a proof right away. Etching is one long fight to keep the plate under control, and having the courage to scrape out an area if it fails.

Before laying a second ground, be sure that the plate is completely free of grease. Use benzol, followed by the finest bolted whiting and clean water, to clean the plate. Cheap whiting is full of impurities that will scratch the surface.

When you take out an area with scraper, scotch stone, burnisher, and French charcoal, be sure that you get the surface smooth with a good polish. If the hole is quite deep, tap it up from the back, finding the place with calipers.

I generally use a rolled ground, but sometimes prefer a liquid ground in the later states. When you want to remove the ground in one area you can lay the new ground with liquid ground, and do not need to clean off the whole plate. You can make your own liquid ground by dissolving shaved-up ball ground in ether or chloroform. A liquid ground has to be poured very skilfully or it will be thicker on one part of the plate than another.

When a plate is underbitten all over, I sometimes succeed in laying a very thin ground for rebiting all over the surface, something very difficult to do without filling in the lines. Roll out the ground on another steadily heated plate and then deftly pass the

[181]

roller across the surface of the very slightly warmed etched plate two or three times. You have to examine the plate with a magnifying glass to clean out any lines which may contain ground. Sometimes it is possible to re-ground an underbitten plate if you first fill in the lines with whiting paste. The ground does not stick on top of the lines full of whiting, and the whiting can be washed out with water.

I have always been quite patient about making corrections, like scraping out a line or pushing together the sides of a line that I don't want to hold too much ink. You may sometimes grind down a whole area of linework so it will print more gray than black. It is just a trick if done stupidly, but it can be used to say a lot about light and texture.

Lately, I have been using the graver occasionally. It is a tool that takes a lot of practise to control. To make long, sweeping curved lines that lie parallel requires patience and skill. I like the fine clean line, it has a steely quality.

Making over two hundred plates in the last thirty-five years has not made me an expert technician in etching-perhaps I do not wish to be one.

If you are doing a great deal of etching it is wise to use a small electric fan to blow aside the acid fumes. They are bad for the membranes of the throat and nose, and hurt the eyes.

Printing an etching is almost an art in itself. I do not consider myself a proficient workman in that art. It is a matter of regret that very few young men are practising plate printing for artists. Peters Brothers are gone, Peter Platt also. Charles S. White is one of the old craftsmen still available. The young etcher should have his own press if possible, and from Lumsden's book he should be able to train himself to print quite well.

When you go through a lot of proofs, find the places that are apt to print badly and look for those in each proof. Sometimes the lines don't fill up because the inking-up is not done carefully;

ETCHING, AND DIVERS MEDIUMS

sometimes the ink is pulled out from too much retroussaging.

John Taylor Arms, that master technician, has most of his plates printed in England, where they have a real tradition of craftsmanship.

As soon as the first print is made an etching begins to wear down, but with modern steel-facing it is possible to preserve the plate through thousands of printings.

Every print is a handmade thing, the personal work of the artist, yet it may be put out in great quantity as a means of reproducing the artist's concept. Such prints might be sold at fifty cents or a dollar. I don't like high prices for prints, and limited editions. They delude the public, who think, the higher the price is, the better the work must be. It keeps people from having the courage to buy the work of unknown artists. But it is hard to convince the dealer that quality in quantity might be a financial success. He demands limited editions, and perhaps he is right. Today there is so much cheap printing of pictures by other means that it may be wise to keep the artist's etching a rarer item.

Aquatints

The English artists are remarkable craftsmen. There is astounding technique in their prints, especially in the aquatints and mezzotints.

I don't much care for an aquatint that is without at least a few etched lines. Without some linework, the print often looks like a poster or an imitation of a painting. There are a few fine Goyas with no etched lines, and then there is Delacroix's magnificent plate of the Man at the Anvil. Most of my aquatints started out as etchings. Working on a zinc plate, and not liking the coarse bite of the line, I would decide to continue the work in aquatint. There are but few in my product and, like my etching, they have no technical excellence.

The trouble with aquatint is that, if you mar some area or want

GIST OF ART

to make a change in it, it is so very difficult to patch with a tone anywhere near the particular grain you had before. And each time you remove the surface it takes a good deal of the copper off so you get a deep hollow in the plate which becomes hard to print evenly.

The beauty of an aquatint is in the contrast of textural tones. A tone that just looks like an acid tint isn't anything much worth having. You can do all kinds of things with an aquatint plate besides laying fine and coarse grained tones. You can scrape down a tone to lighten it, as one would with a mezzotint. You can work line textures against tone textures. You can melt the edge of a tone into the plain surface of the plate or you can have sharp contrast of gray and white.

To lay a fine aquatint ground, you should use the box method. Put rosin dust in a closed cardboard box and shake it up thoroughly. If you put the plate in the bottom of the box through a slot in the side as soon as you have finished shaking it, the ground will be coarse, as the large particles settle to the bottom first. If you want a fine ground, let the rosin settle to the bottom for quite a time before putting the plate in the box.

If you are not very fussy about getting an even tone, you can put the rosin in a fine muslin bag. Hold the bag well above the plate and tap on it with a pencil until the rosin sifts down to the plate. If you want a very fine ground, hold the bag high and to one side of the plate, and only the finest particles will drift onto the plate itself.

Handle the plate with a great deal of care so the powdered rosin does not move around on the surface. To make the particles stick on the surface, the plate is heated slightly until the powder becomes shiny and gives off a sweet smell. If you want a coarse ground, heat the plate longer until the specks of rosin spread out to form globules.

When the plate is put in the acid bath, the acid attacks the

ETCHING, AND DIVERS MEDIUMS

metal exposed between the grains of rosin. The larger the grains, the larger will be the white specks between the black of the etched parts, in the print. The deeper you bite the plate, the darker will be the tone, because the grooves hold more ink. Naturally, a fine ground looks blacker than a coarse ground, because almost all the surface of the plate is taking ink. If you bite too much, the acid eats under the particles of rosin and the tone will look moth-eaten.

After the ground has been laid on the plate, use stopping-out varnish or liquid ground to block out the areas that are not to be etched. Varnish out, then etch. Repeat this three or four times until the darkest tones are finished. Remove the ground and rosin. A new rosin ground must be laid for each tone that is to be texturally different. When you are very skilful you can lay a ground that graduates from fine particles to coarse particles. This is done partly in the floating of the rosin onto the plate and partly by careful heating.

My own way has been to put in etched lines for the general design before the aquatint tones. More lines may be put in later. It is difficult to draw a clean straight line over a rough aquatint surface, even through the wax ground.

Goya was the great master of aquatint. He designed his plates with broad textural patterns. See how he played finely grained tones against coarsely grained ones; dark tones against lighter ones; even tones against graduated ones. Notice how skilful his edges are, particularly where the aquatint tone is next to the bare plate. See how the light of the bare plate moves into the tone. Sometimes the edges are precise, elsewhere they seem to melt, seem to give tone to an open area. It can be done by very careful manipulation of the acid, or by grinding down the plate a little.

Goya was a master of the medium; he could play with it. He knew just when to use the tone and what tone, and when to go into etched lines. He was a great master of the medium because he had a point of view on life that interested him so much that the

GIST OF ART

plate and the needle were tools of his expression, not his main concern. He cared more for drawing than the "print."

Lithography

The beauty of lithography is in those rare, tender tones that you get only by drawing on the stone itself. A drawing that is made on paper and transferred to stone is not properly a lithograph, it has none of the qualities of a fine print. The stone has a finer surface than the finest paper in the world. It is like some wonderful crisp silk. When it is surfaced with a fine grain you can get very delicate tones and exquisite lines on it.

Study Daumier's prints. His use of the medium is honest and handsome. He made thousands of lithographs and was able to keep the drawing alive and rich and fresh. Study his, rather than Gavarni's because Daumier's are real drawings. Gavarni could do a lot of things with textures, but his work is apt to slip into sentimentality and cleverness and concern with effects rather than things. It is really best to learn about the use of a medium from those who are master draughtsmen and painters; to learn how to make Things from those who made them well.

Delacroix's illustrations for Goethe's Faust are fine prints. The fact that men like Delacroix and Daumier were making illustrations seems to have something to do with the livingness of their prints. They were concerned with something more than making a lithograph. The medium was only incidental and they drew the best qualities out of it for their purposes. Too many making prints nowadays are interested primarily in making prints, they are not interested in life.

It is a good thing to learn about a medium by using subjects that interest you more than the technical process itself. When you have a series of drawings,—butcher shops, subways, bargain basements, parks, and the like, and you feel the need of translating them into another medium, then is a good time to take

[186]

up lithography or etching. There is no excuse for making prints of concepts that are not worth having around once, let alone a hundred times.

An edition of lithographs, unless it is sold out as an illustration job, is necessarily limited because the artist must pay for the printing at the time of making the stone. With an etching you can put the plate away and print as the edition sells.

Water Color

Water color should be used as a colored drawing rather than a painting medium. Daumier's water colors are first of all drawings, with the color used to make the textures more vital and rich. You don't have to run all over the palette to make a water color. Choose two or three main color relations. Limit your colors as you would in oil painting. Use color sequences, significant changes in color to describe the near and far. Work with lines and color-textures on top of neutral under-tones. Even in the simplest sketch, a few lines and some color washes, there can be separation of form and color.

The trouble with water colors is that you hate to jump into a nice wash to get something more real. Always work on good rag paper so you can clean the wash off with a sponge or bristle brush without destroying the surface of the paper. Cheap paper is so absorbent that the color stains the surface.

With good pigments and fine rag paper, water color is a more permanent medium than oil paint. You can grind your own pigments with gum arabic and a little honey or glycerine as the old painters did, but be sure that the pigment is ground very fine. Pan colors are better to use than tube colors. The latter contain so much glycerine that the paint does not dry properly and the paper may mold because of moisture attracted by the glycerine.

Opaque water color used to touch up a transparent wash drawing is sometimes very useful and necessary to the realization of the

[187]

thing. (English custom forbids it.) It is well to remember that those opaque tones obliterate the separation of form and color which you have in the transparent washes on white paper.

Pencil, crayon, pastel and pen work well with water color. Use whatever combination of mediums you need, to get realization.

Gouache paintings have a tendency to look like wall paper. But for studying it is an interesting medium. You can melt one tone into another, or lay crisp marks on the dry surface.

When working with gouache you can't let any of the paper show through. The tones dry lighter than when you put them on the paper, which is annoying if you are using a complicated color scheme. Gouache always has a tendency to look like tones with varying tints of white in them. It is very hard to keep air out of the work because of the presence of white in all the pigments. If you put a full dark over a whitened tone the white comes through.

You can use tempera colors instead of gouache. They have more brilliance. If the work is done on a heavy illustration board, you can isolate the tempera and finish the painting with oil glazes.

CHAPTER XII

THE GIST OF IT ALL

ART IS THE RESULT of the creative consciousness of the order of existence. How can there be any ultimate solution of that? Art is the evidence of man's understanding, the evidence of civilization. Humanness is what counts. Man doesn't change much over the centuries, but there is some evidence that he is growing more human, very slowly, although it is his one great reason for being.

The artist has a song to sing. His creative mind is irritated by something he has to say graphically. You don't need to paint masterpieces or monumental subjects. Look out the window. Use your imagination. Get a kick out of that spacial adventure, the textures of things, the reality of the world. Find the design in things.

Seeing frogs and faces in clouds is not imagination. Imagination is the courage to say what you think and not what you see. Max Eastman has said:—The scientist describes water as H2O; the poet goes further and says "it is wet". We want to describe things that way. An ideograph is better than the thing itself. A better work of art tries to say the thing rather than to be the thing. The image has greater realization than the thing itself. That is the great beauty of poetry,—realization brought about by the use of images.

An artist is a product of life, a social creature. Of necessity he cannot mingle with people as much as he would like, but he reaches them through his work. The artist is a spectator of life. He understands it without needing to have physical experiences. He doesn't need to participate in adventures. The artist is interested in life the way God is interested in the universe.

[189]

The artist has his own life to live; he has to pause and select and find something to say about it. In his work he seeks to express his understanding with all earnestness. The man of integrity works for himself alone, spurning all temptations to sell out his ability for commercial success. Any artist who paints to suit buyers and critics is what Walter Pach calls an Ananias, and unworthy of the name artist.

We live in a complex world in which we are mutually interdependent. But the artist must be independent. I think he is the only person who has a right to be independent. The artist has always had to fight for his life, for freedom of expression, for the right to say what he believes.

There is no end, no goal in this job of being an artist. The longer you live the further you are from it. An artist may develop very slowly. He may be painting his best picture when he dies at seventy-five. The greatest men like Titian and Rembrandt were always growing, expanding. They didn't reach their top work and then start to repeat. They kept on maturing until they died. A man like Rubens found a great formula and was content to repeat himself. In Rembrandt's later work, done when the public ceased to recognize him, he achieved the greatest plastic realization of all the masters. Old and half blind, he drew with his mind and understanding to please himself, not the public.

The artist is in competition with himself only. A bird does not sing beautifully because there is a contest. Great men are not even aware of competition. Jury exhibitions and the awarding of prizes are detrimental to art. When people vote about matters of taste the thing selected is always mediocre, inoffensive, innocuous.

My life has not been very eventful but my work has made it utterly worthwhile. The only reason I am in the profession is because it is fun. I have always painted for myself and made my living by illustrating and teaching. Some of the etchings and a few paintings made twenty years ago sell now and then, but I have

THE GIST OF IT ALL

never made a living from my painting. If what I am doing now were selling I would think there was something the matter with it.

It is a sort of escape, a kind of refuge, not to have too much recognition while one is alive. You can go along doing your own work without being bothered too much with what people think. The works live, or rather exist, so much longer than the man.

Selling one's work is the problem of the individual and society. Too much economic success is a bad sign. If you know your history you will know that this is true.

I never thought of one of my good pictures as art while painting it. Whether it was art or not, it was what I wanted to do. Maybe the reason I haven't made a greater position in the history of art is that I am not sufficiently critical of my own work. Like one of those women in the park with a baby, I am proud of it because it is my own, a young hopeful. But we grow more critical in time.

It is better to send pictures to exhibitions and get them fired than to become so self-critical as never to try to exhibit. Anyone who buys the paper to see what the critic is saying about him when he is twenty-five, will take the critic too seriously by the time he is thirty-five.

Young people today are much concerned with having one-man shows. In my day a man didn't expect to have a one-man show until he was about forty-five. It is very bad to be interested in this kind of thing. Too many pictures are being painted for exhibitions with the hope of crashing the museums. The art schools are full of talented students who are carried away by the desire to paint like successful artists, instead of following the line of their own personal desire and interest.

You young people with your fresh minds, must weigh the words of every man over forty-five. I said that when I was forty-five and I am saying it now again. Every time I tell you something, weigh it with your minds. You don't have to take what I say. I am not an authority. There are no authorities over art.

[191]

The great artist is the bloom on a plant, which is the art of the period. There may be more than one bloom. All the rest of us are the roots, shoots and branches of that plant or falling petals from the flower. The work we are doing today is a preparation for the great artists who are to come.

We are still individualists. We have no traditional art. There are men like Rivera and Orozco who have been able to assimilate their native racial tradition, but the American Indian art is not close enough to us. We must push along. Perhaps a Naissance is coming here in America. We are working our way toward a healthy art expression. The movement for mural painting has done a great deal to stir the public interest in art, which in turn gives the artist a better chance to live. But for me the most interesting pictures are those that can be put in frames and moved about.

If all art students studied with me and carried on my ideas it would be unfortunate. But I hope that some of the younger artists will get hold of the idea I am working on—this principle of realization. It is the students who spread the idea. In fact, some of the most important teaching is done from student to student.

During the twenty-five years that I have been trying to instruct and inspire others I have learned a great deal from my students. Teaching has made me dig into my own work; I want to say something worthwhile to the fresh young minds with which I come in contact. Because I, too, am a student, ten years ago I turned my back on the type of work I had done in the past, work which had been recognized by critic and public. Many pictures I make today are frankly experiments, products of my laboratory. But in looking over my paintings and etchings of the last ten years, I feel satisfied that a number of them stand out as more powerful and truly creative works than those of my earlier period. Now that I am sixty-eight years old, I am grateful to have lived this long and look forward to more years of hard work. I am just a student, chewing on a bone, the way Picasso is.

[192]

INDEX

Ability, 6, 13, 14, 18, 38, 39, 51, 53, 83, 86, 98, 99, 153, 157, 164 Abstract art, 51 Academic study, 52, 55, 56 Academic work, 32, 47 Academicians, 12, 38 Academies of art, 29, 33 Action poses, 97 Advice to students and consumers, 156-165 Aesthetic consumer, 23-26, 156-158 Aesthetic qualities, 40, 41, 45, 46, 59 All Quiet on the Western Front, 5 Amateurs, 34 American Indian, 14, 21, 22, 31, 154 American Scene, 3, 4, 30, 146 Ammonia, 174 Ananias, or the False Artist, 30, 32, 190 Anatomical Facts, 91 Anatomy (see Figure drawing) Anshutz, Thomas P., 89 Anti-, 8 Appearances vs. things, 23, 29, 43 Appreciation, 9, 21, 23, 24, 36, 156-158, 164-165 Apprentice system, 153 Aquatint, 183 Archetype, 49, 85, 88, 103, 163 Armory Show, 15 Arms, John Taylor, 183 Artificial light, 134 Artacademies, 29, 33 and life, 18, 35, 163 and nature, 18, 19, 40, 163 a necessity, 26 as a symbol, 18, 36 buyers, 19, 24, 25 commercial, 32 conservative, 31 consumers of, 14, 23-26, 156-158 criticism, 30, 32, 157 dealers, 31, 33, 34 definitions of, 18, 19, 26, 31, 52, 189 Department of, 27-28 economics and politics, 29 for art's sake, 42 imagination in, 18, 189 imitative impulse in, 19 juries, 30, 33 life consciousness, 18, 19, 20

making a living at, 26-35 oriental vs. occidental, 149 originality and imitation, 35-38 owners, 24 Point of View About Art, Chapter III p. 18 progress in, 22, 23 projects, 29, 154 selling of, 34, 191 standards of, 23, 28, 31, 157 stimulus for (see Subject matter) 8, 9, 19, 20 students, 29, 51, 153, 191, 192 tradition of, 21, 22, 35, 43 ultra-modern, 44 understanding, 24 way to study, 83 "Art life", 18, 98--99 Art schools, 10, 11, 12, 13, 43, 52-55, 153, 191 Art Students League, 7, 10, 11, 56 Articulation of figure, 92 Artist, 22, 156-158, 189, 192 American, 4 anonymous, 22 and critic, 157, 191 and one-man shows, 191 and originality, 35 as easel painter, 16 as imitator, 36 as individualist, 22, 34 as spectator, 13, 14, 20 consciousness of reality, 19, 20 independence of, 7, 33, 34, 35, 190 modern and conservative, 11, 12 prizes in relation to, 29, 190 relation to contemporaries, 13, 30, 164, 192 relation to life, 13-15, 163-164, 192 tools of, 21 Aspect and concept, 12, 43 Assimilate, 6, 37, 51, 53, 154, 156-158 Atelier system, 115, 153 Atmosphere, 3, 74, 100, 161 Authority, 8, 25, 38, 56, 76, 158, 191 Background, 78, 145, 161 Barnes, A. C., 25 Barye, 88 Beardsley, 1 Beauty, 6, 107, 140, 147

[193]

abstract, 41 concept of, 40 emotional content, 44 in common things, 2, 42 in realization, 52 plan of, 48, 49, 106 significance of texture, 59 theories of, 100 what is, 19 Bellini, Giovanni, 110, 164 Bellows, George, 116 Biting, etching, 180-182, 184-185 Black and white, 54, 134-135, 159 Blake, William, 2, 89 Bosch, 164 Botticelli, 165 Bradley, Will, 1 Braque, 32, 53 Breughel, 50, 79, 110, 114, 148 Bronxville P. O. Mural, 155 Brushwork, 15, 160-161 Buyers of art, 19, 24, 25 Camera, 6, 11, 23, 43, 83, 163 Canvas, 166, 168, 170, 171, 174 Cardboard, 168 Caricature, 42, 87, 106, 147 Carpaccio, 110, 164 Casein tempera, 113, 172-176 Cézanne, 13, 25, 32, 35, 37, 48, 50, 66, 116, 147 Character, 78, 88, 105-108 Characeal drawing, 55, 61, 103 Chardin, 112, 146, 160 Chase, Wm. M., 109 Chassériau, Théodore, 165 Chevreul, 126 Chinese drawings, 57, 149 Chinese painting, 48, 57, 67 Chinese students, 84 Chords, of color, 128-130 Civilization, 21, 189 Class, a laboratory, 8 Classical form, 48 Classical linework, 58, 178 Clothed figure, 104-105 Clouds, 151 Color (Painting, Chapter VII) areas, 125, 130-133 Chevreul on, 126 chords, 128-130 common factor in, 133 composition, 124—133 Delacroix's use of, 126, 162 dominant, 124—133 Dudeen color triangle, 119-121 form and, 16-17, 45-48, 62, 109-117, 133, 140

foils, 124-126 formulae, 127-128 harmony, 124-133, 162 in the light, 62, 133-134, 140, 141, 161 local, 125-128 musical scales, 128 not graphic, 109 not simultaneous with form, 45 notations, 120-121, 152 pencils, 135 powers, 117-118 projection and recession, 117-118, 126-128, 131, 144, 152-153, 187 scales, 119-121 system, 115, 137 tangible, 118 texture, 45-48, 60, 114-115, 131, 138-141 tones, 109, 115—116, 126, 132, 135, 148, 151, 159—162, 175—176 triads, 128—130 whites, 131, 139, 177 Commercial work, 7, 32—34 Common things, 41 Competition, 5, 29, 190 Complementary colors, 119-122, 125, 128 Composition (see Design and Drawing) 74-86, 98-99 air pockets in, 74, 100 approach to, 74-80 bad, 80, 158-162 foreshortening in, 65-67, 80, 153, 155 good, 75, 76 method of, 70-72. 74-75 shadows in, 80 Concept, 15, 56, 76 and aspect, 12, 95–96 archetype, 49, 88 in painting, 12, 110 of nature, 18, 88, 148 Consciousness of life, 18, 19, 20 Constable, John, 2, 126, 146, 148 Consumers of art, 14, 19, 23-26, 156—158 Contours, 55, 57, 59, 64, 102 Contrast, 61, 63, 64, 65 Convictions, 36, 38, 158 Copy (see Imitation), 83, 84, 158 Corot, 9, 148 Courbet, 111, 146, 147 Cracking, 113, 166, 168-171, 174 Craftsman, artist, 21, 34 Cranach, 60, 114, 164 Craven, Thomas, 26 Creative impulse, 8, 9, 16, 18, 19, 20, 40 Critical Comments, 158-163

[194]

Criticism, 82-83, 156-158 Critics, 30, 31, 32, 46, 51, 157 Crowds, 78-80 Cruikshank, George, 81 Cube, the, 53, 63, 64 Cubism, 12, 13, 44, 45, 100, 159 Culture, 25, 29 Daumier, 1, 50, 78, 85, 102, 103, 106, 114, 117, 150, 186, 187 humanity of, 30, 41, 88, 106 light and shade, 63 line, 58 Davey, Randall, 116 Dealers, art, 30, 31, 33, 34 Degas, 19 Delacroix, 81, 83, 88, 100, 110, 111, 112, 126, 162, 165, 183, 186 Delacroix's Notebooks, 50, 112 Department of Art, 28, 29 Descriptive line, 57, 58 Design (see Composition), 69-72 Despiau, 107 Details, 75-77, 79, 106, 114, 148, 153, 155 Diagonals, in design, 71-72 Diagram, color, 119-122 Diaz, 25 Direct painting, 112, 113, 116, 166-169 Dissection, 88, 89 Distance (see Perspective and Space), 73, 74, 147, 149, 150, 152 Distemper, 172 Distortion, 65, 66, 86, 91, 155 Distortion vs. exaggeration, 106 Document, 20, 22, 82, 98 Doerner, Max, 112, 169 Dominant colors, 124-126, 128-130 Donatello, 74, 88 Drapery, 104-105, 145 Drawing, Chapter V, p. 53 (see Composition) anatomical knowledge in, 88, 89 approach to, 55-57, 61, 88, 98-99 brush and wash, 103 charcoal, 55, 103 colored, 117, 135, 187-188 for fun, 51 for painting, 159-161 good, 51, 54, 56, 57, 77, 85, 98-99 good academic, 56 informative, 85-86 memory, 81, 85-86, 88, 96, 99 methods of, 61, 62, 77-78, 98-103 outline, 55, 57, 102 pen, 55 reason for, 18, 91, 98-99 recession in, 96

significant, 54 structural understanding, 77, 89, 107 vs. painting, 109-110 with paint, 103, 159-161 Drypoint, 179 Dudeen color triangle, 119-121 Duncan, Isadora, 75 Dürer, 44, 58, 60, 78, 83, 85, 100, 148, 164, 180 Duveneck, Frank, 47 Eakins, Thomas, 3, 12, 89, 158 Easel pictures, 16, 192 Eastman, Max, 189 Edges, 57, 58, 64, 73, 76, 96, 99, 100, 101, 104, 107, 108, 132, 138, 141, 143 Egyptian art, 51 Emotion, 41, 42 Emulsion, casein, 174-175 Engraving, 178, 179, 182 Enters, Angna, 39 English artists, 2, 183 Entombment, Michelangelo, 84 Epstein, 107 Etching, 3, 14, 178-186 Etching, The Art of by E. S. Lumsden, 179 European tradition of painting, 15, 22, 154 Evergood, Philip, 42 Exaggeration, 106 Exhibitions, 30, 190, 191 Experience, 8, 19, 35 Eyesight and mind, 12, 43-44 Eyesight painting, 12, 23, 29, 43, 44, 111 Facility, 38 Facts, anatomical, 91-95 Facts, and truth, 9, 89, 99 Failures, 158 "Fat over lean", 166, 177 Faults, 52, 57, 88, 154, 157 Figure Drawing, 13, 87-108 Figure Painting, 144-145 Fish Girl, The, Hogarth, 2 Flemish painting, 114, 125 Foils, 75, 124-126, 130 Forain, 1 Foreground, 73, 74, 79, 161 Foreshortening, 66-67, 72, 80, 91, 104, 153, 155 Form (see Drawing) 39, 41, 43, 48-49, 50, 77-78 and color, 16-17, 40, 44, 45-48, 109-117, 118, 160-161, 187 and style, 48-49 basic forms, 12-13, 59, 63 color symbols for, 125, 127-128 "egg shell", 93, 102

[195]

imitation of, 49, 83 line and sculpture, 58 local color of, 127 plan in seeing, 100 plastic, 16, 148 projection, 64, 72-74, 78, 101 sculpturing of, 59, 62, 63-65, 77, 159-160 Formalin, 172 Formulae, 38, 46, 49, 50, 58, 62, 88, 110, 115, 163, 179 Freedom, 4 French critics, 32 French art, 22, 28, 34 Gavarni, lithographs, 186 Gelatin, 177 Genius, 8, 36 Geometric design, 70-72 German artists, 112, 164 Gilbert, Douglas, 10 Giorgione, 164 Giotto, 1, 43, 44, 74, 75, 88, 89 Glackens, William, 3, 25, 37, 82 Glackens' technique, 46-48 Glazing (see Form and Color), 136-143, 176-177 Glazing medium, 176 Glue size, 170 Glycerine, 187 Gothic period, 22, 85 Gouache, 88 Government, 4, 5, 28 Government, interest in art, 27-29, 154 Goya, 1, 42, 72, 183, 185 Grammar, 19, 44, 156 Graphic symbols, 53, 109 Graver, use of, 182 Great art, 42, 51, 61, 66 Greco, El, 37, 38, 44, 47, 50, 75, 83, 91, 112, 139 Greek, use of proportion, 90 Grosz, George, 56 Grounds, aquatint, 184—185 Grounds, etching, 180—182 Grounds, gesso, 166, 168—172 Growth, 150 Grünewald, 164 Guys, Constantin, 2 Half-oil ground, 168, 171-172 Harmony (see Composition, Color, etc.) and contrast, 65, 70 and contrast, 65, of concept, 49, 76 of light and shade, 62, 80 of relief, 44, 74 of textures, 65

Hals, Frans, 2, 15

Head, the, 13, 90, 92, 94, 95, 105-108 ricad, tne, 13, 90, 92, 94, 95, 105-10 Heights, scale of, 121 Henner, 25 Henri, Robert, 1, 3, 6, 7, 83, 116 Highlights, 55, 60, 107, 139, 145, 161 Hogarth, 2, 20, 58, 81 Hokusai, 84, 111 Holbein, 143 Homer, Winslow, 3 Hues (see Color) Hues (see Color) Human kindness, 87-88, 106 Humanism, 2, 9, 41, 147, Humor, 81, 147 Ideograph, 18, 189 Ikons, Russian, 42 Illusions, optical, 68-69 Illustration, 1, 2, 3, 7, 44, 81, 86, 150 Image, 12, 14, 18, 21, 37, 40, 41, 189 Imagination, 14, 18, 37, 97, 99, 146, 189 Imitation, 12, 35–38, 47, 49, 54, 60, 157, 163, 178 Impasto, 113, 172-177 Impossible, painting the, 52 Impressionism, 3, 163 Impulse, 20, 34, 37, 39, 40, 50 Independence of the artist, 33-34, 190 Independent Artists, Society of, 7, 14, 31, 155 Indian, American, 14, 21, 22, 31, 154 Individualism, 22, 34, 35 Individuality, 36 Inferiority complex, 5, 23 Informatory drawings, 85-86 Ingres, 100, 102, 111, 165, 180 Innocuous work, 52 Inspiration, 6, 7, 41 Institution, 29, 30 Interest in life, 39, 42, 45, 79, 146, 165 Inventor, 36, 40, 54, 57 Isolating solution for tempera, 176 Italian art, 22, 100, 125 Japanese, work of, 1, 22, 57, 72, 149 Jewish Bride, by Rembrandt, 114 John Brown's Body, 9 Joyce, James, 36 Juries, art, 30, 33 Keene, Charles (in Punch), 2, 104 Kubota, Beisen, 1 Labor organizations, 34

Labor organizations, 34 Laboratory, 8, 192 Landscape, 146—153 Language of art, 6, 14, 36, 40, 156 Leech, John, 2, 58, 79, 81, 178, 180 Leisure, 9, 164

[196]

LeNain brothers, 165 Leonardo da Vinci, 58, 83, 100, 165 Le Rire, 1 Lesser masters, 82, 84-85, 164-165 Life, Point of View About, Chapter I artist's life and work, 13, 14, 15, 16, 26-35, 163-165, 189-192 benut in 2 beauty in, 2 consciousness of, 9, 14, 16, 18-21 owes you nothing, 27 owes you nothing, teaching and, 7, 8 Light, 57-65 and color, 127, 133-134 and less light, 62 and shade, 61-63 areas, 71, 80 as a thing, 115 for working, 95 in composition, 61-63, 75 in landscape, 150 interiors, 80 in underpainted pictures, 114, 138-139 over dark, in painting, 137—139, 166 Likeness, 100, 105—107 Limitations, 14, 39 Line (see Design), 84, 144, 145, 147 as a sign, 15, 55, 57-58 drawing, 57-58, 98, 99, 102-103 in color, 135, 140-142 vs. color, 109 Linework, 55, 58, 134-135, 140-142 as color-texture, 140-141 in etching, 178-182 Signorelli, use of, 141 Titian, use of, 141 Literary motive, 42 Lithography, 186-187 Living, making a, 3, 26-35, 191 Local color, 70, 72, 127-128 "Looks like", 12 Low relief, 49, 59, 73-75, 110, 114, 136, 147-150 Luks, George B., 3 Lumsden, E. S. Art of Etching, 179 MacDowell Groups, 7 Machine Age, 35, 40 Man at the Anvil, Delacroix, 183 Mantegna, 44, 73, 78, 114, 173 Maratta, Hardesty G., 116, 119, 122 Masaccio, 74, 83, 109 Masses, The, 5 Materials of the Artist, Doerner, 112 Masters, great, 50, 83-84, 85 Masterpieces, 40, 50, 84 Matisse, 25 McCarter, Henry, 1 Medium, painting, 166, 167, 176

Memling, 160 Memorydrawing, 81, 85, 99, 150 painting from, 12, 15, 16 plastic concept, 3, 15, 40 Mental concept, 40, 43, 111 Mental technique, 12, 16, 18-21, 23 Mexican artists, 155 Mezzotint, 183, 184 Michelangelo, 41, 43, 83, 84, 154, 165 Millet, 25, 164 Mindand eyesight, 43 and heart, 50, 99 as a tool, 21 open, 82 sees form, 45, 46 Mirror, use of, 86, 103 Mistakes, 51, 82 Mixed technique (see Underpainting and Glazing) Mixed white, 173-174 Model, the, 12, 87-88 drawing from, 91-98 posing of, 95-98 Modelling, 45, 48, 59, 73, 111, 145 Model-stand, 95, 97 Moonlight, neutrals in, 133 Motives of the artist, 3, 19-21, 39-42, 159, 189—192 Motives of the buyer, 24-26 Murals, 16, 68, 115, 153-155, 192 Museum, 23, 30, 84, 92, 164 Music, 18, 20, 26, 40, 162 Musical scale in color, 128 Naissance, 192 National Academy of Design, 6, 28 Nature and art, 18-21, 40-42, 53, 84 simple solids in, 13 (see Landscape) Neutrals, colors, 118, 122-124, 130 dark, 137 significance of, 118, 127, 160 (see Form and Color) Night color, 128, 133-134 Night light quality, 134 Nineties, 1, 15, 106 Notation, color and height, 120-121, 132, 152 Notes, critical and helpful, 158-163 Observation, 85-86, 158, 163 Oil, 166-169, 171-174, 176-177 Oil of cloves, 175 Old masters, understanding of, 15, 32, 44, 47, 83, 113 Opinions, 7, 9, 26, 164

[197]

Optical grays, 116, 138 Optical illusions, 68-69 Orchestration of lights, 62 Order, in life, 20, 41, 53 in thinking, 53, 75 Organizations, 28, 29 Organize palette, 132 Oriental art, 67, 84, 149 Originality, 35–38, 47 Ornamental line, 58 Orozco, 154, 192 Outlines, 55, 57-58, 141 Owners of art, 24 Pach, Walter, 30, 149, 190 Painting (see Color) direct, 112—113, 116, 166—169 eyesight, 12, 23, 29, 43—44 from drawings, 134-135 is drawing, 109-110 linework in, 140-141 night-lit subjects, 133-134 realization in, 47, 109,-112, 114-115, 138-143 suggestions, 158-163 technical notes, 166-177 texture, 114-115, 139-143 underpainting and glazing, 113—117, 136—145, 151 vs. drawing, 109, 135 vs. sculpture, 74 Palette, use of, 123-124, 128-132, 151-153 Panels, wood, 166, 169-171 Paolo da Francesca, 154 Paper, water color, 187 Patriotism, 4 Pennsylvania Academy of Fine Arts, 89 Persian miniatures, 109 Personality, 8, 163-164 Perspective, 23, 65-68 in composition, 72, 74, 79 in figure drawing, 67, 91, 96, 101, 104 in landscape, 149 truth of, 68 Perugino, 154 Peters Bros., Phila., 182 Philadelphia Inquirer, 1 Philosopher, Chinese, 15 Philosophy, Rembrandt's, 105 Photographform in, 43-44 imitation of, 55, 155 of painting, 142, 155 Picasso, 32, 53, 192 Picture plane, 73-74 Pictures, acquaintances with, 24-26, 164 Pigments and binders, 166-175

Planesin composition, 61, 68, 72, 73, 74 light and shade, 45 linework description, 58, 140-142, 178-179 modelling and form, 48, 63, 84 tones to build, 58-59 Plastic concept (see Form), 3 Plastic realization, 45-46 Plasticizer, 171, 172 Plato, 9 Platt, Peter, painter, 182 Play, serious, 8 Poetry, 9, 20, 26, 40, 147, 156, 189 Point of view vs. opinions, 7 Portraits, 105-108 Posing the model, 95, 97 Poster Movement, 1 Poussin, 75, 146, 147 Power, 24, 61 Prestwood, Masonite, 169 Printers, etching, 182 Printing an etching, 182 Prints, 183 Prizes, 29, 52, 190 Profile, drawing the, 55, 96 Progress in art, 22, 23 Projection of color, 127-128, 131 Projection of form (see Planes and Realization) Projector, use of 155 Propaganda, 3, 9, 42 Proportions, 90, 105, 146 in design, 70, 72 of the human figure, 90 Public interest in art, 16, 18, 29, 154, 192 Publicity, 30, 34 Punch, London, 2, 79, 104, 178 Punning, in Shakespeare, 9 Purpose, 7, 51, 52, 55, 96 Quality of paint, 138, 142-143 Rake's Progress, The, Hogarth, 20 Raphael, 75 Realismfact painting, 59 sentimental, 30, 106 vs. realization, 13 Reality, 15, 19-20, 41, 48, 108, 146 Realization (see Form and Color) 4, 13, 39, 41, 45–48, 59–65, 100 114–115, 142–143, 145 definition of, 45 in the light, 62, 63, 80, 141 textural, 59-60, 76, 78 through separation of form and color, 16-17, 111

[198]

Recession of color, 117, 127-128 Recession of form (see Space) Relief, low, 49, 73—74, 136 Rembrandt, 1, 25, 37, 42, 46, 72, 74, 75, 85, 88, 106, 110, 125, 126, 137, 190 an amateur, 34 and Michelangelo, 41 and nature, 40 drawing, 52, 76, 78, 84, 135 easel pictures, 16 etchings, 178, 179, 180 Jewish Bride, 114 knowledge of limitations, 39 light and shade, 62, 72, 125 Man in Gold Helmet, 143 portraits, 105, 108 realization, 46-48, 105, 109, 112, 116, 141 use of lines, 58 Renaissance, 46, 111, 154 Renoir, 21, 25, 32, 37, 46-48, 84, 111, 113, 116, 146 drawing, 78 painting, 112, 126, 139, 147, 148 Reynolds, 2 Re-painting, 168 Repetition (see Contrast and Harmony) in design, 66, 69-72, 73, 77 of color, 117, 145 of symbol, 77 Representation, 42, 45 Resist perspective, 66--68 Rhythms (see Design) Rivera, Diego, 154, 192 Robinson, Boardman, 1 Rogers groups, 30 Romantic, 162 Rosin (see Aquatint) Rousseau, Le Douanier, 42, 52, 75 Rowlandson, 106 Rubens, 33, 44, 83, 109, 110, 111, 190 drawing, 74, 100 realization, 46, 114, 143 system, 115, 137, 139, 142 technique, 33, 36, 37, 46-48 use of color, 125-126, 158 Ruisdael, 143, 146, 148 Sargent, 12, 27 Scalecolor, 119-121 in design, 70, 72, 79, 146, 149 of heights, 121 Schider, Fritz, Plastisch-Anatomischer Handatlas, 89 Sculptor, 46, 88 Sculpture, 49, 59, 88, 145 Sculpturing form, 77, 96-103, 159-161

Scumbling (see Glazing) Seeing, with the mind, 7, 13, 15, 40, 43 Self-expression, 6, 18 Selling art, 34, 190, 191 Semi-neutrals and hues (see Color) Sensitivity, 9, 39, 82, 164 Sentimentality, 9, 41 Separation of form and color, 16-17. 45-48, 109-117 Set Palettes, 128-133, 151 Seurat, use of color, 163 Shade (see Light), 141 Shadows, 55, 58, 61-63, 80, 95, 107 Shaw, Bernard, 7 Shakespeare, 1, 9, 24, 37, 85 Shellac, 168, 176 Shimizu, Toshi, 111 Shinn, Everett, 3 Shoes, drawing of, 105 Signature, 85 Significant drawing, 45, 48, 54, 55, 59, 74, 109 Significant texture, 59 Signorelli, 74, 83, 141, 173 Signs, 15, 21, 36, 53, 54, 57, 58, 62, 109 Simple solids, 12, 13, 59, 63 Simultaneous contrast, 69, 124-125, 128, 132, 152 Sizing, 169-170 Sketches, 81, 85, 98, 105, 157, 158 Social consciousness, 3, 4, 5. Socialist, 3, 33 Solids (see Simple Solids) Southwest, landscape, 4, 147 Space, 49, 72-73, 96, 100 Spectator's attitude, 13, 14, 20, 40, 189 Spectrum, 117-118 Spiritual utilities, 28 Standards of art, 23, 28, 31, 157 Steinlen, 1 Still life, 12 Stimulus for art, 9, 19, 20, 40-41 Stripped glazes, 139 Students, 6—9, 10, 11, 16, 84, 191—192 Study, 32, 50, 51, 90, 98, 104, 158—163 of nature, 40, 146-151 of the masterpieces, 83-86 work you don't like, 24, 26, 50 Style, 38, 49, 50 Subconscious, 6, 51, 82, 94 Subject, the, 24, 41, 80, 99, 100, 106, 146 Subject matter, 3, 4, 8, 9, 16, 20, 21, 22, 30, 40, 41, 42, 44, 79, 81-82, 83, 85, 86, 87, 146, 147, 165 Success, 7, 27, 29, 33, 157 Surface, texture, 45, 59, 133 Surrealism, 44

[199]

Symbolism, 149 Symbols (signs), 18, 21, 36, 44, 45, 48, 49, 84, 88, 109–110, 156 System, color, 115, 137 Taste, 82-83, 90, 158 Teaching art, 6-17, 29, 43, 51, 192 literal interpretation of, 7 summary of principles, 15, 16, 17 Techniqueand the consumer, 156-158 melodramatic, 61, 179 mental, 19, 21, 23, 43 notes on painting, 166-177 secrets of, 37 significant, 44 skill in, 37-39, 101-102, 110 the "how", 7 visual, 83 Temperaadvantages of, 172 casein emulsion, 172, 174–175 underpainting, 136–139, 172–176 Texture, 57, 59–61, 63, 65, 95, 96, 101, 114–115 in relation to design, 73, 76 in Rembrandt's etchings, 179 in the light, 61-62, 80, 134, 135, 145 of living existence, 51 realization, 13 significance of, 59 tangibility, 45, 46 Things, Chapter IV 7, 15, 20, 23, 29, 38, 43, 103, 146, 150 Titanic white, 175 Titian, 44, 83, 109, 111, 116, 126, 164, 190 line drawings, 58, 141 realization, 46–48, 60 technique, 37 Tintoretto, 74, 111 Tolstoi, 10 Tonality (see Light and Shade) Corot landscape, 148 in composition, 75, 76, 78 in painting, 111, 115, 124-125, 130, 133, 161 Tones (see Design and Color) as foils, 124-126, 130 in drawing, 58-59, 176 mis-related, 161 Toolgraphic signs, 21, 53 mind as, 21 Touch, sense of, 43 Toulouse-Lautrec, 1, 117 Tradition (see Imitation and Technique), 6, 11, 22, 29, 35, 43, 85, 112, 115

French, 22 our heritage, 35 Training, 12, 37, 51, 56 Triads, color, 128-130 Triangle, Dudeen color, 119-122 Truth, 9, 99, 189 Truth in perspective, 65-68 Turner, 1 Ultra-modern art, 3, 6, 12, 15, 16, 23, 32, 44, 48, 56 Underpainting, 112-114, 172-176 and glazing, 136-142 for artificial light, 137 Understanding, 8, 13, 14, 16, 24, 37, 147, 156-158, 163-165 Unity of concept, 50, 76, 99 Universe, 8 Van Eyck, 164 Van Gogh, 17, 32, 33, 34, 148, 160 Van Leyden, 84 Van Ostade, 79 Varnish, 166-168 Velasquez, 15 Venetian mural painters, 80 Venetian painters, 114 Venice turpentine, 167, 174 Vermeer, 160 Veronese, 71, 110, 111, 137, 152 Visual, falseness of the, 12, 15, 19, 43, 55 Volumes, 105 War, 4, 5, 28 War Series, Goya, 42 Warping, 169 Water color, 77, 134-135, 187-188 Watteau, 165 Wax, 169 Whistler, 15, 178 White, Chas. S., printer, 182 White pigments, 168 Whites, built-up, 139, 177 Whiting, 170-171 Whitman, Walt, 147 Will, power of, 24 Winter, Chas. A., 116, 119 Wit, 6 Word symbols, 18, 21 Work, 1, 5, 9, 50-51, 82-83 Works of art, 26, 35, 87, 90 World, a better, 35 Worry, 3, 35 Yeats, John Butler, 24, 105 Zorn, 178

[200]

A CATALOG OF SELECTED DOVER BOOKS IN ALL FIELDS OF INTEREST

100 BEST-LOVED POEMS, Edited by Philip Smith. "The Passionate Shepherd to His Love," "Shall I compare thee to a summer's day?" "Death, be not proud," "The Raven," "The Road Not Taken," plus works by Blake, Wordsworth, Byron, Shelley, Keats, many others. 96pp. 5% x 8%. 0-486-28553-7

100 SMALL HOUSES OF THE THIRTIES, Brown-Blodgett Company. Exterior photographs and floor plans for 100 charming structures. Illustrations of models accompanied by descriptions of interiors, color schemes, closet space, and other amenities. 200 illustrations. 112pp. 8% x 11. 0-486-44131-8

1000 TURN-OF-THE-CENTURY HOUSES: With Illustrations and Floor Plans, Herbert C. Chivers. Reproduced from a rare edition, this showcase of homes ranges from cottages and bungalows to sprawling mansions. Each house is meticulously illustrated and accompanied by complete floor plans. 256pp. 9% x 12%.

0-486-45596-3

101 GREAT AMERICAN POEMS, Edited by The American Poetry & Literacy Project. Rich treasury of verse from the 19th and 20th centuries includes works by Edgar Allan Poe, Robert Frost, Walt Whitman, Langston Hughes, Emily Dickinson, T. S. Eliot, other notables. 96pp. 5% x 8½. 0-486-40158-8

101 GREAT SAMURAI PRINTS, Utagawa Kuniyoshi. Kuniyoshi was a master of the warrior woodblock print — and these 18th-century illustrations represent the pinnacle of his craft. Full-color portraits of renowned Japanese samurais pulse with movement, passion, and remarkably fine detail. 112pp. 8% x 11. 0-486-46523-3

ABC OF BALLET, Janet Grosser. Clearly worded, abundantly illustrated little guide defines basic ballet-related terms: arabesque, battement, pas de chat, relevé, sissonne, many others. Pronunciation guide included. Excellent primer. 48pp. 4% x 5%.

0-486-40871-X

ACCESSORIES OF DRESS: An Illustrated Encyclopedia, Katherine Lester and Bess Viola Oerke. Illustrations of hats, veils, wigs, cravats, shawls, shoes, gloves, and other accessories enhance an engaging commentary that reveals the humor and charm of the many-sided story of accessorized apparel. 644 figures and 59 plates. 608pp. 6 ½ x 9½.

0-486-43378-1

ADVENTURES OF HUCKLEBERRY FINN, Mark Twain. Join Huck and Jim as their boyhood adventures along the Mississippi River lead them into a world of excitement, danger, and self-discovery. Humorous narrative, lyrical descriptions of the Mississippi valley, and memorable characters. 224pp. 5% x 8½. 0-486-28061-6

ALICE STARMORE'S BOOK OF FAIR ISLE KNITTING, Alice Starmore. A noted designer from the region of Scotland's Fair Isle explores the history and techniques of this distinctive, stranded-color knitting style and provides copious illustrated instructions for 14 original knitwear designs. 208pp. 8% x 10%. 0-486-47218-3

ALICE'S ADVENTURES IN WONDERLAND, Lewis Carroll. Beloved classic about a little girl lost in a topsy-túrvy land and her encounters with the White Rabbit, March Hare, Mad Hatter, Cheshire Cat, and other delightfully improbable characters. 42 illustrations by Sir John Tenniel. 96pp. 5% x 8½. 0-486-27543-4

AMERICA'S LIGHTHOUSES: An Illustrated History, Francis Ross Holland. Profusely illustrated fact-filled survey of American lighthouses since 1716. Over 200 stations — East, Gulf, and West coasts, Great Lakes, Hawaii, Alaska, Puerto Rico, the Virgin Islands, and the Mississippi and St. Lawrence Rivers. 240pp. 8 x 10³.

0-486-25576-X

AN ENCYCLOPEDIA OF THE VIOLIN, Alberto Bachmann. Translated by Frederick H. Martens. Introduction by Eugene Ysaye. First published in 1925, this renowned reference remains unsurpassed as a source of essential information, from construction and evolution to repertoire and technique. Includes a glossary and 73 illustrations. 496pp. 6% x 9%. 0-486-46618-3

ANIMALS: 1,419 Copyright-Free Illustrations of Mammals, Birds, Fish, Insects, etc., Selected by Jim Harter. Selected for its visual impact and ease of use, this outstanding collection of wood engravings presents over 1,000 species of animals in extremely lifelike poses. Includes mammals, birds, reptiles, amphibians, fish, insects, and other invertebrates. 284pp. 9 x 12. 0-486-23766-4

THE ANNALS, Tacitus. Translated by Alfred John Church and William Jackson Brodribb. This vital chronicle of Imperial Rome, written by the era's great historian, spans A.D. 14-68 and paints incisive psychological portraits of major figures, from Tiberius to Nero. 416pp. 5\% x 8½. 0-486-45236-0

ANTIGONE, Sophocles. Filled with passionate speeches and sensitive probing of moral and philosophical issues, this powerful and often-performed Greek drama reveals the grim fate that befalls the children of Oedipus. Footnotes. 64pp. $5\% \times 8\%$. 0-486-27804-2

ART DECO DECORATIVE PATTERNS IN FULL COLOR, Christian Stoll. Reprinted from a rare 1910 portfolio, 160 sensuous and exotic images depict a breathtaking array of florals, geometrics, and abstracts — all elegant in their stark simplicity. 64pp. 8% x 11. 0-486-44862-2

THE ARTHUR RACKHAM TREASURY: 86 Full-Color Illustrations, Arthur Rackham. Selected and Edited by Jeff A. Menges. A stunning treasury of 86 full-page plates span the famed English artist's career, from *Rip Van Winkle* (1905) to masterworks such as *Undine, A Midsummer Night's Dream*, and *Wind in the Willows* (1939). 96pp. 8% x 11.

0-486-44685-9

THE AUTHENTIC GILBERT & SULLIVAN SONGBOOK, W. S. Gilbert and A. S. Sullivan. The most comprehensive collection available, this songbook includes selections from every one of Gilbert and Sullivan's light operas. Ninety-two numbers are presented uncut and unedited, and in their original keys. 410pp. 9 x 12.

0-486-23482-7

THE AWAKENING, Kate Chopin. First published in 1899, this controversial novel of a New Orleans wife's search for love outside a stifling marriage shocked readers. Today, it remains a first-rate narrative with superb characterization. New introductory Note. 128pp. 5% x 8%. 0-486-27786-0

BASIC DRAWING, Louis Priscilla. Beginning with perspective, this commonsense manual progresses to the figure in movement, light and shade, anatomy, drapery, composition, trees and landscape, and outdoor sketching. Black-and-white illustrations throughout. 128pp. 8% x 11. 0-486-45815-6

THE BATTLES THAT CHANGED HISTORY, Fletcher Pratt. Historian profiles 16 crucial conflicts, ancient to modern, that changed the course of Western civilization. Gripping accounts of battles led by Alexander the Great, Joan of Arc, Ulysses S. Grant, other commanders. 27 maps. 352pp. 5% x 8½. 0486-41129-X

BEETHOVEN'S LETTERS, Ludwig van Beethoven. Edited by Dr. A. C. Kalischer. Features 457 letters to fellow musicians, friends, greats, patrons, and literary men. Reveals musical thoughts, quirks of personality, insights, and daily events. Includes 15 plates. 410pp. 5% x 8%. 0-486-22769-3

BERNICE BOBS HER HAIR AND OTHER STORIES, F. Scott Fitzgerald. This brilliant anthology includes 6 of Fitzgerald's most popular stories: "The Diamond as Big as the Ritz," the title tale, "The Offshore Pirate," "The Ice Palace," "The Jelly Bean," and "May Day." 176pp. 5% x 8½. 0-486-47049-0

BESLER'S BOOK OF FLOWERS AND PLANTS: 73 Full-Color Plates from Hortus Eystettensis, 1613, Basilius Besler. Here is a selection of magnificent plates from the *Hortus Eystettensis*, which vividly illustrated and identified the plants, flowers, and trees that thrived in the legendary German garden at Eichstätt. 80pp. 8% x 11.

0-486-46005-3

THE BOOK OF KELLS, Edited by Blanche Cirker. Painstakingly reproduced from a rare facsimile edition, this volume contains full-page decorations, portraits, illustrations, plus a sampling of textual leaves with exquisite calligraphy and ornamentation. 32 full-color illustrations. 32pp. 9% x 12½. 0-486-24345-1

THE BOOK OF THE CROSSBOW: With an Additional Section on Catapults and Other Siege Engines, Ralph Payne-Gallwey. Fascinating study traces history and use of crossbow as military and sporting weapon, from Middle Ages to modern times. Also covers related weapons: balistas, catapults, Turkish bows, more. Over 240 illustrations. 400pp. $7\% \times 10\%$. 0-486-28720-3

THE BUNGALOW BOOK: Floor Plans and Photos of 112 Houses, 1910, Henry L. Wilson. Here are 112 of the most popular and economic blueprints of the early 20th century — plus an illustration or photograph of each completed house. A wonderful time capsule that still offers a wealth of valuable insights. 160pp. 8% x 11.

0-486-45104-6

THE CALL OF THE WILD, Jack London. A classic novel of adventure, drawn from London's own experiences as a Klondike adventurer, relating the story of a heroic dog caught in the brutal life of the Alaska Gold Rush. Note. 64pp. 5% x 8%.

0-486-26472-6

CANDIDE, Voltaire. Edited by Francois-Marie Arouet. One of the world's great satires since its first publication in 1759. Witty, caustic skewering of romance, science, philosophy, religion, government — nearly all human ideals and institutions. 112pp. 5% x 8%. 0-486-26689-3

CELEBRATED IN THEIR TIME: Photographic Portraits from the George Grantham Bain Collection, Edited by Amy Pastan. With an Introduction by Michael Carlebach. Remarkable portrait gallery features 112 rare images of Albert Einstein, Charlie Chaplin, the Wright Brothers, Henry Ford, and other luminaries from the worlds of politics, art, entertainment, and industry. 128pp. 8% x 11. 0-486-46754-6

CHARIOTS FOR APOLLO: The NASA History of Manned Lunar Spacecraft to 1969, Courtney G. Brooks, James M. Grimwood, and Loyd S. Swenson, Jr. This illustrated history by a trio of experts is the definitive reference on the Apollo spacecraft and lunar modules. It traces the vehicles' design, development, and operation in space. More than 100 photographs and illustrations. 576pp. 6% x 9%. 0-486-46756-2

A CHRISTMAS CAROL, Charles Dickens. This engrossing tale relates Ebenezer Scrooge's ghostly journeys through Christmases past, present, and future and his ultimate transformation from a harsh and grasping old miser to a charitable and compassionate human being. 80pp. 5% x 8%. 0-486-26865-9

COMMON SENSE, Thomas Paine. First published in January of 1776, this highly influential landmark document clearly and persuasively argued for American separation from Great Britain and paved the way for the Declaration of Independence. 64pp. 5% x 8%. 0-486-29602-4

THE COMPLETE SHORT STORIES OF OSCAR WILDE, Oscar Wilde. Complete texts of "The Happy Prince and Other Tales," "A House of Pomegranates," "Lord Arthur Savile's Crime and Other Stories," "Poems in Prose," and "The Portrait of Mr. W. H." 208pp. 5% x 8%. 0-486-45216-6

COMPLETE SONNETS, William Shakespeare. Over 150 exquisite poems deal with love, friendship, the tyranny of time, beauty's evanescence, death, and other themes in language of remarkable power, precision, and beauty. Glossary of archaic terms. 80pp. 5% x 8%. 0-486-26686-9

THE COUNT OF MONTE CRISTO: Abridged Edition, Alexandre Dumas. Falsely accused of treason, Edmond Dantès is imprisoned in the bleak Chateau d'If. After a hair-raising escape, he launches an elaborate plot to extract a bitter revenge against those who betrayed him. 448pp. 5% x 8½. 0-486-45643-9

CRAFTSMAN BUNGALOWS: Designs from the Pacific Northwest, Yoho & Merritt. This reprint of a rare catalog, showcasing the charming simplicity and cozy style of Craftsman bungalows, is filled with photos of completed homes, plus floor plans and estimated costs. An indispensable resource for architects, historians, and illustrators. 112pp. 10 x 7. 0-486-46875-5

CRAFTSMAN BUNGALOWS: 59 Homes from "The Craftsman," Edited by Gustav Stickley. Best and most attractive designs from Arts and Crafts Movement publication — 1903–1916 — includes sketches, photographs of homes, floor plans, descriptive text. 128pp. 8% x 11. 0-486-25829-7

CRIME AND PUNISHMENT, Fyodor Dostoyevsky. Translated by Constance Garnett. Supreme masterpiece tells the story of Raskolnikov, a student tormented by his own thoughts after he murders an old woman. Overwhelmed by guilt and terror, he confesses and goes to prison. 480pp. 5% x 8½. 0-486-41587-2

THE DECLARATION OF INDEPENDENCE AND OTHER GREAT DOCUMENTS OF AMERICAN HISTORY: 1775-1865, Edited by John Grafton. Thirteen compelling and influential documents: Henry's "Give Me Liberty or Give Me Death," Declaration of Independence, The Constitution, Washington's First Inaugural Address, The Monroe Doctrine, The Emancipation Proclamation, Gettysburg Address, more. 64pp. 5% x 8¼. 0-486-41124-9

THE DESERT AND THE SOWN: Travels in Palestine and Syria, Gertrude Bell. "The female Lawrence of Arabia," Gertrude Bell wrote captivating, perceptive accounts of her travels in the Middle East. This intriguing narrative, accompanied by 160 photos, traces her 1905 sojourn in Lebanon, Syria, and Palestine. 368pp. 5% x 8½.

0-486-46876-3

A DOLL'S HOUSE, Henrik Ibsen. Ibsen's best-known play displays his genius for realistic prose drama. An expression of women's rights, the play climaxes when the central character, Nora, rejects a smothering marriage and life in "a doll's house." 80pp. 5% x 8¹/₄. 0-486-27062-9

DOOMED SHIPS: Great Ocean Liner Disasters, William H. Miller, Jr. Nearly 200 photographs, many from private collections, highlight tales of some of the vessels whose pleasure cruises ended in catastrophe: the *Morro Castle, Normandie, Andrea Doria, Europa*, and many others. 128pp. $8\% \times 11\%$. 0-486-45366-9

THE DORÉ BIBLE ILLUSTRATIONS, Gustave Doré. Detailed plates from the Bible: the Creation scenes, Adam and Eve, horrifying visions of the Flood, the battle sequences with their monumental crowds, depictions of the life of Jesus, 241 plates in all. 241pp. 9 x 12. 0-486-23004-X

DRAWING DRAPERY FROM HEAD TO TOE, Cliff Young. Expert guidance on how to draw shirts, pants, skirts, gloves, hats, and coats on the human figure, including folds in relation to the body, pull and crush, action folds, creases, more. Over 200 drawings. 48pp. 8½ x 11. 0-486-45591-2

DUBLINERS, James Joyce. A fine and accessible introduction to the work of one of the 20th century's most influential writers, this collection features 15 tales, including a masterpiece of the short-story genre, "The Dead." 160pp. 5% x 84.

0-486-26870-5

EASY-TO-MAKE POP-UPS, Joan Irvine. Illustrated by Barbara Reid. Dozens of wonderful ideas for three-dimensional paper fun — from holiday greeting cards with moving parts to a pop-up menagerie. Easy-to-follow, illustrated instructions for more than 30 projects. 299 black-and-white illustrations. 96pp. 8% x 11.

0-486-44622-0

EASY-TO-MAKE STORYBOOK DOLLS: A "Novel" Approach to Cloth Dollmaking, Sherralyn St. Clair. Favorite fictional characters come alive in this unique beginner's dollmaking guide. Includes patterns for Pollyanna, Dorothy from *The Wonderful Wizard of Oz*, Mary of *The Secret Garden*, plus easy-to-follow instructions, 263 blackand-white illustrations, and an 8-page color insert. 112pp. 8¼ x 11. 0-486-47360-0

EINSTEIN'S ESSAYS IN SCIENCE, Albert Einstein. Speeches and essays in accessible, everyday language profile influential physicists such as Niels Bohr and Isaac Newton. They also explore areas of physics to which the author made major contributions. 128pp. 5 x 8. 0-486-47011-3

EL DORADO: Further Adventures of the Scarlet Pimpernel, Baroness Orczy. A popular sequel to *The Scarlet Pimpernel*, this suspenseful story recounts the Pimpernel's attempts to rescue the Dauphin from imprisonment during the French Revolution. An irresistible blend of intrigue, period detail, and vibrant characterizations. 352pp. 5% x 8%. 0-486-44026-5

ELEGANT SMALL HOMES OF THE TWENTIES: 99 Designs from a Competition, Chicago Tribune. Nearly 100 designs for five- and six-room houses feature New England and Southern colonials, Normandy cottages, stately Italianate dwellings, and other fascinating snapshots of American domestic architecture of the 1920s. 112pp. 9 x 12. 0-486-46910-7

THE ELEMENTS OF STYLE: The Original Edition, William Strunk, Jr. This is the book that generations of writers have relied upon for timeless advice on grammar, diction, syntax, and other essentials. In concise terms, it identifies the principal requirements of proper style and common errors. 64pp. 5% x 8%. 0-486-44798-7

THE ELUSIVE PIMPERNEL, Baroness Orczy. Robespierre's revolutionaries find their wicked schemes thwarted by the heroic Pimpernel — Sir Percival Blakeney. In this thrilling sequel, Chauvelin devises a plot to eliminate the Pimpernel and his wife. 272pp. 5% x 8%. 0-486-45464-9

AN ENCYCLOPEDIA OF BATTLES: Accounts of Over 1,560 Battles from 1479 B.C. to the Present, David Eggenberger. Essential details of every major battle in recorded history from the first battle of Megiddo in 1479 B.C. to Grenada in 1984. List of battle maps. 99 illustrations. 544pp. 6½ x 9½. 0-486-24913-1

ENCYCLOPEDIA OF EMBROIDERY STITCHES, INCLUDING CREWEL, Marion Nichols. Precise explanations and instructions, clearly illustrated, on how to work chain, back, cross, knotted, woven stitches, and many more — 178 in all, including Cable Outline, Whipped Satin, and Eyelet Buttonhole. Over 1400 illustrations. 219pp. 8% x 11%. 0-486-22929-7

ENTER JEEVES: 15 Early Stories, P. G. Wodehouse. Splendid collection contains first 8 stories featuring Bertie Wooster, the deliciously dim aristocrat and Jeeves, his brainy, imperturbable manservant. Also, the complete Reggie Pepper (Bertie's prototype) series. 288pp. 5% x 8½. 0-486-29717-9

ERIC SLOANE'S AMERICA: Paintings in Oil, Michael Wigley. With a Foreword by Mimi Sloane. Eric Sloane's evocative oils of America's landscape and material culture shimmer with immense historical and nostalgic appeal. This original hardcover collection gathers nearly a hundred of his finest paintings, with subjects ranging from New England to the American Southwest. 128pp. $10\% \times 9$.

0-486-46525-X

ETHAN FROME, Edith Wharton. Classic story of wasted lives, set against a bleak New England background. Superbly delineated characters in a hauntingly grim tale of thwarted love. Considered by many to be Wharton's masterpiece. 96pp. 5% x 8 ¹/₄. 0-486-26690-7

THE EVERLASTING MAN, G. K. Chesterton. Chesterton's view of Christianity — as a blend of philosophy and mythology, satisfying intellect and spirit — applies to his brilliant book, which appeals to readers' heads as well as their hearts. 288pp. 5% x 8½. 0-486-46036-3

THE FIELD AND FOREST HANDY BOOK, Daniel Beard. Written by a co-founder of the Boy Scouts, this appealing guide offers illustrated instructions for building kites, birdhouses, boats, igloos, and other fun projects, plus numerous helpful tips for campers. 448pp. 5% x 8%. 0-486-46191-2

FINDING YOUR WAY WITHOUT MAP OR COMPASS, Harold Gatty. Useful, instructive manual shows would-be explorers, hikers, bikers, scouts, sailors, and survivalists how to find their way outdoors by observing animals, weather patterns, shifting sands, and other elements of nature. 288pp. 5% x 8½. 0-486-40613-X

FIRST FRENCH READER: A Beginner's Dual-Language Book, Edited and Translated by Stanley Appelbaum. This anthology introduces 50 legendary writers — Voltaire, Balzac, Baudelaire, Proust, more — through passages from *The Red and the Black*, *Les Misérables, Madame Bovary*, and other classics. Original French text plus English translation on facing pages. 240pp. 5% x 8½. 0-486-46178-5

FIRST GERMAN READER: A Beginner's Dual-Language Book, Edited by Harry Steinhauer. Specially chosen for their power to evoke German life and culture, these short, simple readings include poems, stories, essays, and anecdotes by Goethe, Hesse, Heine, Schiller, and others. 224pp. 5% x 8%. 0-486-46179-3

FIRST SPANISH READER: A Beginner's Dual-Language Book, Angel Flores. Delightful stories, other material based on works of Don Juan Manuel, Luis Taboada, Ricardo Palma, other noted writers. Complete faithful English translations on facing pages. Exercises. 176pp. 5% x 8½. 0-486-25810-6

FIVE ACRES AND INDEPENDENCE, Maurice G. Kains. Great back-to-the-land classic explains basics of self-sufficient farming. The one book to get. 95 illustrations. 397pp. 5% x 8½. 0-486-20974-1

FLAGG'S SMALL HOUSES: Their Economic Design and Construction, 1922, Ernest Flagg. Although most famous for his skyscrapers, Flagg was also a proponent of the well-designed single-family dwelling. His classic treatise features innovations that save space, materials, and cost. 526 illustrations. 160pp. 9% x 12%.

0-486-45197-6

FLATLAND: A Romance of Many Dimensions, Edwin A. Abbott. Classic of science (and mathematical) fiction — charmingly illustrated by the author — describes the adventures of A. Square, a resident of Flatland, in Spaceland (three dimensions), Lineland (one dimension), and Pointland (no dimensions). 96pp. 5% x 8%.

0-486-27263-X

FRANKENSTEIN, Mary Shelley. The story of Victor Frankenstein's monstrous creation and the havoc it caused has enthralled generations of readers and inspired countless writers of horror and suspense. With the author's own 1831 introduction. 176pp. 5% x 8%. 0-486-28211-2

THE GARGOYLE BOOK: 572 Examples from Gothic Architecture, Lester Burbank Bridaham. Dispelling the conventional wisdom that French Gothic architectural flourishes were born of despair or gloom, Bridaham reveals the whimsical nature of these creations and the ingenious artisans who made them. 572 illustrations. 224pp. 8% x 11. 0-486-44754-5

THE GIFT OF THE MAGI AND OTHER SHORT STORIES, O. Henry. Sixteen captivating stories by one of America's most popular storytellers. Included are such classics as "The Gift of the Magi," "The Last Leaf," and "The Ransom of Red Chief." Publisher's Note. 96pp. 5% x 8½. 0-486-27061-0

THE GOETHE TREASURY: Selected Prose and Poetry, Johann Wolfgang von Goethe. Edited, Selected, and with an Introduction by Thomas Mann. In addition to his lyric poetry, Goethe wrote travel sketches, autobiographical studies, essays, letters, and proverbs in rhyme and prose. This collection presents outstanding examples from each genre. 368pp. 5% x 8½. 0-486-44780-4

GREAT EXPECTATIONS, Charles Dickens. Orphaned Pip is apprenticed to the dirty work of the forge but dreams of becoming a gentleman — and one day finds himself in possession of "great expectations." Dickens' finest novel. 400pp. 5% x 8%. 0-486-41586-4

GREAT WRITERS ON THE ART OF FICTION: From Mark Twain to Joyce Carol Oates, Edited by James Daley. An indispensable source of advice and inspiration, this anthology features essays by Henry James, Kate Chopin, Willa Cather, Sinclair Lewis, Jack London, Raymond Chandler, Raymond Carver, Eudora Welty, and Kurt Vonnegut, Jr. 192pp. 5% x 8½. 0-486-45128-3

HAMLET, William Shakespeare. The quintessential Shakespearean tragedy, whose highly charged confrontations and anguished soliloquies probe depths of human feeling rarely sounded in any art. Reprinted from an authoritative British edition complete with illuminating footnotes. 128pp. 5% x 8½. 0-486-27278-8

THE HAUNTED HOUSE, Charles Dickens. A Yuletide gathering in an eerie country retreat provides the backdrop for Dickens and his friends — including Elizabeth Gaskell and Wilkie Collins — who take turns spinning supernatural yarns. 144pp. 5% x 8%. 0-486-46309-5

HEART OF DARKNESS, Joseph Conrad. Dark allegory of a journey up the Congo River and the narrator's encounter with the mysterious Mr. Kurtz. Masterly blend of adventure, character study, psychological penetration. For many, Conrad's finest, most enigmatic story. 80pp. 5% x 8½. 0-486-26464-5

HENSON AT THE NORTH POLE, Matthew A. Henson. This thrilling memoir by the heroic African-American who was Peary's companion through two decades of Arctic exploration recounts a tale of danger, courage, and determination. "Fascinating and exciting." — *Commonweal*. 128pp. 5% x 8½. 0-486-45472-X

HISTORIC COSTUMES AND HOW TO MAKE THEM, Mary Fernald and E. Shenton. Practical, informative guidebook shows how to create everything from short tunics worn by Saxon men in the fifth century to a lady's bustle dress of the late 1800s. 81 illustrations. 176pp. 5% x 8%. 0-486-44906-8

THE HOUND OF THE BASKERVILLES, Arthur Conan Doyle. A deadly curse in the form of a legendary ferocious beast continues to claim its victims from the Baskerville family until Holmes and Watson intervene. Often called the best detective story ever written. 128pp. 5% x 8½. 0-486-28214-7

THE HOUSE BEHIND THE CEDARS, Charles W. Chesnutt. Originally published in 1900, this groundbreaking novel by a distinguished African-American author recounts the drama of a brother and sister who "pass for white" during the dangerous days of Reconstruction. 208pp. $5\% \times 8\frac{1}{2}$. 0-486-46144-0

THE HUMAN FIGURE IN MOTION, Eadweard Muybridge. The 4,789 photographs in this definitive selection show the human figure — models almost all undraped engaged in over 160 different types of action: running, climbing stairs, etc. 390pp. 7% x 10%. 0-486-20204-6

THE IMPORTANCE OF BEING EARNEST, Oscar Wilde. Wilde's witty and buoyant comedy of manners, filled with some of literature's most famous epigrams, reprinted from an authoritative British edition. Considered Wilde's most perfect work. 64pp. 5% x 8¼. 0-486-26478-5

THE INFERNO, Dante Alighieri. Translated and with notes by Henry Wadsworth Longfellow. The first stop on Dante's famous journey from Hell to Purgatory to Paradise, this 14th-century allegorical poem blends vivid and shocking imagery with graceful lyricism. Translated by the beloved 19th-century poet, Henry Wadsworth Longfellow. 256pp. 5% x 8%. 0-486-44288-8

JANE EYRE, Charlotte Brontë. Written in 1847, *Jane Eyre* tells the tale of an orphan girl's progress from the custody of cruel relatives to an oppressive boarding school and its culmination in a troubled career as a governess. 448pp. 5% x 8%.

0-486-42449-9

JAPANESE WOODBLOCK FLOWER PRINTS, Tanigami Kônan. Extraordinary collection of Japanese woodblock prints by a well-known artist features 120 plates in brilliant color. Realistic images from a rare edition include daffodils, tulips, and other familiar and unusual flowers. 128pp. 11 x 8½. 0-486-46442-3

JEWELRY MAKING AND DESIGN, Augustus F. Rose and Antonio Cirino. Professional secrets of jewelry making are revealed in a thorough, practical guide. Over 200 illustrations. 306pp. 5% x 8½. 0-486-21750-7

JULIUS CAESAR, William Shakespeare. Great tragedy based on Plutarch's account of the lives of Brutus, Julius Caesar and Mark Antony. Evil plotting, ringing oratory, high tragedy with Shakespeare's incomparable insight, dramatic power. Explanatory footnotes. 96pp. 5% x 8%. 0-486-26876-4

THE JUNGLE, Upton Sinclair. 1906 bestseller shockingly reveals intolerable labor practices and working conditions in the Chicago stockyards as it tells the grim story of a Slavic family that emigrates to America full of optimism but soon faces despair. 320pp. 5% x 8%. 0-486-41923-1

THE KINGDOM OF GOD IS WITHIN YOU, Leo Tolstoy. The soul-searching book that inspired Gandhi to embrace the concept of passive resistance, Tolstoy's 1894 polemic clearly outlines a radical, well-reasoned revision of traditional Christian thinking. 352pp. 5% x 8%. 0-486-45138-0

THE LADY OR THE TIGER?: and Other Logic Puzzles, Raymond M. Smullyan. Created by a renowned puzzle master, these whimsically themed challenges involve paradoxes about probability, time, and change; metapuzzles; and self-referentiality. Nineteen chapters advance in difficulty from relatively simple to highly complex. 1982 edition. 240pp. 5% x 8½. 0-486-47027-X

LEAVES OF GRASS: The Original 1855 Edition, Walt Whitman. Whitman's immortal collection includes some of the greatest poems of modern times, including his masterpiece, "Song of Myself." Shattering standard conventions, it stands as an unabashed celebration of body and nature. 128pp. 5% x 8%. 0-486-45676-5

LES MISÉRABLES, Victor Hugo. Translated by Charles E. Wilbour. Abridged by James K. Robinson. A convict's heroic struggle for justice and redemption plays out against a fiery backdrop of the Napoleonic wars. This edition features the excellent original translation and a sensitive abridgment. 304pp. 6% x 9%.

0-486-45789-3

LILITH: A Romance, George MacDonald. In this novel by the father of fantasy literature, a man travels through time to meet Adam and Eve and to explore humanity's fall from grace and ultimate redemption. 240pp. $5\% \times 8\%$.

0-486-46818-6

THE LOST LANGUAGE OF SYMBOLISM, Harold Bayley. This remarkable book reveals the hidden meaning behind familiar images and words, from the origins of Santa Claus to the fleur-de-lys, drawing from mythology, folklore, religious texts, and fairy tales. 1,418 illustrations. 784pp. 5% x 8½. 0-486-44787-1

MACBETH, William Shakespeare. A Scottish nobleman murders the king in order to succeed to the throne. Tortured by his conscience and fearful of discovery, he becomes tangled in a web of treachery and deceit that ultimately spells his doom. 96pp. 5% x 8%. 0-486-27802-6

MAKING AUTHENTIC CRAFTSMAN FURNITURE: Instructions and Plans for 62 Projects, Gustav Stickley. Make authentic reproductions of handsome, functional, durable furniture: tables, chairs, wall cabinets, desks, a hall tree, and more. Construction plans with drawings, schematics, dimensions, and lumber specs reprinted from 1900s *The Craftsman* magazine. 128pp. 8% x 11. 0-486-25000-8

MATHEMATICS FOR THE NONMATHEMATICIAN, Morris Kline. Erudite and entertaining overview follows development of mathematics from ancient Greeks to present. Topics include logic and mathematics, the fundamental concept, differential calculus, probability theory, much more. Exercises and problems. 641pp. 5% x 8%. 0-486-24823-2

MEMOIRS OF AN ARABIAN PRINCESS FROM ZANZIBAR, Emily Ruete. This 19th-century autobiography offers a rare inside look at the society surrounding a sultan's palace. A real-life princess in exile recalls her vanished world of harems, slave trading, and court intrigues. 288pp. 5% x 8½. 0-486-47121-7

THE METAMORPHOSIS AND OTHER STORIES, Franz Kafka. Excellent new English translations of title story (considered by many critics Kafka's most perfect work), plus "The Judgment," "In the Penal Colony," "A Country Doctor," and "A Report to an Academy." Note. 96pp. 5% x 8¹/₄. 0-486-29030-1

MICROSCOPIC ART FORMS FROM THE PLANT WORLD, R. Anheisser. From undulating curves to complex geometrics, a world of fascinating images abound in this classic, illustrated survey of microscopic plants. Features 400 detailed illustrations of nature's minute but magnificent handiwork. The accompanying CD-ROM includes all of the images in the book. 128pp. 9 x 9. 0-486-46013-4

A MIDSUMMER NIGHT'S DREAM, William Shakespeare. Among the most popular of Shakespeare's comedies, this enchanting play humorously celebrates the vagaries of love as it focuses upon the intertwined romances of several pairs of lovers. Explanatory footnotes. 80pp. 5% x 8½. 0-486-27067-X

THE MONEY CHANGERS, Upton Sinclair. Originally published in 1908, this cautionary novel from the author of *The Jungle* explores corruption within the American system as a group of power brokers joins forces for personal gain, triggering a crash on Wall Street. 192pp. 5% x 8½. 0-486-46917-4

THE MOST POPULAR HOMES OF THE TWENTIES, William A. Radford. With a New Introduction by Daniel D. Reiff. Based on a rare 1925 catalog, this architectural showcase features floor plans, construction details, and photos of 26 homes, plus articles on entrances, porches, garages, and more. 250 illustrations, 21 color plates. 176pp. 8% x 11. 0-486-47028-8

MY 66 YEARS IN THE BIG LEAGUES, Connie Mack. With a New Introduction by Rich Westcott. A Founding Father of modern baseball, Mack holds the record for most wins — and losses — by a major league manager. Enhanced by 70 photographs, his warmhearted autobiography is populated by many legends of the game. 288pp. 5% x 8½. 0-486-47184-5

NARRATIVE OF THE LIFE OF FREDERICK DOUGLASS, Frederick Douglass. Douglass's graphic depictions of slavery, harrowing escape to freedom, and life as a newspaper editor, eloquent orator, and impassioned abolitionist. 96pp. 5% x 8%. 0-486-28499-9

THE NIGHTLESS CITY: Geisha and Courtesan Life in Old Tokyo, J. E. de Becker. This unsurpassed study from 100 years ago ventured into Tokyo's red-light district to survey geisha and courtesan life and offer meticulous descriptions of training, dress, social hierarchy, and erotic practices. 49 black-and-white illustrations; 2 maps. 496pp. 5% x 8½. 0-486-45563-7

THE ODYSSEY, Homer. Excellent prose translation of ancient epic recounts adventures of the homeward-bound Odysseus. Fantastic cast of gods, giants, cannibals, sirens, other supernatural creatures — true classic of Western literature. 256pp. 5% x 8%.

0-486-40654-7

OEDIPUS REX, Sophocles. Landmark of Western drama concerns the catastrophe that ensues when King Oedipus discovers he has inadvertently killed his father and married his mother. Masterly construction, dramatic irony. Explanatory footnotes. 64pp. 5% x 8%. 0-486-26877-2

ONCE UPON A TIME: The Way America Was, Eric Sloane. Nostalgic text and drawings brim with gentle philosophies and descriptions of how we used to live — selfsufficiently — on the land, in homes, and among the things built by hand. 44 line illustrations. 64pp. 8% x 11. 0-486-44411-2

ONE OF OURS, Willa Cather. The Pulitzer Prize-winning novel about a young Nebraskan looking for something to believe in. Alienated from his parents, rejected by his wife, he finds his destiny on the bloody battlefields of World War I. 352pp. 5% x 8¹/₄. 0-486-45599-8

ORIGAMI YOU CAN USE: 27 Practical Projects, Rick Beech. Origami models can be more than decorative, and this unique volume shows how! The 27 practical projects include a CD case, frame, napkin ring, and dish. Easy instructions feature 400 two-color illustrations. 96pp. 8¼ x 11. 0-486-47057-1

OTHELLO, William Shakespeare. Towering tragedy tells the story of a Moorish general who earns the enmity of his ensign Iago when he passes him over for a promotion. Masterly portrait of an archvillain. Explanatory footnotes. 112pp. 5% x 8%.

0-486-29097-2

PARADISE LOST, John Milton. Notes by John A. Himes. First published in 1667, Paradise Lost ranks among the greatest of English literature's epic poems. It's a sublime retelling of Adam and Eve's fall from grace and expulsion from Eden. Notes by John A. Himes. 480pp. 5% x 8%. 0-486-44287-X

PASSING, Nella Larsen. Married to a successful physician and prominently ensconced in society, Irene Redfield leads a charmed existence — until a chance encounter with a childhood friend who has been "passing for white." 112pp. 5% x 8%. 0-486-43713-2

PERSPECTIVE DRAWING FOR BEGINNERS, Len A. Doust. Doust carefully explains the roles of lines, boxes, and circles, and shows how visualizing shapes and forms can be used in accurate depictions of perspective. One of the most concise introductions available. 33 illustrations. 64pp. 5% x 8½. 0-486-45149-6

PERSPECTIVE MADE EASY, Ernest R. Norling. Perspective is easy; yet, surprisingly few artists know the simple rules that make it so. Remedy that situation with this simple, step-by-step book, the first devoted entirely to the topic. 256 illustrations. 224pp. 5% x 8½. 0-486-40473-0

THE PICTURE OF DORIAN GRAY, Oscar Wilde. Celebrated novel involves a handsome young Londoner who sinks into a life of depravity. His body retains perfect youth and vigor while his recent portrait reflects the ravages of his crime and sensuality. 176pp. 5% x 8½. 0-486-27807-7

PRIDE AND PREJUDICE, Jane Austen. One of the most universally loved and admired English novels, an effervescent tale of rural romance transformed by Jane Austen's art into a witty, shrewdly observed satire of English country life. 272pp. 5% x 8%.

0-486-28473-5

THE PRINCE, Niccolò Machiavelli. Classic, Renaissance-era guide to acquiring and maintaining political power. Today, nearly 500 years after it was written, this calculating prescription for autocratic rule continues to be much read and studied. 80pp. $5\% \times 8\%$. 0-486-27274-5

QUICK SKETCHING, Carl Cheek. A perfect introduction to the technique of "quick sketching." Drawing upon an artist's immediate emotional responses, this is an extremely effective means of capturing the essential form and features of a subject. More than 100 black-and-white illustrations throughout, 48pp. 11 x 8¼.

0-486-46608-6

RANCH LIFE AND THE HUNTING TRAIL, Theodore Roosevelt. Illustrated by Frederic Remington. Beautifully illustrated by Remington, Roosevelt's celebration of the Old West recounts his adventures in the Dakota Badlands of the 1880s, from roundups to Indian encounters to hunting bighorn sheep. 208pp. 6¼ x 9¼. 048647340-6

THE RED BADGE OF COURAGE, Stephen Crane. Amid the nightmarish chaos of a Civil War battle, a young soldier discovers courage, humility, and, perhaps, wisdom. Uncanny re-creation of actual combat. Enduring landmark of American fiction. 112pp. 5% x 8%. 0-486-26465-3

RELATIVITY SIMPLY EXPLAINED, Martin Gardner. One of the subject's clearest, most entertaining introductions offers lucid explanations of special and general theories of relativity, gravity, and spacetime, models of the universe, and more. 100 illustrations. 224pp. 5% x 8%. 0-486-29315-7

REMBRANDT DRAWINGS: 116 Masterpieces in Original Color, Rembrandt van Rijn. This deluxe hardcover edition features drawings from throughout the Dutch master's prolific career. Informative captions accompany these beautifully reproduced landscapes, biblical vignettes, figure studies, animal sketches, and portraits. 128pp. 8% x 11. 0-486-46149-1

THE ROAD NOT TAKEN AND OTHER POEMS, Robert Frost. A treasury of Frost's most expressive verse. In addition to the title poem: "An Old Man's Winter Night," "In the Home Stretch," "Meeting and Passing," "Putting in the Seed," many more. All complete and unabridged. 64pp. 5% x 8%. 0-486-27550-7

ROMEO AND JULIET, William Shakespeare. Tragic tale of star-crossed lovers, feuding families and timeless passion contains some of Shakespeare's most beautiful and lyrical love poetry. Complete, unabridged text with explanatory footnotes. 96pp. 5% x 8%. 0-486-27557-4

SANDITON AND THE WATSONS: Austen's Unfinished Novels, Jane Austen. Two tantalizing incomplete stories revisit Austen's customary milieu of courtship and venture into new territory, amid guests at a seaside resort. Both are worth reading for pleasure and study. 112pp. 5% x 8½. 0-48645793-1

THE SCARLET LETTER, Nathaniel Hawthorne. With stark power and emotional depth, Hawthorne's masterpiece explores sin, guilt, and redemption in a story of adultery in the early days of the Massachusetts Colony. 192pp. 5% x 8%.

0-486-28048-9

THE SEASONS OF AMERICA PAST, Eric Sloane. Seventy-five illustrations depict cider mills and presses, sleds, pumps, stump-pulling equipment, plows, and other elements of America's rural heritage. A section of old recipes and household hints adds additional color. 160pp. 8% x 11. 0-486-44220-9

SELECTED CANTERBURY TALES, Geoffrey Chaucer. Delightful collection includes the General Prologue plus three of the most popular tales: "The Knight's Tale," "The Miller's Prologue and Tale," and "The Wife of Bath's Prologue and Tale." In modern English. 144pp. 5% x 8%. 0-486-28241-4

SELECTED POEMS, Emily Dickinson. Over 100 best-known, best-loved poems by one of America's foremost poets, reprinted from authoritative early editions. No comparable edition at this price. Index of first lines. 64pp. 5% x 8%. 0-486-26466-1

SIDDHARTHA, Hermann Hesse. Classic novel that has inspired generations of seekers. Blending Eastern mysticism and psychoanalysis, Hesse presents a strikingly original view of man and culture and the arduous process of self-discovery, reconciliation, harmony, and peace. 112pp. 5% x 8½. 0-486-40653-9

SKETCHING OUTDOORS, Leonard Richmond. This guide offers beginners stepby-step demonstrations of how to depict clouds, trees, buildings, and other outdoor sights. Explanations of a variety of techniques include shading and constructional drawing. 48pp. 11 x 8¹/₄. 0-486-46922-0

SMALL HOUSES OF THE FORTIES: With Illustrations and Floor Plans, Harold E. Group. 56 floor plans and elevations of houses that originally cost less than \$15,000 to build. Recommended by financial institutions of the era, they range from Colonials to Cape Cods. 144pp. 8% x 11. 0-486-45598-X

SOME CHINESE GHOSTS, Lafcadio Hearn. Rooted in ancient Chinese legends, these richly atmospheric supernatural tales are recounted by an expert in Oriental lore. Their originality, power, and literary charm will captivate readers of all ages. 96pp. 5% x 8½. 0-486-46306-0

SONGS FOR THE OPEN ROAD: Poems of Travel and Adventure, Edited by The American Poetry & Literacy Project. More than 80 poems by 50 American and British masters celebrate real and metaphorical journeys. Poems by Whitman, Byron, Millay, Sandburg, Langston Hughes, Emily Dickinson, Robert Frost, Shelley, Tennyson, Yeats, many others. Note. 80pp. 5% x 8%. 0-486-40646-6

SPOON RIVER ANTHOLOGY, Edgar Lee Masters. An American poetry classic, in which former citizens of a mythical midwestern town speak touchingly from the grave of the thwarted hopes and dreams of their lives. 144pp. 5% x 8%.

0-486-27275-3

STAR LORE: Myths, Legends, and Facts, William Tyler Olcott. Captivating retellings of the origins and histories of ancient star groups include Pegasus, Ursa Major,
Pleiades, signs of the zodiac, and other constellations. "Classic." — Sky & Telescope.
58 illustrations. 544pp. 5% x 8½.58 illustrations. 544pp. 5% x 8½.

THE STRANGE CASE OF DR. JEKYLL AND MR. HYDE, Robert Louis Stevenson. This intriguing novel, both fantasy thriller and moral allegory, depicts the struggle of two opposing personalities — one essentially good, the other evil — for the soul of one man. 64pp. 5% x 8½. 0-486-26688-5

SURVIVAL HANDBOOK: The Official U.S. Army Guide, Department of the Army. This special edition of the Army field manual is geared toward civilians. An essential companion for campers and all lovers of the outdoors, it constitutes the most authoritative wilderness guide. 288pp. 5% x 8%. 0486-46184X

A TALE OF TWO CITIES, Charles Dickens. Against the backdrop of the French Revolution, Dickens unfolds his masterpiece of drama, adventure, and romance about a man falsely accused of treason. Excitement and derring-do in the shadow of the guillotine. 304pp. 5% x 8½. 0-486-40651-2

TEN PLAYS, Anton Chekhov. The Sea Gull, Uncle Vanya, The Three Sisters, The Cherry Orchard, and Ivanov, plus 5 one-act comedies: The Anniversary, An Unwilling Martyr, The Wedding, The Bear, and The Proposal. 336pp. 5% x 8%. 0-486-46560-8

THE FLYING INN, G. K. Chesterton. Hilarious romp in which pub owner Humphrey Hump and friend take to the road in a donkey cart filled with rum and cheese, inveighing against Prohibition and other "oppressive forms of modernity." 320pp. 5% x 8½. 0-486-41910-X

THIRTY YEARS THAT SHOOK PHYSICS: The Story of Quantum Theory, George Gamow. Lucid, accessible introduction to the influential theory of energy and matter features careful explanations of Dirac's anti-particles, Bohr's model of the atom, and much more. Numerous drawings. 1966 edition. 240pp. 5% x 8%. 0-486-24895-X

TREASURE ISLAND, Robert Louis Stevenson. Classic adventure story of a perilous sea journey, a mutiny led by the infamous Long John Silver, and a lethal scramble for buried treasure — seen through the eyes of cabin boy Jim Hawkins. 160pp. 5% x 8½. 0-486-27559-0

THE TRIAL, Franz Kafka. Translated by David Wyllie. From its gripping first sentence onward, this novel exemplifies the term "Kafkaesque." Its darkly humorous narrative recounts a bank clerk's entrapment in a bureaucratic maze, based on an undisclosed charge. 176pp. 5% x 8½. 0-486-47061-X

THE TURN OF THE SCREW, Henry James. Gripping ghost story by great novelist depicts the sinister transformation of 2 innocent children into flagrant liars and hypocrites. An elegantly told tale of unspoken horror and psychological terror. 96pp. 5% x 8%. 0-486-26684-2

UP FROM SLAVERY, Booker T. Washington. Washington (1856-1915) rose to become the most influential spokesman for African-Americans of his day. In this eloquently written book, he describes events in a remarkable life that began in bondage and culminated in worldwide recognition. 160 pp. 5% x 8½. 0-486-28738-6

VICTORIAN HOUSE DESIGNS IN AUTHENTIC FULL COLOR: 75 Plates from the "Scientific American – Architects and Builders Edition," 1885-1894, Edited by Blanche Cirker. Exquisitely detailed, exceptionally handsome designs for an enormous variety of attractive city dwellings, spacious suburban and country homes, charming "cottages" and other structures — all accompanied by perspective views and floor plans. 80pp. 9% x 12%. 0-486-29438-2

VILLETTE, Charlotte Brontë. Acclaimed by Virginia Woolf as "Brontë's finest novel," this moving psychological study features a remarkably modern heroine who abandons her native England for a new life as a schoolteacher in Belgium. 480pp. 5% x 8%. 0-486-45557-2

THE VOYAGE OUT, Virginia Woolf. A moving depiction of the thrills and confusion of youth, Woolf's acclaimed first novel traces a shipboard journey to South America for a captivating exploration of a woman's growing self-awareness. 288pp. 5% x 8%. 0-486-45005-8

WALDEN; OR, LIFE IN THE WOODS, Henry David Thoreau. Accounts of Thoreau's daily life on the shores of Walden Pond outside Concord, Massachusetts, are interwoven with musings on the virtues of self-reliance and individual freedom, on society, government, and other topics. 224pp. 5% x 8%. 0-486-28495-6

WILD PILGRIMAGE: A Novel in Woodcuts, Lynd Ward. Through startling engravings shaded in black and red, Ward wordlessly tells the story of a man trapped in an industrial world, struggling between the grim reality around him and the fantasies his imagination creates. 112pp. 6% x 9%. 0-486-46583-7

WILLY POGÁNY REDISCOVERED, Willy Pogány. Selected and Edited by Jeff A. Menges. More than 100 color and black-and-white Art Nouveau-style illustrations from fairy tales and adventure stories include scenes from Wagner's "Ring" cycle, *The Rime of the Ancient Mariner, Gulliver's Travels*, and *Faust.* 144pp. 8% x 11.

0-486-47046-6

WOOLLY THOUGHTS: Unlock Your Creative Genius with Modular Knitting, Pat Ashforth and Steve Plummer. Here's the revolutionary way to knit — easy, fun, and foolproof! Beginners and experienced knitters need only master a single stitch to create their own designs with patchwork squares. More than 100 illustrations. 128pp. 6½ x 9¼. 0-486-46084-3

WUTHERING HEIGHTS, Emily Brontë. Somber tale of consuming passions and vengeance — played out amid the lonely English moors — recounts the turbulent and tempestuous love story of Cathy and Heathcliff. Poignant and compelling. 256pp. 5% x 8%. 0-486-29256-8